Teaching Art, (Re)imagining Identity

A collection of articles from
VISUAL ARTS RESEARCH

Edited by Laura Hetrick

COMMON THREADS

An anthology from the
University of Illinois Press

Contents

Introducing the Many Face[t]s of Identity

Laura Hetrick

This Common Threads collection carefully curates and showcases *Visual Arts Research* scholarship from the last 20+ years that, when juxtaposed in a new way, intertextually illustrates a variety of methods to engage and negotiate complex identities in the art classroom. These methods emphasize approaches to exploring identity through art making; actions to reinforce identity in a positive manner; and ways to enhance marginalized identities. First, it begins by briefly addressing multiple understandings of the concept of identity in fields related to art education as a foundation for the collection. Next, it places particular focus on the concept of personal identity and how it relates to K-16 grade students' negotiations of their complex identities within society. Lastly, it provides a short citation from each author's contribution included in this collection to offer suggestions on how each paper might help arts educators productively engage with their students who are continuously [re]imagining their identities inside and outside of the art room.

Perspectives on Identity

While *identity* is a word or concept that seems to get mishandled and/or overused in mainstream U.S. vernacular, it is an important concept to explore and attempt to understand within the art classroom in consideration of students' ever-evolving identities. Identity is a concept that can be, has been, and remains to be considered from many different theoretical and ontological standpoints. While perhaps "one of the most accepted definitions of identity is that proposed by Miller (1963, 1983) who defines the term as a set of observable and inferable attributes that identifies a

person to him and to others" (Diab & Mi'ari, 2007, p. 427), there are many other conceptualizations of identity that add to the academic discourse as well as attempt to trouble its outdated insular definition. Literature from general education and identity studies illuminates many diverse understandings of identity.

Similar to Miller's definition above, "a traditional notion of identity is of something well-defined about oneself, fixed and unchanging, something inside of us 'like the kernel of a nut' (Currie, 1998, p. 2)," (Watson, 2006, p. 509). Analogous to this notion is a more colloquial understanding of identity "in terms of a person's self-image or fundamental values and beliefs" (Garrett, 1998, p. 1). While these definitions, and others of their ilk, have been more or less accepted as certain since Lockean times (1632–1704), more contemporary and alternative views argue

> that identity can never be something that is just interior because identity is necessarily relational, to do with recognition of sameness and difference between ourselves and others. Identity only has meaning within a chain of relationships, i.e. there is no fixed point of reference for 'an identity'. (Watson, 2006, p. 509)

There are other definitions of identity that correspond to Watson's alternative view that dispel or trouble the concept of identity as an 'unchanging core' by considering the influences of external forces such as family, environment, and society. Some of these other definitions of identity include the field of sociology's identity control theory (ICT), in which identity is understood as the set of meanings that define who one is "in terms of a group or classification (such as being an American or female), in terms of a role (e.g. a stockbroker or a truck driver) or in terms of personal attributes (as in being friendly or honest)" (Stets & Burke, 2005, p. 45). And then there are those that posit that "identity is not something one has, but something that develops during one's whole life" (Beijaard, Meijer, & Verloop, 2004, p. 107).

With so many plausible definitions and conceptualizations of identity which, at times, may seem to be in conflict, it is understandable that the concept of identity is continuously contested and researched within scholarly literature across various disciplines such as psychology, sociology, and education. Identity develops during one's whole life, which includes one's life as a student in the art room and beyond. Consistent with this reasoning is Danielewicz's (2001) assertion that identity is under constant construction. It is worth quoting her relevant passage at length as it eloquently synopsizes the concept of identity conceptualized in this collection. Danielewicz (2001) writes

> All identity categories, even those that seem biologically designated like gender or race, are processes under construction. They are not unified or fixed entities that exist permanently inside individuals. This process of be-

coming is what I call identity development. As persons in the world, we are continually engaged in becoming something or someone . . . Because identities are conditional, restless, unstable, ever-changing states of being, they can never be ultimately completed. Though identities are fluid, individuals do have recognizable selves. We might think of a person's identities as points of fixation, temporarily arrested states, that are achieved moment by moment in the course of relations between individuals. (p. 3)

As Danielewicz states, identities are processes under development. She also posits that persons in the world are continually engaged in becoming something or someone. This is an important concept that arts educators should keep in mind, especially if they see their students over several years of schooling. Though educators will recognize them through their temporary points of fixation, students will continually change.

While keeping Danielewicz's sentiments in mind, this Common Threads collection also borrows Bracher's (2002) rather unconstrained definition of identity as "the sense of oneself as a more or less coherent and continuous force that matters in the world" (p. 94). Though our students' identities may constantly be [re]forming or changing it is important for educators, current and emergent, to be aware of the various components and desires that may constitute our students' identities. The main challenge for educators is to "understand the multiple identity components and desires that pervade the educational field; and to variously recruit, redirect, reinforce, circumvent, or neutralize these forces" (Bracher, 2002, p. 93). Furthermore, as educators, it may be important to think of identity as similar to Sturken and Cartwright's (2018) definition of culture as a fluid "set of processes or practices through which individuals and groups produce, consume, and make sense of things, including their own identities" (p. 6). Similar to culture, a student's personal identity is fluid and a set of processes continually [re]produced and [re]imagined through complex negotiations with others in society.

Focus on Personal Identity

The main focus of this collection is the personal identity development of each student through the act of art making. Because adolescents are still developing emotionally and cognitively, they are often solely concerned with the self, how the self relates to its immediate surroundings, and what their peers think of them. Likewise, when most individuals of any age think about the concept of identity, they are likely thinking about *personal identity*.

Person[al] identities relate to verifying the 'real self'. Because they are activated across situations, roles, and groups, they are more likely to be

prominent. Further, because more people know the individual in terms of the characteristics of the person[al] identity, there is more commitment to person[al] identities. (Stets & Burke, 2005, p. 58)

Personal identity's focus is on the self—or the sense of oneself—as unique from others and more or less recognizable across time. "The individual level focuses on oneself as a unique being, and self-esteem derives from interpersonal comparisons of traits, abilities, goals, performance, and the like. The basic motivation is self-interest, and the individual is essentially independent and autonomous" (Sluss & Ashforth, 2007, p. 9). Personal identity sets an individual apart from others and is therefore more indicative of self as a separate entity than self as part of a group. While the concept of self may be partially determined by who it is not, within a group or amongst other random individuals, one's personal identity is distinguished by a person's (expected) actions and characteristics over time—though changes in behavior are nearly inevitable. "At the individual level, the personal orientation is activated and people are motivated by self-interest, perceiving themselves in terms of their individual traits and characteristics and utilizing comparisons with other individuals as a frame of reference" (Stout, 2001, p. 6). Though individuals, especially adolescents, may use others as a frame of reference for determining self, it must also be noted that "historical, sociological, psychological, and cultural factors may all influence" (Beijaard, et al., 2004, p. 113) the individual's sense of self. Arts educators have the perfect supportive space for students to artistically work through some of these cultural factors and explore how these different influences affect them.

Additionally, arts educators should have conversations about how individuals are composed of multiple, often conflicting, identities to help reassure students that they are not alone in their struggles, nor is their confusion about who they are abnormal. It is reassuring for students to know that it is okay that their identities are "constantly under construction as they are reformed, added to, eroded, reconstructed, integrated, dissolved, or expanded. Each of these conceptions of 'self' exists simultaneously and fluidly, with varying degrees of importance or relevance given any one time or place" (Danielewicz, 2001, p. 4). Knowing that they are not alone in feeling these disruptions and conflicts that seem tumultuous will potentially relieve some stress of *being the only one* going through this evolving identity formation process.

This cursory yet foundational understanding of identity as fluid and ever-evolving, illuminates how engaged art making is a key tool in working through this process. In the next section, a short citation of each author's contribution will offer suggestions on how each paper might help arts educators productively engage with their students who are continuously [re]imagining their identities inside and outside of the art room.

Identity & Art Making in VAR

The papers that have been curated for this collection are arranged chronologically to show a historical shift in how identity has been actuated and operationalized within art education literature and to allow for new intertextualities to influence each other. The first paper is by Katter (1991) who sets up the basics of how arts educators can introduce cultural diversity into the classroom. "Students can be given continuous opportunities to see how art functions in both their own lives and in the lives of others as a means of understanding their own culture in relationship to that of others," (p. 31 of original text). Building on the idea of cultural diversity, Ambush (1993) focuses on minority children's place in society and the classroom, and their treatment within the school curriculum. She offers that "the notion of curricular ecology demands that we see individuals, events, materials, activities, and values as complex and interrelated, and that we attend to various aspects of this complex[ity]" (p. 22 of original text). While incorporating cultural diversity and utilizing curricular ecology methods in the classroom will likely aid in positive identity development for underrepresented students, Hernandez (1993) troubles this concept by speaking from his own mestizo subjectivity. He points out that "in order to build their own identity, some people and groups need to create an image of 'the other' as the enemy, who is an excuse to justify all their inadequacies and limitations and is also created for their own self-defense" (pp. 5–6 of original text). To eradicate this proclivity for *othering*, he encourages arts educators to be more inclusive in their offerings of all cultures' artists in the classroom, and while not being reductive, upholding the wisdom from people everywhere in the world.

Moving forward ten years—Freedman and Schuler's (2003) paper accounts for students' leisure activities outside of the classroom and their possible effects on identity development. "Adolescents are at a time in their lives when they are developing their identities. When viewing television, they are able to explore the construction of identity through a variety of roles and life possibilities presented on the screen," (p. 166 of original text). The authors' text speaks to how popular visual culture images and representations are part of the body of visual information that students pull from in order to [re]imagine their own evolving identities. Directly in line with this reasoning on images' influences, Lampela (2007) notes how important it is for LGBTQ students to actually have images (fine art and popular art) available to them in the classroom to aid in healthy identity development. "If lesbian and gay adolescents receive information about other accepted and productive lesbian and gay artists who could serve as positive role models, they may feel relieved they are not alone and can accept who they are," (p. 35 of original text). In other words, all students should be able to *see themselves* positively within the imagery shown in the art classroom.

Transitioning into the current decade of the 2010s—Bae's (2011) study "lends itself to demystification of what postfeminist girl power displays in terms of girl-hood and girls' agency, contributing to a realistic representation of girlhood" (p. 39 of original text). Furthering the notion of gender's importance in transforming ideas of self, Cosier's (2011) paper "found that by focusing on the interplay between *power* and *position*, students can tease out the ways gender, race, class, and other factors influence the construction of knowledge and identity" (p. 51 of original text). Faucher (2016) introduces other influential factors such as the informal youth cultural prac-tices that adolescents engage with outside the classroom. She notes that by being in tune with these practices, "art teachers can then be more connected to the symbolic production processes that contribute to the formation and assertion of the individual and collective cultural identity of young people" (p. 68 of original text). Following the same concept of students' online practices outside the art room, Lalonde, Castro, and Pariser (2016) posit that there is a "reciprocal relationship between how youth construct and perform their identity and how that performance in conjunction with other participants in an online community is also influenced by the identity performance of other members of the community" (p. 40 of original text). And, as the last paper in this collection, Pérez Miles and Jenkins (2017) expand this idea of online communities and "propose media-rich platforms and interface structures that encourage nonlinear, interactive, and multimodal outcomes and have the potential to expand how we create, consume, and produce text" (p. 46 of original text), especially in relation to transgender youth. As a final note, in an effort to not be prescriptive, this introduction will not further outline the strengths, weaknesses, main ideas, or specific overlaps of each paper. As a dynamic resource, it is hoped that each arts educator will take from each paper the ideas, concepts, and suggestions that most resonate or inspire them and will ultimately help them in discovering and utilizing methods to engage and negotiate students' complex identities in the art classroom.

References

Ambush, D. (1993). Points of intersection: The convergence of aesthetics and race as a phenomenon of experience in the lives of African American children. *Visual Arts Research; 19*(2), 13–23.

Bae, M. S. (2011). Interrogating girl power: girlhood, popular media, and postfeminism. *Visual Arts Research, 37*(2), 28–40.

Beijaard, D., Meijer, P. C., & Verloop, N. (2004) Reconsidering research on teachers' professional identity. *Teaching and Teacher Education, 20,* 107–128.

Bracher, M. (2002). Identity and desire in the classroom. In J. Jagodzinski (Ed.), *Pedagogical desire: Authority, seduction, transference, and the question of ethics.* (pp.93–121). USA: Library of Congress.

Cosier, K. (2011). Girl stories: On narrative constructions of identity. *Visual Arts Research, 37*(2), 41–54.

Danielewicz, J. (2001). *Teaching selves: Identity, pedagogy, and teacher education*. Albany, NY: State University of New York Press.

Diab, K., & Mi'ari, M. (2007). Collective identity and readiness for social relations with Jews among Palestinian Arab students at the David Yellin Teacher Training College in Israel. *Intercultural Education*, *18*(5), 427–444.

Faucher, C. (2016). Informal youth cultural practices: Blurring the distinction between high and low. *Visual Arts Research*, *42*(1), 56–70.

Freedman, K., & Schuler, K. (2003). Please stand by for an important message: Television in art education. *Visual Arts Research*, *29*(57), 163–172.

Garrett, B. (1998). *Personal identity and self-consciousness*. London: Routledge.

Hernandez, F. (1993). From multiculturalism to mestizaje in world culture. *Visual Arts Research*, *19*(2), 1–12.

Katter, E. (1991). Meeting the challenge of cultural diversity. *Visual Arts Research*, *17*(2), 28–32.

Lalonde, M., Castro, J. C., & Pariser, D. (2016). Identity tableaux: Multimodal contextual constructions of adolescent identity. *Visual Arts Research*, *42*(1), 38–55.

Lampela, L. (2007). Including lesbians and gays in art curricula: The art of Jeanne Mammen. *Visual Arts Research*, *33*(1), 34–43.

Pérez Miles, A., & Jenkins, K. (2017). (Re)Born digital–trans-affirming research, curriculum, and pedagogy: An interactive multimodal story using twine. *Visual Arts Research*, *43*(1), 43–49.

Sluss, D. M., & Ashforth, B. E. (2007). Relational identity and identification: Defining ourselves through work relationships. *Academy of Management Review*, *32*(1), 9–32.

Stets, J. E., & Burke, P. J. (2005). New directions in identity control theory. In S. R. Thye & E. J. Lawler (Eds.) *Social identification in groups: Advances in group processes, Volume 22*. Amsterdam: Elsevier Ltd, 43–64.

Stout, D. M. (2001). *Teacher identity orientations: Personal, relational, and collective*. Unpublished manuscript. University of Colorado at Denver.

Sturken, M., & Cartwright, L. (2018). *Practices of looking: An introduction to visual culture, Third Edition*. Oxford, UK: Oxford University Press.

Watson, C. (2006). Narratives of practice and the construction of identity in teaching. *Teachers and Teaching: theory and practice*, *12*(5), 509–526.

Meeting the Challenge of Cultural Diversity

Eldon Katter
Kutztown University

The purpose of this paper is to suggest ways in which art education can meet the challenge of cultural diversity in our schools. The argument takes into account the history of competing ideologies that have influenced schooling practices in general and art education in particular. Teachers are encouraged to involve students in examining universal human systems, weighing cultural influences, and testing personal criteria and standards of excellence.

Cultural diversity in America is a fact. At different periods in our history, we, as a nation of many peoples, have embraced various ideologies to meet the challenge of this fact. These ideologies have ranged from the privateness of separatism and elitism to some degree of openness through pluralism. Conceptions of creating a desirable social order have been based on at least five competing ideologies which Richard Pratte (1979) refers to as assimilation, amalgamation, insular pluralism, modified pluralism and open society.

In the United States, the ideology of assimilation has been called Anglo-conformity. This position has held that, over time, all groups, or those who are permitted to, will conform to the life-style, values, and mores of the dominant majority. Amalgamation, sloganed as the "melting pot theory" of Americanization, is a modified form of assimilation. The ideology of amalgamation holds that all diverse groups will be synthesized into one distinct new group, the fusion of many nationalities and cultures into a new, composite American people. In the melting pot, everyone would speak the same language, share the same traditions, and agree about most basic values.

| 1

From *Visual Arts Research*, Vol. 17, No. 2 (Fall 1991), pp. 28–32

Cultural pluralism can be expressed as two different ideologies: insular pluralism and modified pluralism. The ideology of insular pluralism implies that each different social group shall, over time, maintain its own unique identity. Modified pluralism implies that each different social group will change over time from its original nature, but remain distinct from other social groups. In Pratte's analysis, the ideology of an open society envisions a thoroughly modern, secular society. In the larger picture, differences of race, religion, national origin, and such, are simply irrelevant in determining the nature of acceptable primary and secondary associations. Group associations give way to a more individualistic participation. Popular participation, equal opportunity, and the elimination of ethnicity are the hallmarks of an open society.

To a certain extent, each of the ideologies has influenced our nation's schooling practices. Pratte's analysis of the contending ideologies and their parallel curriculum practices clearly demonstrates that as the citizen model has evolved from the homogenized, rational, industrious, democratic person to a bicultural, bilingual, open personality, American schools have failed to evolve.

According to Pratte, in the late nineteenth and early twentieth centuries the curriculum focused on the ideology of assimilation. Anglo-Saxon values and attitudes were central to the development of curricula, as they were thought to be in some sense superior to those of other cultural groups. Public schooling developed a negative view of immigrant children and formulated specific goals for them. Schooling practices served to reinforce the point that to be human, accepted, and valued was to cherish the attitudes, values, and behaviors of the dominant majority.

Under the more permissive notion of the melting pot ideology of amalgamation in the early decades of the twentieth-century, the curriculum aimed at eliminating cultural diversity by bringing about a unified or amalgamated citizenry. A wide range of cultural groups were to be studied within the different subject areas of the curriculum. Teaching strategies focused on cooperation, cooperative attitude, sharing, and submerging one's own personal interests in the larger, seemingly better, group interest.

The ideology of insular pluralism, which guided some innovative educational practices in the mid-twentieth-century, suggested a patchwork of cultural hegemonies. Schooling practices provided the opportunity for students to establish a bicultural identity. The curriculum focus was on the secular and humanistic study of ethnic groups as people sharing a common ancestry, culture, history, sense of peoplehood, and common experience in American society. According to Ramirez and Castaneda (1974), preserving the language, heritage, and cultural values of the ethnic group was an often-stated goal of insular pluralism.

Modified pluralism is perhaps best included under the umbrella of multicultural education. The development of modified pluralism has occurred primarily within the

last two decades. The curriculum focus is the on the study of a wide range of American cultural groups, their common problems and struggle to maintain their distinctive ness. The study of various ethnic groups for the purpose of distinguishing similarities as well as differences between cultural groups becomes central to the curriculum.

According to Pratte, the curriculum focus for an open society is on civic and citizen well-being. The curriculum centers around the attainment of a common good or public interest. The curriculum considers the teaching, interpreting, and explaining of symbols which describe and justify the large-scale, impersonal, secular, corporate structures of modern society.

Examining the craft of tie-dye in art education programs provides an example of how art curricula in American schools has evolved from homogenized to bicultural. Among the files of student lesson plans prepared for student teaching practice at Kutztown University (1930–50), one can find examples of lessons from the 1930s, in which the craft of tie-dye is being offered as a means to make table covers to beautify one's home—to make everyone's home environment more alike, presumably more "American." From my childhood, I remember such a tie-dye table cover in our home. My mother had made it in a home arts course in the mid-1920s. The fringed velvet cloth, which covered a small lamp table in our living room, appeared rich with the mottled pattern of dark, deep ambers. Neither for my mother nor for me was there any association with African or Asian traditions. The purpose, as I recall, was to make our rural home "better" or more like those of another, supposedly more acceptable social class. In plans prepared in the 1940s we can find lessons for tie-dyeing head scarfs as a way to make things better on the home front in a time of war. In the 1960s, tie-dye was offered as an alternative to mass production, and as a means to express one's individuality as part of a counter-culture, presumably recognizing cultural pluralism in a modified way. In the 1970s, tie-dye projects were suggested in ethnic-centered programs as a means to instill pride in one's African heritage and to preserve ethnic traditions (Board of Public Education, 1972). Such goals are generally associated with insular pluralism. More recently, tie-dye has become associated with ecology, natural fibers, and colorants (Guhin, 1989), and less with ethnic pride and tradition, perhaps indications of a move toward the concept of an open society where ethnicity no longer matters.

While the written curriculum in our schools has reflected change, the goals of schooling have remained essentially the same. Throughout the history of the public school movement, the traditional goals of schooling have been to produce a certain kind of citizen for participation in a democracy and to acculturate some groups into the reigning culture. Gary Weaver (1990) compares acculturation into the mainstream to shaping dough with a cookie cutter. The shape of the mold, not unlike the composition of the U.S. Senate, reflects the traditions and values of white, Anglo, Protestant males. For example, the school year still reflects the calendar of

the male-dominated agricultural workforce. The school day still reflects the white/ blue collar work schedule which assumes that one parent, presumably the mother, is at home to send off and greet the children when they come home. The curriculum emphasis is on competition, achievement, acquisition of material wealth, knowledge through counting and measuring, dichotomous thinking, and advancement of technology, as opposed to values related to other worldviews identified by Edwin Nichols (1990) as the acquisition of group cohesiveness, knowledge through symbolic imagery and transcendence, the union of opposites, and the advancement of harmonious interrelationships and spiritual networks.

For some people, education has been a way of fitting into the cookie-cutter mold and joining mainstream society. Educational practices have allowed others to escape from the regimentation and standardization of the cookie cutter. For still another segment, the educational process has been a way of maintaining the exclusive shape of the cookie cutter. Indeed we are a nation of competing schooling practices.

Art education practices in the public schools of the United States have also aimed to serve quite different and seemingly competing purposes (Kern, 1985). According to Kern, art education, in its brief history, has endeavored to train artisans for industry, produce a moral citizenry, and promote creativity and self-expression (p. 40). These stated purposes of art education, as identified by Kern, do not come from theorists or philosophers, but from the curriculum literature promoted by state departments of education. A historical review of art education texts and curriculum guides written by school officials and teachers presents us with a similar array of philosophies and rationales (Katter, 1985). When analyzed, these statements of purpose articulate beliefs in: (1) cloning everyone into the dominant culture, (2) melting everyone into a new American, (3) isolating particular groups as a way of equalizing educational programs, (4) encouraging participation in the mainstream while retaining ethnic pride, or (5) moving toward an open society in which racial and ethnic differences no longer matter (Katter, 1989). Thus our goals for art education and our methods for dealing with cultural diversity have been modified as our conceptions of a desirable social order have changed.

A major theme of recent advocates of educational reform such as Hirsch (1988) and Ravitch (1990) has been based on the fact of cultural diversity and on a belief that all children in a democracy, regardless of their diverse cultural backgrounds or social prospects, should be brought together through a common core of knowledge or a common culture. Hirsch's notion of a common culture through cultural literacy has generated considerable controversy. For example, Simonson and Walker (1988), the editors of *Graywolf Annual Five: Multicultural Literacy*, consider Hirsch's worldview to be outdated and his definition of culture static and shallow. In their words, he "is disturbingly ignorant of some very common aspects of culture" (p. xii). While most of us participate to some extent in the mass culture, many of us also participate in the community of a subculture. We have wide differences in values, attitudes, beliefs,

family life, and child-rearing practices. It is this richness of cultural diversity that gives our nation its strength. It is a richness that deserves to be celebrated.

The wide diversity of cultures and life styles in our nation is not necessarily the result of ethnicity or ancestral roots. A teacher may have a classroom of students who appear quite similar, but after careful observation, may find they are culturally quite different. Influencing the range of diversity are such things as the values one learns as a child, social opportunities to learn, exposure to understandable instruction, acceptance by sex, family stability, the ability to reject rejection, and an individual's degree of tolerance for change.

Art is a carrier and transmitter of many of these influences. For example, there are many public monuments in Washington, D.C. depicting men of action—"the doers" of our society—mounted on a horse, a seat of power. Only one woman, Joan of Arc, is depicted in this position of power on horseback. These works of art in our nation's capital reflect and model mainstream values.

The theme of the mounted leader or rider of power is present in works of art from a variety of cultures. In her unpublished master's thesis, Karen Palcho (1990) has included an instructional unit on cross cultural interpretations of this theme. A few examples of the equestrian images she has selected for her students to interpret and compare include twentieth-century American works by Mary Frank and Frederick Remington, Chinese terra-cottas from the T'ang and Q'in Dynasties, rock art versions of equestrians from southern Africa, Cameroon brass sculptures by Salefon Mbetukom, Dogon wood carvings from Mali, small equestrian figures from Sumatra, a skirmish of mounted soldiers from seventeenth-century Japan, horse columns from a sixteenth-century temple of Vishnu in India, fourth-century Greek vases, an Egyptian horse and groom, and a Roman sculpture of Marcus Aurelius.

Hierarchy, social status, sexual dominance, motherhood or family, and attitudes toward work and leisure are other examples of themes that can be compared cross culturally. Because of this, art educators might consider favoring a global perspective for dealing with art in its most universal expression of humanness, in its most cultural and societal signification of what it means to be human, and its most individual interpretation of the human spirit. Each child brings a unique life experience, a valuable cultural heritage, and certain universal qualities of humanness to the art experience.

In attempting to bring our nation together through a common core of knowledge or common culture as suggested by Hirsch (1988) and Ravitch (1990), art education need not lay down one canon of excellence or beauty. Characteristics of excellence need not be represented by the statues of "men of action on horseback" in our nation's capitol or restricted to the cookie-cutter mold of the dominant culture or Western world. We often fail to acknowledge the extent to which Western culture has always been intertwined with other cultures (Trachtenberg, 1990). For example, sculptors in India were influenced by Greek techniques in early representations of the Buddha. When artists such as Van Gogh, Gauguin, and Picasso found inspiration

in objects and images imported from the Orient, Oceania, and Africa, non-Western art helped to transform the art of Western Europe in the late nineteenth- and early twentieth-centuries. Art education can call attention to these and other fascinating examples of cultural interconnections by involving students in examining universal human systems, weighing cultural influences, and testing personal criteria and standards of excellence.

Students can be given continuous opportunities to see how art functions in both their own lives and in the lives of others as a means of understanding their own culture in relationship to that of others. Important or significant art has the capacity to carry individuals beyond their ancestry, beyond their own immediate world. But to know significant African art does not necessarily transfer to knowledge of significant Asian art. Comparing significant works of art from a variety of cultures has the capacity to carry individuals beyond their ancestry and back again.

Teachers may first want to find out how individual students relate to art forms from various cultures or subcultures. A teacher might be attentive to how cultural styles of body language and gesture, or representations of status, sexual roles, or personal relationships influence students' responses to visual forms. Listening to what students say, a teaching skill advocated by Michael Parsons (1990), might help a teacher deter mine the extent to which preconceptions and harbored stereotypes influence how and what students see. By listening carefully to remarks and responses, and following up with a related question or even a simple directive such as "say more about that," the teacher can elicit reasons for perceptions and opinions.

Two basic questions might establish the appropriate framework for studying an art form: "What is this work about?" and "Why does this work look the way it does?" Teachers can help students become more thoughtful about their interpretations rather than imposing mono-cultural opinions about what those interpretations should be. It should be possible for students to consider alternatives and to make informed explanations without being pressured to employ only Western concepts and classifications. Students can be exposed to other concepts, without being expected to reject their personal preferences and values. They can think reflectively and critically about who they are as Americans, about what makes beauty in their own lives, and about beauty in the lives of others. They can attend to the sensory, formal, technical, and expressive aspects of a work, a method proposed by Broudy (1972), as a way to move beyond stereotyped preconceptions. The results may be that students will respond to their social environment as they have learned to respond to art. They may respond to new ideas and extend their life-style to encompass a wider social group, or they may choose to stay within the context of their own cultural patterns for the purpose of refining and improving their personal environment.

This approach takes diversity seriously by taking personal interest and value differences into account. It requires that due recognition be given to all contributions

to our national heritage. It offers to all individuals and groups the opportunity to branch out or move away from the structures of subgroup factions to new communities of interest. These new communities of interest have as their main justifying function the employment of each individual's essential powers, including human dignity and respect, and making individuals responsible by developing their powers for considering alternatives of action, feeling, thinking, and meaning. A broad-based art curriculum integrating the universal, cultural, and individual features of the art experience would hopefully contribute toward this humanistic goal and toward the realization that nothing human need be foreign in a multicultural society.

References

Board of Public Education. (1972). *African and Afro-American art: A supplement for teachers of the visual arts*. Pittsburgh, PA: Board of Public Education.

Broudy, H. S. (1972). *Enlivened cherishing: An essay on aesthetic education*. Urbana, IL: University of Illinois Press.

Guhin, P. (1989). Tie dye is back. *School Arts*, 88(6), 26–28.

Hirsch, E. D. (1988). Cultural literacy: Let's get specific. *NEA Today*, 6(6), 15–21.

Katter, E. (1989). Making distinctions among universal, cultural, and individual features of the art experience as a direction for art education in a multicultural society (Doctoral dissertation, The Pennsylvania State University, 1988). *Dissertation Abstracts International*, 49(09), 2507A.

Katter, E. (1985). Hands-on instructional resources for the teaching of art: An historical perspective. In B. Wilson and H. Hoffa (Eds.), *The History of Art Education: Proceedings from the Penn State Conference*. Reston, VA: National Art Education Association.

Kern, E. J. (1985). The purposes of art education in the United States from 1870 to 1990. In B. Wilson and K. Hoffa (Eds.), *The History of Art Education: Proceedings from the Penn State Conference*. Reston, VA: National Art Education Association.

Kutztown (Pennsylvania) University. Files of Unit and Lesson Plans from Student Teaching Practicums, 1930–50. (Typewritten and mimeographed.)

Nichols, E. (1990, February). *The philosophical aspects of cultural difference*. Paper presented at a lecture series on cultural diversity, Kutztown University, Kutztown, PA.

Palcho, K. (1990). *Global perspectives on the arts: A planned course*. Unpublished master's thesis, Kutztown University, Kutztown, PA.

Parsons, M. (1990, April). *Children's understanding of paper*, presented at an art education lecture series, Kutztown University, Kutztown, PA.

Pratte, R. (1979). *Pluralism in education*. Springfield, IL: Charles C. Thomas. Ravitch, D. (1990). Diversity and democracy. *American Educator*, 74(1), 16–48.

Simonson, R., & Walker, S. (1988). *The Graywolf annual five: Multicultural literacy*. Saint Paul, MN: Graywolf Press.

Trachtenberg, S. J. (1990). Multiculturalism can be taught only by multicultural people. *Phi Delta Kappan*, 71(8), 610–611.

Weaver, G. (1990, April). *Values in conflict*. Paper presented at a lecture series on cultural diversity, Kutztown University, Kutztown, PA.

Points of Intersection: The Convergence of Aesthetics and Race as a Phenomenon of Experience in the Lives of African American Children

Debra Ambush
Montgomery Blair High School

Demographic forecasts and current realities indicate a need to better educate our citizenry. Increasing portions of the United States' population will be comprised of minority children, children who by virtue of their minority status have not fared well in our schools. The following study discusses three notions central to addressing this concern: self-identity, aesthetic negation, and curriculum ecology, and poses a model for curriculum change. This model is built on the practice of aesthetic inquiry and identifies stages of curriculum development for planners and teachers.

American society has always been challenged and renewed by the markings of large bodies of time. The coming and passing of centuries provide symbolic occasions with which to create visions for education that are innovative, insightful, and promising. Past and possibility compel those who endeavor in such educational change to engage in critical reflection concerning how well we have obtained the goal of serving the educational needs of a multi-ethnic society.

As we approach the 21st century, children of color will make up an increasing portion of the population (Isaacs and Benjamin, 1991). By the year 2000, minority children will increase to 33 percent of the child population, by the year 2020 they are expected to increase to 40 percent.

These demographics give us a sense of who the critical human resources of the future will be. Anyon (1981) observes a significant variation in students between their potential relationships to the ownership of symbolic capital, authority, and control, and their own productive activity. This variation suggests ideological

8

From *Visual Arts Research*, Vol. 19, No. 2 (Fall 1993), pp. 13–23

points of intersection that configure as a system of advantage. Schools have been found *not* to foster within African American children who are poor what are often described as effective, cognitive, and problem solving skills (Ogbu 1983; Boykin, 1983; Kozol, 1991). Boykin (1983) contends that such cognitive skills are delivered in a particular context that is imbued with cultural chauvinism and psycho-ideological hegemony.

Concurrently, we witness a promotion of curricula that teach students to con duct analyses of society and to control situations (Anyon, 1981). These curriculum goals are characteristically embraced by affluent schools. Knowledge and practice in manipulating the socially legitimated tools of analysis and control of systems allow children to develop certain potential relationships to their future occupations and lifestyles (Anyon, 1981). Among the cognitive skills and dispositions held in high regard in these schools are popular notions of artistic and aesthetic appreciation. Indeed individual thought and expressiveness, expansion and illustration of ideas, and choice of appropriate method and material emerge as commonly held features of both sound analytical reasoning and aesthetic judgment.

Kozol (1991) maintains that there is a growing gap in the kinds of educational resources that rich and poor children receive. Edmonds (1983) confirms this in his study of schools and their effectiveness. He concludes that variability in the achieve-ment among school age children in the United States is explained by the variability in the nature of the schools to which they go. Ogbu (1986) attributes differences in curriculum orientations to the existence of a caste system that is based on minor-ity status. Ogbu (1986) maintains that membership in a caste-like minority group is acquired at birth and often retained permanently. Members of this group are regarded and treated as inferior by a dominant group. A growing number of educa-tional re searchers observe that the inability to access human capital requirements for our changing economy shares a curious relationship with the educational and skill deficits that encumber high numbers of African Americans who typically receive a contemporary urban education.

As success for every student is the ultimate goal of education, opportunities for students of color may be confounded in an atmosphere which emphasizes a singular cultural value orientation, often reinforced through the presentation of correspondent cultural representational forms and symbol systems. Carter and Helms (1990) define *cultural value orientations* as those dimensions that are characteristically considered important and desirable. What a group considers important and desirable guides the behaviors of its individuals, forms the basis for group norms, and dictates lifestyles that are deemed appropriate for group members.

Value orientations are conveyed within *curriculum ecologies* that may include community organizations, churches, the media, and peer influences wherever active learning is taking place.

When value orientations are structured through a curricular ecology, an interdependent network of education curricula, directing outlooks and ideas, will reflect what a particular group of people find important and desirable. For example, America has always held democracy as a critical cultural value that has attracted people worldwide who are also invested in the idea of freedom and equality. The manner in which American communities support and nurture the concept of democracy is directly related to the historical processes that form human character, direct actions, and inspire innovation.

Sylva (1993) asserts that major representational forms and symbol systems are central to art curricula as they reflect cultural value orientations. The capacity of image and form to provide consonance, dissonance, and resonance within our culture cannot be overstated.

Aesthetic negation is a value orientation that conveys the devaluation of a people based on representational forms and symbol systems. As a theoretical framework, aesthetic negation attends to how knowledge of cultural representational form, how symbol systems are conveyed in the curriculum stratification process, and to what extent this knowledge acts as precursor to the curricular endeavor of aesthetic inquiry.

In the field of art education, aesthetics (as in the philosophy of art) attends to the development of critical thinking skills and philosophical inquiry through classroom dialogue (Hagaman, 1990). Aesthetic inquiry proposes to engage students in understanding the nature of philosophical inquiry as it relates to their own thinking and to the thinking, speaking, and writing of others. It offers opportunities to learn specific skills involved in the understanding and appreciation of art. To examine philosophically the nature and value of art promotes a sense of pleasure and fulfillment in children (Stewart, 1988). Although contemporary approaches to aesthetic inquiry are valuable in their capacity to provide cognitive skills and are seen as a vehicle for accessing human capital and resources, they typically do not reflect a consideration of an African-based aesthetic philosophy.

The purpose of this compendium is to provide a theoretical framework for the psychological concept of aesthetic negation as a component of curriculum ecology and its relationship to the identity development of African American children. In addition this article raises issues regarding three distinctive challenges in the design, development, and implementation of aesthetic inquiry in a curriculum that is not weighted down by aesthetic negation. One challenge to be addressed here is the what, why, and how of culturally relevant curricula. The second challenge to be addressed focuses on the identification of a conceptual framework for culturally relevant teaching. A third challenge is devoted to the concept of aesthetic inquiry in art education, and the manner in which curriculum planning may evolve in this area.

Race as a Dimension of the Identity Development Process
for African American Children

Spencer and Markstrom-Adams (1990) define *identity development* as a psychosocial task. It involves the development of a sense of unification and cohesive ness within one's self, thereby providing meaning, direction, and purpose while serving a critical function for the individual's manifest competence and adaptive functioning. Emergence of recent social cognitive theories suggest that cognitive processes undergird the identification process (Ogbu, 1992; Spencer and Markstrom-Adams, 1990; Tatum, 1992). The complex process of identity formation may be intensified by such issues as skin color, behavioral distinctions, language differences, physical features, and long standing, although unaddressed, social stereotypes (Spencer and Markstrom-Adams, 1990).

For African American children, their existence is still very much predicated by nineteenth and early twentieth century ideas regarding the visual (i.e., color symbology, stereotypes, and other aspects of symbol systems). For instance, they are the children of parents who when writing a check may experience being classified by the color of their skin (Pyatt, 1991).

Drake (1991) suggests that skin color provides a stimulus cue to thoughts and emotions in some domains of interpersonal relationships. Youths themselves are tied to interlocking assumptions about color that may be protected by the law. An example of this is the Florida judge who awarded compensation to a woman who allegedly has a phobia that allows her to equate skin color with danger (Duke, 1992). Hamlin (1986) takes the following position.

> The Afro-American child in our society receives a variety of subtle and some times blatant messages that there is something inherently wrong with him. Standards of beauty as projected in media advertising, television programming, movies, etc. tell the Black child that his physical features fall outside of the desired norm. Beauty in America has been associated with Blonde hair, blue eyes, white skin, pointed noses and thick lips. Much attention has been focused on assisting the Black child (and adult) in changing those things about him that society finds physically unappealing. Most of the advertising that specifically addresses the grooming of Black people deals with the chemical denaturalization of their natural hair to make it straight or more loosely curled, (p. 209)

Spencer (1990) contends that African American parents, relatives, and teachers must actively and continually struggle to present evidence to children that con firms the worth of African American culture, as a mechanism for offsetting cultural identity confusion (cited in Spencer and Markstrom-Adams, 1990). The prevalence of color stereotyping and color bias results in the potential for unique identity formation processes for minority youth (Spencer and Markstrom-Adams, 1990).

Boykin (1983) suggests that African American children continue to negotiate three distinct realms of experience which may often translate into their lives as a triple quandary. This incomplete socialization into the European American cultural system is described by Boykin as including: the mainstream, which is experienced by everyone and is central to the assignment of values within a society; the African-rooted Black culture which represents a culturally indigenous basis from which African Americans interpret and negotiate social reality; and the status of an oppressed minority which requires a unique set of adaptive reactions to social, economic, political oppression.

In the course of their development, African American children are required to make choices in terms of how they will cope with these dimensions of their bicultural existence. Biculturalism is defined here as a dual socialization for minorities that includes enculturation into their own cultural group as well as socialization into the larger society. Staples (1976) suggests that the bicultural socialization of African Americans is forced on them and is often antithetical to their own values (cited in Locke, 1992). Isaacs and Benjamin (1991) suggest that assimilation into the dominant culture for minority groups has historically and contemporarily meant accepting negative stereotypes and beliefs about one's own ethnic group. They observe the growing realization that denying the importance of ethnicity creates problems that are having a negative impact on children. The identity development process for minority youth may be seen as a paradox of desocialization or assimilation.

Desocialization is a process for African American youth that reflects the inversion of the socialization process. Desocialization places the primary responsibility for developing coping skills and social competencies on the youth themselves (Perkins, 1993). When youth are left to develop their own socializing skills, the effects can be devastating as they attempt to invent, circumvent, or modify those fundamental abilities that prepare children for adolescence and adolescents for adulthood (Perkins, 1993).

Assimilation represents one of four options in the acculturation process (the others being integration, rejection, and deculturalization). Assimilation as part of the acculturation motif can be a dynamic in the group level adaptation to value systems where individuals answer yes or no to the following questions: "Is my culture identity of value and to be sought?" and "Are positive relations with the larger society to be sought?" (Berry, 1980 cited in Sodowsky, Wai Ming Lai, & Plake, 1991).

Aesthetic Negation and Self-Identity

In understanding that culture teaches people to recognize phenomena and respect certain logical relations amongst phenomena (Nobles, 1989), the invalidation of basic cultural components which emanate from an essential core of shared cultural experiences is a hallmark of aesthetic negation. Such aesthetic negation systems remain unchecked within educational venues.

Welsh-Asante posits that "an aesthetic defines and establishes culturally consistent elements and then enthrones standards based on the best historical and artistic examples" (1993, p. 4). Aesthetics as a component of mental health has been discussed by several authors. Pasteur and Toldsen (1982) observe how the mental health of a society can be linked to its art forms. They maintain that happiness, as the end goal of all healthy personalities, is only possible when a conductive atmosphere is created that nurtures the affect and feeling component of personality. Korzenik (1985) highlights the combination of spiritual convictions and aesthetic interests as having the capacity to keep one mentally intact. Schubert (1986), and L. J. Myers (1993) have conceptualized aesthetics as holding the key to a relationship between the harmony and rhythm of the universe. Schubert describes how aesthetics has a close relationship to axiology and ethics in advocating judgment about a work of art.

For those who advocate the inclusion of aesthetic inquiry in the curriculum, developing an awareness of the capacity this discipline has in nurturing or extinguishing what social cognitive scientists describe as the "possible self" is of vital importance. Critical to this awareness is the notion of centering. Centering is a perspective that involves locating students within the context of their own cultural references so that they can relate socially and psychologically to other cultural perspectives (Asante, 1990).

Specifically then, new questions are raised for the art educator, who in the course of the year presents (through curriculum implementation) cultural representational forms and symbol systems that advance and nurture ideas about not only the nature of art but also the nature of self. How do possible selves, elements of self-concept that represent what individuals could become and are afraid of becoming, interface with effective performance? What is the impact of a person's self-perception on behavior and functioning? What is the role of the visual in young people's ability to access possible selves? What has the role been historically in America in the unexamined (or perhaps deliberate) utilization of imagery as a controlling mechanism regarding access to possible selves?

As a motivational resource that organizes a person's future, possible selves are crucial to the process of centering. The idea of instilling in children during the course of their development the desire to do well requires that they be given self-relevant forms capable of individualized translation that creates and sustains their motivation (Ruvolo & Markus, 1992). When such aspects of self are attended to in curriculum planning, the choice to assent to learn—rather than noncooperation—is within the grasp of students.

Assent to learning and noncooperation is discussed by Kohl (1991) as a response to the triple quandary for African American students. Kohl emphasizes the essential role that free will and choice play in learning. The stance people take toward learning is directly related to the larger context of the choices they make as they create

lives for themselves. For some of the youth in Kohl's (1991) interviews, "cooperative not-learning" is often the only stance they can take in order to resist racism and not be thrown out of school—not learning serves as a passive defense of their personal and cultural integrity. Kohl posits that "willed not learning consists of a consciousness and chosen refusal to assent to learn" (1991, p. 41). The conscious, willed refusal not to learn for political and cultural reasons becomes the silent factor in oppressive education that so often remains unacknowledged (Kohl, 1991).

Aesthetic Negation as a Pivotal Force in the Formulation of Possible Selves

The preoocupation of aesthetics has always been that of seeking meaning and conditions of value (Santayana, 1955). Those who speak about and use the term aesthetics are held to a particular context and meaning in investigating the perception of value in art. This has always carried over into daily practices in our society. As early as the 1800s, the cultural category "highbrow" emerged as a way to describe intellectual or aesthetic superiority, while the cultural category "low brow" was indicative of something or someone who was without the capacity to be highly intellectual or aesthetically refined (Levine, 1988). Such cultural categories were "openly associated with and designed to preserve, nurture, and extend the cultural history and values of a particular people in a specific historical context" (Levine, 1988, p. 223).

While the aforementioned categories are not overtly represented in the aims of contemporary aesthetic inquiry, introspection as to the degree to which the discipline may serve as a conduit for the perpetuation of such categories is due. Aesthetic negation is proffered through social cognitions that shape how people interpret and construct their social environment. Within the field of social psychology, social cognition research emphasizes the process of extracting meaning from behavior, making attributions for events that have occurred, inferring characteristics of people associated with those events, and constructing social reality (Weiner, Graham, & Taylor, 1983).

Delimiting what is traditionally a discussion which regards the philosophy of beauty as a theory of perception of values may assist art educators in gaining a broader understanding of the complex role of those values in the lives of African Americans. Aesthetic value is both a matter of individual response to things and the social and cultural context of those responses.

Aesthetic ideologies historically constitute an important function within the microsystem and macrosystem's derived devaluation of African people and their progeny. The emergence of a symbol system that advanced social control in the form of racial hierarchy was an invention whose inception is rooted in social cognitions that are born out of nineteenth century and twentieth century American culture

(Barnett, 1984). Early on in the history of American society the survival of African Americans was dependent upon an accurate reading of cultural representational form and symbol systems. Memory of the motherland's tongues, arts, and wisdom had to be obliterated from the minds of enslaved Africans so that they could be divided, ruled, and denationalized (Kaplin & Kaplin, 1989).

Social cognitions give agency to the symbol systems that assist in the identity formation process, and moreover serve as indexes for the possible selves. Carter and Helms (1987) posit that there is a relationship between Black and White racial identity and cultural value orientations. Locke (1992) maintains that the cultural group serves as the basis for individuals to become humanized—individuals become fully human through the process of participating in a cultural group or groups.

An increasing body of literature has devoted itself to the concept of negation inherent in the lives of African Americans as related to American standards of beauty (Russell, Wilson, and Hall, 1993; Brown, 1993). The resonation of these social and ideological factors within the lives of contemporary children should be of vital interest to those who teach aesthetic inquiry, especially to those whose investure in a western conception of aesthetics remains unchallenged. According to Drake (1991), in the modern world negative aesthetic evaluations of Negroidness persist tenaciously and reinforce negative beliefs about the intelligence and personality traits of African Americans, and consequently factor into the life chances and self-esteem of people so evaluated.

Social cognitive research enables us to further examine the longevity of these particular variables for both African American and European American children. One such study, *Individual Correlates in the Belief in a Just World* (1984), examined the relationships perceived among the factors of social inequality, evaluated social inequality, the work ethic, political preference, several social identity variables, and the belief in a just world concept. The results indicate that race, income, age, and political party preference were significantly associated within a just world concept while sex educational attainment, and occupational prestige were not (Smith & Green, 1984).

In another study, the Early Development to Stigmatizing Reactions to Physical Differences Study (1986), European American children in grades kindergarten through third grade were tested. Results indicate that preference for the same sex, same race, disabled child over other tar get children was apparent at all ages, suggesting that the earliest form of stigmatization is a generalized bias against anyone who is physically deviant (Siegelman, Miller, & Whitworth, 1986).

Findings reflected in data collected by the Clarks in the 1940s reveal a strong identification with a European American doll by African American children. These findings remain virtually unchanged in recent replicated studies done by Hopson-Powell (cited in Talen, 1988). Often the commitment to Eurocentric values is assumed

to be of positive benefit to all those who embrace these values. However, the compliant behavior of minority groups may be misconstrued to be a strong commitment to such values (Locke, 1992, p. 16).

The research findings of Smith, Burlew, and Lungren (1991) support the need to identify culturally sensitive definitions of beauty and aesthetic value for African Americans. Spencer and Markstrom-Adams (1990) assert that schools continue to reflect monofocal historical values and beliefs, including racial stereotypes and prejudice. They call for a compensatory (media-focused) cultural emphasis that affirms rather than negates group identity for all youth, and thus enhances both ego-identity processes and group pride. Additionally, J. F. Brown (1993) believes that those in the counseling profession need to be prepared to take on the role of educator/political scientist in helping African American women reject the Euro-American definition of physical beauty as the only valid definition.

Infusion Competencies: Implications for the Development of an Aesthetic Inquiry Curriculum

In the construction of an aesthetic inquiry curriculum, Hagaman's (1990) approach bears consideration. Hagaman describes the "student-student" community of dialogue where students are encouraged to examine and explain why they think as they do about issues being discussed. The facilitator of such discussions should be able to preface such events with the question of who is being affirmed in the proposed dialogue. Other questions must include: What values are framed here? What values are being negated, by either omission or by stereotyping? What constitutes the phenomena of aesthetic negation in the lives of children I teach, and is there any measure of that in the proposed dialogue? What does the proposed dialogue accomplish: commitment to a cycle of oppression or empowerment, narrowing or expansion of frames of reference, denial or affirmation of the integrity of self? How does the inquiry facilitate the cultivation of positive directions for the possible self? What are the aesthetic traditions that support and affirm students? Are multiple aesthetic traditions embraced in the classroom?

In aesthetic inquiry the challenge of culturally relevant teaching involves the recognition, celebration, and utilization of a conceptual framework for aesthetic inquiry that is inclusive of African American aesthetic traditions. Boykin (1983) suggests that the acquisition of skills must be embedded in value constellations that promote human welfare and do not degrade the pluralistic society that is America.

This may be the blind spot for well intentioned packaged aesthetic inquiry curriculum materials that currently come out of both DBAE and multicultural education—but a sense of normalcy in referencing the work and accomplishments of African descended people has yet to be achieved. Any vendor catalogue currently

available to art educators indexes where we are with regard to this problem—segmented and unjoined from vignettes that portray the American art tradition. We may finally come to realize in our art education curriculum efforts that our primary issues lie in how we think and relate to each other with regard to enabling the traditional and longstanding *invisibility* of African American culture and its viable aesthetic traditions.

The transcendence of what are seemingly unrelated issues of identity, aesthetics, and art education are given further context when we consider Pindell's (1990) assertion,

> Double speak and double think codes are used in the art world to imply the ability of one group of artists (people of European descent) to produce "quality" work, and the inability of another group of artists (people who are not of European descent) to produce "quality work." The word "quality" is therefore used as if it were synonymous with skin pigmentation and ancestry, but stated publicly as signifying an unsullied and courageous color blind standard. (p. 19)

Unless aesthetic inquiry model developers are to subscribe to traditions of privilege and invisibility, where the bulk of what is done is seen as work that nurtures the creation of a mirror image of the dominant class (Mcintosh, 1991), aesthetic inquiry planning must embark on another path. Such a path is described here as *infusion*. Curricula must be in fused with multiple aesthetic value orientations. The process of infusion involves specific changes in how we view aesthetic inquiry. The goal and aim of infused aesthetic inquiry models promote a sense of inter- and intra-cultural understanding, and reflect the ability to present a variety of cultural value orientations in a culturally competent manner. The word competence is defined as having the capacity to function effectively (Brazzon, Dennis, & Isaacs, 1989).

An infusion/competency model for aesthetic inquiry curriculum development may be extrapolated from what Schuster and Van Dyne (1984) describe as the curriculum change process. This process involves the following stages: initial stages where the absence of a cultural group is conceptualized as normal; the second stage occurs when exceptional minority/women exemplars are added and placed *within* conventional paradigms; the third stage involves an attempt to empathize with "disadvantaged" groups within the perspective of the traditional paradigm; the fourth stage involves a cultural group being studied on its own terms whereby an insider perspective is embraced; the fifth stage involves requestioning of dominant paradigms initiated by the acquisition of new knowledge; and the final stage is represented as an inclusive vision of human experience based on difference and diversity, and not solely sameness or generalization. A fundamental goal of an infusion/competency model for aesthetic inquiry and ultimately art education is to move effectively into

this final stage in curriculum planning. Clearly a majority of art education curriculum models and materials indicate that we are bordering between the first and second stages of change.

An infusion/competency model complements what Boykin, in addressing the ineffectiveness of current educational practices with respect to children of African descent, has described as the strategies for curriculum change. The first strategy for curriculum change is concerned with responsiveness to African Americans themselves. Adaptations of both teaching methods and task context must lend themselves to African American cultural styles, and lead to improvement in the performance of African American children. The second strategy for curriculum change is concerned with the use of culturally relevant material. Academic performance can be enhanced when tasks are embedded in a context that is experientially familiar or culturally compatible. Teacher responsiveness, as a third strategy for curriculum change, requires that the educator understand the nature of African American psychological experiences and their attendant values and styles, in order to maximize teaching materials and procedures. The fourth strategy for curriculum change involves instilling the will to learn into the formal school setting along with the encouragement of intrinsic interest in academic tasks and task persistence. Art educators at this time have a limited and often mistaken understanding of African American or any non-European ethnic values, psychological experiences, or cultural styles.

Future directions for aesthetic inquiry with regard to the issue of offsetting aesthetic negation through infusion competencies must include addressing what Boykin (1983) identifies as three contexts of schooling in which psycho-ideology and hegemony are conveyed: *task definition*—how a particular skill or competence is defined for students and how its purposes are presented to them; *task format*—the manner in which the skills in question are acquired and performed; and *ambience*—the environmental flux that envelops the task itself and forms the backdrop for learning.

Art Education at the Crossroads: Some Final Considerations

We are currently at the crossroads of tradition and change in how we view artistic and aesthetic excellence. We are beginning to investigate the manner in which diverse cultures within and outside the United States set forth their notions of excellence, and how they establish their own systems of sanctions that pro mote the production of and participation in artistic/aesthetic activity. Some of these notions coincide with western traditions; some do not. Our curricula at this time do not adequately reflect this realization.

Clearly a majority of curriculum models and materials indicate that we border between what Schuster and Van Dyne identify as the first and second stages of

curriculum change, indicating that we have a way to go yet. The absence of cultural groups in curriculum materials is noticed, and some attempts have been made to identify the exemplary work of minorities and women, but these exemplars are added on, placed within the philosophical systems of western theory, rather than studied for their own contribution, and within their own contexts. Some notable exceptions are beginning to signal the advent of third and fourth stages, in which empathy and "insider" perspectives are fostered. These are encouraging signs of growth. We must keep in mind, however, that the final stages of requestioning dominant paradigms and fostering an inclusive vision of human experience cannot be reached without systematic study of the traditions and innovations, cultural beliefs and aesthetic systems of diverse peoples. There are no shortcuts to this goal.

With regard to Boykin's model for curricular change, it is disturbing to realize that currently art educators have a limited understanding of the realities of the lives of African descended students, or the lives and values of most children whose ethnic descent differs from their own. An understanding of minority children's psychological experiences, cultural styles, or personal modes of interaction is generalized through an understanding of the values of the mainstream or dominant culture. Clearly, significant differences exist, yet it has been the unchallenged premise that "they" must adapt to succeed in "our" society. A more contemporary view suggests that it is educational practices that must "adapt" to better address the multi-cultural and multi-ethnic nature of our society. Our minority children have not benefitted from educational efforts to the degree that majority students have. Before we can "adapt teaching methods and task contexts," as suggested by Boykin, we need to do our homework and get to know our students better. We need to teach our students how to get to know one another better while they are in our classrooms. Then and only then will we be able to instill the "will to learn" and foster mutual understanding without resorting to subtle and covertly violent mechanisms of control.

It is generally understood among art educators that self-identity undergirds cognitive and aesthetic development. It is also commonly held that culture plays a large role in how individuals deal with the world, and that many individuals live simultaneously in several cultures. The educational and social practice of negation of self and culture when those notions of identity get in the way of "doing as we have always done" can no longer go unchallenged.

We are beginning to understand the pervasive impact of curricular ecology on the learning and socialization of children. The notion of curricular ecology demands that we see individuals, events, materials, activities, and values as complex and interrelated, and that we attend to various aspects of this complex. Although this may seem a daunting task to impose on educators, the alternative is unacceptable. Each of us can grow and move forward. Such an endeavor is predicated on the premise

that we can reach for the goal stated at the beginning of this paper, that of serving the educational needs of our multi-ethnic society. To do so benefits us all.

References

Anyon, J. (1981). Social class and the hidden curriculum of work. In H. A. Giroux, A. N. Penna, & W. F. Pinar (Eds.). *Curriculum and instruction: Alternatives in education*, Berkeley: McCutchan Publishing Corporation.

Asante, M. K. (1990). Afrocentricity and culture. In M. K. Asante & K. W. Asante (Eds.). *African Culture: The rhythms of unity*, Trenton: Africa World Press.

Barnett, M. R. (1984). *Stereotypes of African Americans in U.S. popular art*, New York: Publishing Center for Cultural Resources.

Bazron, B. J., Dennis, K. W., & Isaacs, M. R. (1989). Towards a culturally competent system of care. *Monograph for the National Institute of Mental Health, Child and Adolescent Service System Program* (Volume I).

Boykin, A. W. (1983). The academic performance of Afro-American children. In J. T. Spence (Ed.), *Achievement and achievement motives: Psychological and sociological approaches* (pp. 321–363), New York: W. H. Freeman.

Brown, J. F. (1993, Winter). Helping Black women build high self-esteem, *American Counselor*, 9–11.

Carter, R. T., & Helms, J. E. (1990). Development of the White racial identity inventory. In J. Helms (Ed.), *Black and white racial identity: Theory, research, and practice*. New York: Greenwood Press.

Drake, S. (1991). *Black folk here and there: An essay in history and anthropology* (Volume I). Los Angeles: Center for Afro-American Studies.

Duke, L. (1992, August 16). Color me stressed. What if we all sought compensation for our race-based problem. *Washington Post*, p. C5.

Hagaman, S. (1990, December), Aesthetics in Art Education, *Eric Art Digest*, EDO-SO-90-11.

Hamlin, W. T. (1986, September). The mental health professional, the Black child and the adoption process: Increasing the chances of successful intervention. In P. V. Grabe (Ed.), *Adoption resources for mental health professionals* (Mental Health Adoption Therapy Project, Children's Aid Society in Mercer County), Butler, PA: Adoption Resources.

Isaacs, M. R., & Benjamin, P. (1991). Towards a culturally competent system of care—Programs which utilize culturally competent of principles. *Monograph for the National Institute of Mental Health, Child and Adolescent Service System Program*. (Volume II).

Kaplin, S., & Kaplin, E. N. (1989). *The Black presence in the era of the American revolution*, Amherst: The University of Massachusetts Press.

Kohl, H. (1991). *"I Won't Learn From You": The role of assent in learning*. (Thisite Series), Minneapolis: Milkweed Editions.

Korzenik, D. (1985). *Drawn to art: A nineteenth century American dream*. Hanover: University Press of New England.

Kozol, J. (1991, Autumn). *Savage inequalities: Children in America's schools*. New York: Harper Perennial.

Levine, L W. (1988). *Highbrow/lowbrow: The emergence of cultural hierarchy*. Cambridge: Harvard University Press.

Locke, D. C. (1992). *Increasing multicultural understanding: A comprehensive model.* (Multicultural Aspects of Counseling Series 1). Newbury Park: Sage Publications.

McIntosh, P. (1991, February). On the invisibility of privilege, *Peacework*.

Myers. L. J. (1993). The African American aesthetic as optimal consciousness. In K. Welsh-Asante (Eds.). *The African aesthetic: Keeper of the tradition* (pp. 21–29), Westport, CT: Greenwood Press.

Nobles, W. W. (1989). *African centered education and training glossary,* California: The Institute for the Advanced Study of Black Family Life and Culture, Inc.

Ogbu, J. U. (1986). The consequences of the American caste system. In U. Neisser (Ed.), *The school achievement of minority children* (pp. 19–55). New Jersey: Lawrence Erlbaum.

Ogbu, J. U. (1992). Adaption to minority status and impact on school success. *Theory into Practice, 37*(4), 287–302.

Pasteur, A. B., & Toldson, I. L. (1982). *Roots of soul: The psychology of Black expressiveness.* New York: Anchor Press/Doubleday.

Perkins, U. E. (1993, August). Violence: A community health crisis, *Black Books Bulletin, 7*(6), 32–34.

Pindell, H. (1990, October). Breaking the silence, *New Art Examiner,* 23–27.

Pyatt, R. A. (1991, May 6). The risks of check coding by race, *Washington Business,* p. 51.

Russell, K., Wilson, M., & Hall, R. (1992). *The color complex: The politics of skin color among African Americans.* New York: Harcourt Brace Jovanovich, Publishers.

Ruvolo, A. P., & Markus, H. R. (1992). Possible selves and performance: The power of self-relevant imagery. *Social Cognition, 10*(1), 95–123.

Santayana, G. (1955). *The sense of beauty: Being the outline of aesthetic theory,* New York: Dover Publications.

Schubert, W. H. (1986). *Curriculum: Perspective, paradigm, and possibility,* New York: Macmillan Publishing Company.

Shuster, M., & Van Dyne, S. (1984). Placing women in the liberal arts: Stages of curriculum transformation, *Harvard Educational Review, 54*(4), 413–428.

Slegelman, C. K., Miller, T. E., & Whitworth, L. A. (1986, January–March). The early development of stigmatizing reaction to physical differences, *Journal of Applied Developmental Psychology, 7*(1), 17–32.

Smith, K., & Green, D. (1984). Individual correlates of the belief in a just world, *Psychological Reports, 54*(2), 435–438.

Smith, L. R., Burlew, A. K., & Lundgren, D. C. (1991). Black consciousness, self-esteem, and satisfaction with physical appearance among African-American female college students, *Journal of Black Studies, 22*(2), 269–283.

Sodowsky, G. R., Wal Ming Lai, E., & Plake, B. S. (1991). Moderating effects of sociocultural variables on acculturation attitudes of Hispanics and Asian Americans, *Journal of Counseling & Development, 70*(1).

Spencer, M. B. (1990). Development of minority children: An introduction, *Child Development, 61*(2), 267–269.

Spencer, M. B., & Markstrom-Adams, C. (1990). Identity processes among racial and ethnic minority children in America, *Child Development, 61*(2), 290–310.

Stewart, M. (1988). Workshop: Application to the classroom. In M. Erickson, E. Katter, & M. Stewart, *BASIC curriculum for art,* Kutztown: MELD.

Sylva, R. (1993). Creation and recreation in art education, *Art Education, 46*(1). 7–11.

Talan, J. (1988, September). After 40 years, Black kids still lack strong racial identity, *Dayton Daily News.*

Tatum, B. D. (1992). Talking about race, learning about racism: The application of racial identity development theory in the classroom, *Harvard Educational Review, 62*(1), 1–24.

Toldson, I., & Pasteur, A. (1975). Developmental stages of Black self-discovery: Implications for using Black art forms in group interaction, *Journal of Negro Education, 44,* 130–138.

Welner, B., Graham, S., & Taylor, S. E. (1983). Social cognition in the classroom, *Educational Psychologist, 18*(2), 109–124.

Welsh-Asante, K. J. (1993). The aesthetic conceptualization of Nzurl. In K. Welsh-Asante (Ed.), *The African aesthetic: Keeper of the tradition* (1–29), Westport, CT: Greenwood Press.

Williams, S. (1993). Fragments of history: In the National Museum of African Art. *Astonishment and power* (pp. 11–14). Washington, DC: Smithsonian Institution Press.

From Multiculturalism to *Mestizaje* in World Culture

Fernando Hernandez
Barcelona University

This paper looks at multiculturalism in the United States through a mestizo's *eyes. A narration of events and experiences set the backdrop for considering a variety of topics of concern. The search for a multicultural identity, the effort to make sense of an amalgam of issues associated with multicultural notions, and a reconciliation of beliefs and practices suitable to an art educator are offered.*

A Journey from an Outsider to an Insider Point of View:
The Importance of Personal Biography

The initial objective of this paper was to write about the different perspectives on multiculturalism that I am perceiving and appreciating during my sabbatical in the United States, and, through my views as an outsider and observer, to offer critical insight about these issues. However, during the process of writing, this first intention has been evolving in my mind. After my reading of the recent complete surveys in this field, especially by Banks (1993, 1993a), and other authors[1] from different ideological approaches, the complexity and diversity of meanings and interpretations under this common umbrella called "multiculturalism"—and also "cultural perspective," "diversity," "ethnicity," and so on—have become clearer to me.

During the process of reading, taking notes, discussing with other colleagues, and, particularly, paying attention to those social facts and events around me[2] linked with the different meanings of this topic, my starting purpose appears to me an ambitious presumption, especially if I do not wish to be shallow and inconsistent in my views and comments.

| 23

From *Visual Arts Research*, Vol. 19, No. 2 (Fall 1993), pp. 1–12

At the same time that these thoughts were going through my mind, I felt the need to look at my own biography in order to better understand my personal evolution and positions on all these issues. Hence, I started to write the initial draft of this paper, urged on by my personal need for self-clarification, and through this process came to view some of the main topics related to multiculturalism in the United States from an insider perspective. Concepts such as culture, identity, *alterity*,[3] diversity, "difference," and particularly the notion of *mestizaje*[4] have been fundamental in this personal exploration. Moreover, the assumption of living *on the border*[5] as an approach to our multicultural world has begun to make sense to me through the construction of a discourse about my own cultural identity. This position is similar to that of the *mestizo* (French and Vietnamese) anthropologist George Condominas, who, through the first hundred pages of his ethnographic study on the *Mnong gar* in Vietnam (1991), explains his biography with "the finality that will be possible to evaluate the influence from my life, without my knowledge, under the outcomes I will explain."

The creation and assumption of a Western, multicultural, or multiethnic identity (Banks, 1993a) is the result, not only of an individual decision or an intellectual and political attitude, but above all, from autobiography. My views and comments on multiculturalism in the United States have been written from this perspective and with the notion that such a controversial topic demands the study of all the implicit assumptions behind all these issues. In other words, writing about multiculturalism would require a deeper analysis and more space than my present working conditions allow.

Cultural Identity and Affective Cultural Experience

The Canary Islands where I was born are situated off the West coast of Africa, more than one thousand miles away from the Iberian peninsula. Some of the Islands were conquered by the Spaniards at the same time that Christopher Columbus, who stood in La Gomera before crossing the ocean, arrived in the Antilles. The native population of the Canaries, called generically "Guanches," had its ethnic roots in the North African Berbers. Moreover, when Europeans arrived there, the native population had developed a complex culture based on a sophisticated system of beliefs and relationships.

The Islands were the first place where the Spaniards tested the process of implementing their laws and the missionary Catholic indoctrination, which they later imposed from Mexico to Tierra del Fuego. During part of the last five centuries the Canaries have been a stopping place on the journey between America and Europe, and many people from the Islands, under different circumstances, have emigrated to Central and South America. As part of this emigration, my grandfather and two

uncles traveled to Cuba and Venezuela in the fifties seeking fortune and better work opportunities. As a result of all these cultural exchanges the inhabitants of the Canary Islands are a jumble of Berber-Guanche roots, Spanish culture, and Latin American influences.

With this background, the perception I had about my cultural identity was, until I was a teenager, quite ambivalent. At the same time that I idealized the stories and traditions of the extinct natives, I felt emotionally closer to South America than to Spain or Europe; and I loathed the *Peninsulares* (the Spaniards from Europe) whom I saw as the winners of the Spanish Civil War. They were represented by the governor, the commanders of the police and military forces, and the heads of all the state agencies and companies set up in La Palma, the small island where I grew up and where my parents are still living. As for my feelings about the Godos (Goths, the popular name to call the Spaniards from the continent), a blend of admiration and trepidation come now to mind. At this time, when most of the children in the village where I lived were friends, only two *Peninsulares* were members of our group and participated in our games. If I had to choose a single word which summarizes my cultural identity at that time, this word probably would be *Palmero*, the patronymic name for the inhabitants of La Palma.

The conclusion of this primary step in the reconstruction of my own cultural identity could make clear that, initially, personal attitudes are strongly influenced by the affective approach each person has to his or her surrounding reality. The intellectual experience of culture comes from the values of the community or social group to which each one belongs, and it is depicted by a combination of mystification, misconceptions, and Manichean dualism.

Open Minds: From Prejudice to Equilibrium

I was born in Tenerife, the largest island of the Archipelago, and went back there to study at the high school and for my first two years at the university. I attended the University of La Laguna in the early seventies. That was the last period of Franco's dictatorship, when people from different political and social groups intended to establish democracy. At this time my mind and personal experiences were being opened to other realities. The cultural references I had brought from La Palma seemed too narrow and restricted to explain the complexity of the social and political situation that was happening around me.

Meanwhile, I was involved with some of these political groups and started to study, in a deeper way, the history of the Canary Islands as a way of building my consciousness and social commitment. Through this process I made three fundamental discoveries. First, the economic and political relationships between the Archipelago and Spain have had some of the characteristics of a colonial situation, similar to that

of other places and countries throughout the world. Second, in the particular case of the Canaries, people responsible for these conditions were not only the continental Spaniards, but also the members of the local oligarchy. And third, in the Islands as in the Peninsula, many people, men and women, from diverse social and cultural backgrounds, were fighting together for democracy.

From these thoughts and observations, concepts such as solidarity, social classes, ideology, political change, nationalism, and cultural identity started to make sense. Although there was a group (whose leader resided in Algeria) which reconstructed the Guanche language and traditions and defended the Archipelago's North African roots and its independence from Spain, the general concern of most of the population had as its first aim the arrival of democracy.

When Franco died and the democratic process was implemented, under a new Constitution (1978) Spain was reconfigured as a state organized into diverse regional autonomies. The main ideas and wishes of international solidarity during the sixties and until the middle seventies made a sharp turn toward a combination of folk idealism and pragmatic new nationalism. At this time, many families gave their children native names;[6] it was a revival of Guanche traditions and sports; in the school curriculum, the history and social geography of the Canaries became a fundamental topic;[7] emotive feelings of a new identity were exalted everywhere through music folk festivals;[8] "Canary people first" and "In accordance with Canaries' reality" were the magic words of the new cultural identity,[9] for people from university scholars to politicians and for the rest of the population.[10]

During this era we may observe two relevant consequences of this Canaries renaissance. First, the rise of local parties in each of the seven islands,[11] parties whose leaders defend, in general, their own interests, some of them because they have always been members of the local oligarchy, and younger leaders because they are close to real estate and tourist lobbies. Second, the new localism added fuel to the *insular dispute* between influential groups from the two main capital towns of the Archipelago. This dispute has been manipulated by the media and has put the population in a permanent situation of emotional confrontation.[12]

The main consequence for my cultural identity from this period[13] was the discovery that nationalism and cultural feelings are easily manipulated by the social group and social class whose members have control of the economy and have a strong influence upon public opinion, because these people are also the owners of the media. These same groups take advantage of the division and confrontation between different sectors of the population.

Finally, I started to discover that I felt closer to people, not in relationship to their geographical, racial, gender, or socio-cultural origins (we are not able to choose these important differences), but rather because of their approach to life, their common sense, open minds, and personal sensitivity. If I had to choose a single word

which summarized at that time my cultural identity, this word probably would be *canario*, but with a deep sense of internationalism and a desire for an open mind.

In fact when I realized that I was learning this lesson, I was in the next step of my trajectory. It happened when I moved to live in a new town, the capital city of a country with a different language and cultural patterns: Barcelona, in Catalonia.

In the Melting Pot

Though most people in my circle decided to go to Madrid to conclude their studies, I went to Barcelona, attracted by a culture with plenty of symbolic references, even with its own language (Catalan), and supported by a civil society which resisted Franco's government repression, a culture which defended its cultural identity and idiosyncratic values. I was also attracted by the possibility of writing my own story in a context where geographical origin was not a permanent reference for personal identity. Also, to some extent, I had the advantages of anonymity.

When I arrived in Barcelona, in January 1974, the town was full of energy, creativity, and cultural diversity. Catalonia, with a population of more than five million inhabitants, had around two million people from the rest of Spain. Those who arrived were attracted by possibilities of a better life in a region where the industrial revolution took place in the last part of the nineteenth century. Moreover, some of my new friends were Catalan, with parents who were mixed couples (normally the mother was from another part of Spain).

Surprisingly, the Catalan Communist Party (PSUC) and libertarian ideas both dominated Barcelona's public and cultural scene. Some of the most relevant writers from South America (Donoso, García Marquez, Vargas Llosa, among others) were residents of the town. At this time, frequent events reflected a permanent public debate about cultural, social, and political issues of democracy. I sensed that people, by themselves and through their support of the democratic process (particularly the claim to "freedom, amnesty, and autonomous statute"), were more relevant than geographical origins or cultural identities. These feelings continued with the first autonomous government which restored the political institutions abolished since the Spanish Civil War, particularly the Catalan Parliament and the *Generalitat*. This was a consensus government where all the majority political parties were represented, as a mirror of the diverse values and cultural realities in society.

However, this ideal situation started to change quickly. Under the slogan *"fer pais"* ("build the country"), this priority was formulated, particularly by the nationalists, to "Catalanize" as quickly as possible the cultural forms of thought and expression in the country. The Catalan Nationalist Party (CDC) has been ruling the autonomous government since the first elections in 1980. Its main leader, Jordi Pujol, a former founder of the Catalan Bank (Banca Catalana) and a genuine

representative of the Catalan bourgeoisie, the powerful and influential Catholic church, and the rural middle class, has been since the beginning the president of the Catalan government. He has been a real master, playing the game of cultural victimization against the Social-Democratic central government and its insensitivity to the cultural and political diversity of Spain. Pujol has built a notion of Catalonia and Catalan identity exclusively according to his values, and has frequently identified it with his person.

Pujol's main goals during his government have been in some ways contradictory. However, politically and socially they have been very effective. On one hand, the emphasis of his cultural policy was aimed from the very beginning at the "normalization"[14] of Catalan language in all spheres of the society, especially in the public schools. On the other hand, under the slogan "*Catalan és tot el que viu i treballa a Catalunya*" ("A Catalan is everybody who lives and works in Catalonia")[15] he made relevant a "melting pot" notion, in order to avoid original and social differences and cultural identities and to implement a homogeneous system of values in Catalan society, under the rules of a hidebound notion of culture and national identity.[16]

The inculcation of these values has been very effective, particularly in the immigrant working class, who fear reduced access to jobs, especially in economically precarious circumstances. Therefore, they have developed some agreements for accepting these cultural processes. At the same time, from the very beginning of the democracy, it has promoted a debate about the meaning of Catalan cultural identity.[17] This has contributed to a mythical sense of cultural and intellectual superiority among the native Catalans,[18] particularly because they have control of the use of the language[19] and of the political, economic, and cultural institutions.[20]

The consequences of this process of indoctrination are very complex to analyze, especially when it is very difficult to predict their effects under the present circumstances. First, we are able to observe an emergent and minority consciousness, particularly among school teachers, on multiculturalism, and to see ideas which recognize different forms of diversity in the school population and in society.[21] Second, in the last ten years, groups of emigrants with a very strong sense of cultural identity from Ghana, Senegal, North African Arab countries, some from Asia, and others from Eastern Europe are establishing themselves in Catalonia.[22] Their children are attending Catalan schools, and some of them, especially those who are Muslims, are starting to make demands on the schools to teach their children their own language and religion. Third, the notion and practice of Balkanization (the confrontation among different ethnic and religious groups) and its disastrous effects for the former Yugoslavia and U.S.S.R. has had a strong and unpredictable impact on other multicultural societies like Spain and Catalonia. Fourth, the reaction of the third generation of recent immigrants will also be unpredictable. They could adopt radical Catalan values in

order to be socially accepted, or, as has been the practice in other countries, as a consequence of their social marginalization, they could turn to the values of their grandparents.

I must recognize at this moment in the narration of my multicultural experiences, that all of these observations might seem to be coming from a critical observer. This impression is probably true, and I would like to defend my attitude, which is based not only on Catalonia, which is the place where I lived, but also on my life in the Canary Islands, my time in England at the beginning of the eighties, and now in the United States. To be critical does not necessarily mean that one is personally against other ideas, as conservative multiculturalists and of course all monoculturalists believe. Simply put, I have another perspective, and I will present arguments in favor of my views in opposition to the monolithic ideas of others. However, when their assumptions and practices are reflecting racism, sexist values, homogenization, discrimination, and superior attitudes, I will always be actively against their positions wherever they come from. This is a fundamental attitude among people who believe in the idea that some common and universal human rights[23] have to be respected as rules for local and international cohabitation with cultural diversities.

In the particular case of Catalonia, the present situation of multiculturalism reflects a society with little experience in democracy and a reduced assumption of diversity (ethnic, sexual, or cultural) and little experience in the practice of free expression of ideas. Probably for these reasons the dominant values tend to establish a monocultural society, which as Geyer (1993: p. 501) points out, "presumes a hierarchy of cultural values or a teleology of homogenizing progress emanating from a single center."

What I am learning from this situation is something similar to that which I discovered when I left the Canary Islands.[24] In order to build their own identity, some people and groups need to create an image of "the other" as the enemy, who is an excuse to justify all their inadequacies and limitations and is also created for their own self-defense. Normally, those who defend these positions are members of social classes who are part of the elite and have the social influence to control the distribution of knowledge and power. The imposition of a set of norms and rules[25] over the others, especially people from the working class and minorities, appears as a form of social control, and frequently, as an expression of cultural discrimination. Children from this elite are educated in the perspective of an open historical, social, and political view and, as it is fundamental for future leaders, they attend schools where they are able to learn several languages and to study in foreign countries. These same groups tend to reduce the experience of learning and knowledge for the rest of the population, especially through the control of the curriculum in the public schools. They assume that a literate person has to know, basically, the topics related to the history, geography, and cultural forms of Catalonia.

Over all, through these experiences I realize that, as Haro Teglan (1993) a Spanish journalist said, maybe it is possible to explain these attitudes because "they are people who need to belong to normative peer groups, because they don't have enough within themselves (and also they—the leaders—must be of a source belief, an idol to others). They are panicked at the idea of being individuals."

If I had to choose a single word which summarizes at this time my own cultural identity, this word would probably be *barcelonés*, because the town still offers complex and diverse experiences in a diverse and urbane environment where it is still possible to learn from multiple cultural perspectives and easily find social alternatives when gender, ethnic, and cultural discriminations appear.

A Summary: The Development of Cultural Identity

In order to link these ideas with the situation I am observing in the United States, I would like to maintain the argument that the creation and assumption of a Western, Eastern, multicultural, or multiethnic identity is the result, not only of an individual decision or an intellectual and political attitude, but over all, of personal autobiography. In the process of reconstructing my cultural identity in the Canary Islands, Barcelona, Seville, London, and in the United States, I will clarify the following topics for the reader:

First, at the beginning of everyone's life, personal and cultural attitudes are strongly influenced by the affective approach each person has to his or her surrounding reality. The intellectual experience of culture comes from the values of the community or social group to which each one belongs, and it is maybe depicted as the result of unjust and discriminatory circumstances. What seems problematic, in this initial stage, for the construction of each one's personal identity are prejudices and expectations on gender, ethnic, and religious characteristics. Under these circumstances when social discrimination appears, many people are unable to choose what they would like to be (in general, I have had this opportunity in my life), or how they would like to be perceived and accepted.

Second, nationalism, ethnic, gender, and cultural feelings are easily manipulated by the groups and the social classes whose members control the economy or the political power and who have a strong influence upon public opinion. These same groups take advantage of the division and confrontation between various sectors of the population, and frequently manage to capitalize on these ethnic, gender, and religious differences.

Third, some people and groups need (in order to build their own identity) to create the image of "the other," as the enemy who is an excuse to justify all their inadequacies and limitations, and who is created for their own self-defense. On some occasions, self-defense and auto-exclusion seem the only way for some groups

to create a sense of identity, especially those which are not socially accepted by their ethnic, gender, and religious characteristics.

Fourth, the interest in multiculturalism (or nationalism) has behind it battles for academic power and social control which are always based on the exclusion of other groups and intellectual perspectives.

Finally, in education, special curricula which reduce the complexity of reality into only one historical explanation or present knowledge through only one language, are implemented with the argument that they are necessary to reinforce some groups' personal and cultural identities. However, future leaders are often educated in the perspective of an open historical, social, and political view, and they attend schools where they are able to learn several languages, and they also go to study in foreign countries. Maybe it is not unthinkable that these same powerful groups tend to reduce the experience of learning and knowledge for other groups, essentially through the control of curriculum in public school systems.

Looking at Multiculturalism Through a *Mestizo*'s Eyes

My brief encounter with multiculturalism in the United States has to be seen within the context of previous experiences and considerations, without any intention of generalizing, and with special emphasis on the construction of multicultural knowledge from a global educational perspective. Multiculturalism, according to Banks (1993a) is a notion like a puzzle, reflecting a variety of meanings and interests. It is a common umbrella under which one can focus topics such as ethnicity (particularly African American identity), minority cultural expression (in opposition to the traditional Anglo male culture), folklore and traditions (especially regarding Native Americans), feminist studies, global education, multicultural society (vs. *melting pot* society), cultural deprivation (Banks, 1993), cultural diversity in the Arts (Smith, 1993), Western imperialism, Eurocentrism, and so on. And of course all these adjectives are linked to people who are "conservative multiculturalists" (Estrada & McLaren, 1993), "radical postmodern multiculturalists" (Goldner, 1993), "institutional racists" (Banks, 1993), and so on.

Behind each of these categories we are able to discover school curriculum projects, perspectives for social and scientific studies (particularly in history), political interests, and new forms of control and participation in democracy. However, above all, I find a stimulating and controversial debate on the identity of the United States as a nation (Schelesinger, 1992), and the roles of the different cultural and social groups inside the country.

Faced with this amalgam, let me choose a comprehensive definition of multiculturalism, from Geyer (1993: p. 501), who refers to the term as a set of ideas and practices "that explore the diversity and difference of cultural articulation and their

uneasy, embattled interaction." From this definition, I would like to introduce some ideas to the debate on multiculturalism in the United States.

Searching for Multicultural Knowledge

Eurocentrists and some postmodern radical multiculturalists have something in common: they represent "Western" culture, "like all cultures[,] as a self-contained phenomenon" (Goldner, 1993), without contacts, influences and exchanges among them. From this starting point it would be possible to ask the following questions:

Why don't they tell us something about the *syncretistic cross-fertilization* of cultures in the past, and more than ever, during the 20th century? When in Art Education, or in any curriculum subject, we talk about Multiculturalism in opposition to Eurocentrism, have we in mind the influence of ancient Egypt on Greece and on the Christian religion? Are we taking into account the relevance of Arab philosophers, scientists, and poets during the twelfth and thirteenth century, and in the Italian Renaissance? Or are we avoiding the multicultural reality of towns such as Salamanca, Toledo, or Girona, where between the tenth and fifteenth century Arabs, Christians, and Jews lived together, exchanging their knowledge and wisdom? Or, on the contrary, are we reducing more than three thousand years of mutual influence to the Anglo-German nineteenth century *Hellenophile romance*?

One possible answer to these questions could be, as Loren Goldner (1993: p. 29) has explained, "the postmodernists are so busy exposing the 'canon' as a litany of racism, sexism[,] and imperialism that they, exactly like the explicit Eurocentrists, fail to notice that some of the canon's greatest works have roots in the very cultures they supposedly *erase*." They have to re-write history—which is basically narration, a confluence of voices, and an excuse for real Eurocentrists and some multiculturists to avoid the mutual influence of ideas from Alexandria and Islam in the Western consciousness and vice versa—in order to reinforce their academic power through twisted interpretations.

In Art Education, some multiculturalists who are against showing students works by Picasso, Matisse, or Klee as *terrible* figures in Western art, fail to notice that their works have evident roots in the cultures that they intend to rescue. Looking in a different direction, they should know that some North African artists from Morocco to Syria are trying to build a synthesis between their ethnic roots and Western colonial influences, both present in their background. The same syncretism was observable in the Mozarabic culture in Spain, where Muslims, Jews, and Christians lived for centuries, mutually influencing each other.

Within a multicultural perspective, the exclusion of Western and male ideas becomes nonmulticultural, and it plays the same role that the traditional Eurocentrists (from the eighteenth century until the present time) are defending. Cultural

links and mutual influences contributed everywhere to the construction of reality. At this moment in human history, development does not exist in any culture isolated and without external influences. Failure to recognize this, especially in schooling, contributes to misinterpretations and misunderstandings. The processes of invention of tradition, or re-writing history from only one point of view (ethnic, gendered, imperialist) turns into the same reductionism (and in some cases cultural oppression) of those the multiculturalists are against. Such teaching would remove the possibility of self-understanding from these people, particularly young people such as African Americans and Latinos, whom these people pretend to save and to give a new identity. In some ways, there are no differences between these intellectual positions and those developed by totalitarian and dogmatic political systems.

The notions and practices which occur under the umbrella of multicultural studies, with all the diverse assumptions we could find (Banks, 1993; 1993a; Slatter & Grant, 1987; Chicago Cultural Studies Group, 1992), reinforce the idea of offering children of each ethnic or racial group a kind of curriculum to improve their performance. The main criticism of this perspective is similar to those I mentioned above. If teachers and educators do not present ideas and realities close to students' cultural references and, at the same time, the dominant knowledge and values in society, the children will have fewer possibilities for success in this competitive society, and in the end, they will be victims of a new form of discrimination. Camille Paglia (1992) argues, in the specific case of African Americans, they "must study the language and structure of Western public power while still preserving their cultural identity."

Consequently, it is an illusion to think, as in the latest fashion, or as the final answer, that multiculturalism is the solution to the problems of society or to general education. As Basil Bernstein (1973), the British sociolinguist, noticed when the discussion about compensatory education started in the sixties, "school cannot compensate for society."

I have had the opportunity to observe, not only in the United States, but also in Catalonia, that the interest in multiculturalism (or nationalism) has behind it fights for academic power and social control, and these fights are always based on the exclusion of other groups and intellectual perspectives. Instead, we should have an open cultural approach to knowledge as a form of mutual recognition and understanding.

In conclusion, we are now becoming like the Hellenists from the fourth century A. D. who were simultaneously influenced by Egyptian wisdom, Greek philosophy, Roman laws, Persian refinement, and Christian syncretism. We are living on the border of a transition era where new values about cultural identity are emerging from extreme positions: between the mutual enrichment which comes through the recognition of personal and cultural diversity and destructive *Balkanization*.

In other words, after my journey through some aspects of multiculturalism, I am able to recognize my own identification with feelings close to those of being a *cultural mestizo* (a person of mixed cultural ancestries and identities). In the same way, most human beings should live in a *mestizo world* and in a cultural, sexual, and ethnic situation of permanent *mestizaje*.

I have recently seen the actor Denzel Washington in three films: "Mississippi Massala" where he plays the role of a working-class African American who falls in love with an Indian woman; "Malcolm X" where he plays this African American figure; and in Shakespeare-Branagh's "Much Ado about Nothing" where he is Don Pedro, a Western character in an Italian village. Probably, this is one of the best examples of multiculturalism and *mestizaje* I can imagine.

As an art educator I consider *Art* a conveyor of knowledge which allows me to build, with my students and school teachers, a more complex and global understanding of different cultures and personal identities. Therefore, I try to develop with them an approach to learn through topics (Hernández & Ventura, 1992) where they are able to discover that mutual cultural influence through knowledge, arts, science, and beliefs among world communities has been the normal status of human beings in their construction of reality.

Under this perspective of Art Education, the idea of cultural identity has always been something more complex than the reductionisms of concepts such as nation, ethnicity, or gender. *Recognize and understand the wisdom coming from people everywhere* has been the attitude since Egyptian times, held by all the men and women who make the passion for knowledge and equity the guide of their lives. This will be our challenge as educators and human beings.

Notes

This paper is in part the result of different encounters and exchanges during my sabbatical, especially with some of the members of the Art Education Department at The Ohio State University. I would like to express my acknowledgement to Tony Scott who, as an Englishman living in the United States, made clear to me the legal distinction between interculturalism and multiculturalism. Thanks to Patricia Stuhr for her comments about the political implications of this domain, especially among academics and minority groups on campus. My gratitude also goes to the graduate students participating in Michael Parsons' "Dissertation seminar," especially to Hanneke Homan for our discussions on cultural imperialism and the differences between notions and uses of multiculturalism in the United States and the European Community; and to Jay Hanes and Cassandra Broadus for our conversations on art education and multiculturalism. Finally, I am grateful to Vesta Daniel, for the opportunity to think together, especially in her classes, about ethnicity and cultural meanings, and, of course, for encouraging me to write this essay.

I am also in debt to Loren Goldner, from Cambridge, MA, for his suggestions and comments about different and more complex perspectives in understanding multicultural phenomena. Thanks to Lois Johnson for her support in the editing of this paper.

1. For the preparation of this paper I went to some of the classical references on multiculturalism such as Sleeter and Grant (1987); some recent approaches which pay

attention to the relationship between Art Education and multiculturalism such as Canada (1992), Smith (1993), and Tomhave (1992); critical views from different perspectives on all these topics, from Schelesinger (1992) to Chicago Cultural Studies Group (1992), Geyer (1993), and Goldner (1993); and some authors representative of the most recent bibliography, such as Estrada and McLaren (1993), Greene (1993), and Ogbu (1992) among others.

2. For example, I have seen very few Hispanic and African American students around Harvard or MIT during this spring term; however, there were many Asian-Americans. The third of July, during one of the pop concerts at Boston's esplanade, almost all people around me were white families or groups. And the "water buffalo" incident on the University of Pennsylvania campus appears as an example of radical intolerance. Finally, through different teachers' presentations on a multicultural approach to Art Education, I have noticed that generally this is a topic with little ambition in its aims and curriculum materials, which follows a very simplistic understanding of cultural notions and complexities.

3. *Alter*, in Latin, means "the other." In this context it means the recognition of any other person as different from myself.

4. *Mestizo* originally means "racially mixed"; "*mestizaje*" has cultural significance to authors such as the Mexican Nobel Prize winner Octavia Paz, who has pointed out this notion in the Latin American cultural heritage.

5. This notion was frequently used in my conversations with the Spanish anthropologist of Renaissance breadth, Alberto Cardin. Also it appears in the novel by J. L. Sampedro, *La Vieja Sirena* (The Old Mermaid) whose action takes place in Mediterranean countries at the turn of the fourth century A. D.

6. In the Canary Islands many children, now between ten and fifteen years old, have names such as Airán, Tinerfe, Gara, Gazmira, and so on.

7. The Canary Islands have one of the lowest levels of unemployment in Spain; moreover, the demographic pyramid data shows the largest young population in the country. Statistics indicate one of the highest indices of illiteracy.

8. The leader of the most well known of these groups, Los Sabandeños, is the mayor of the third most important town in the Canary Islands, La Laguna, and has been taking advantage of these folk nationalist feelings.

9. A similar process started in the other Spanish regions.

10. In Spain, almost every year, there are tenure examinations for acquiring civil service posts as teachers. Under this nationalist euphoria, some teachers from the Canaries boycotted the presence of candidates from continental Spain at this examination. They justified this action with the argument that jobs should be only for unemployed teachers from the Islands, and of course, because Island teachers were able to understand the children's values. When I spoke about this affair with some peasants from the less developed part of La Palma, their comment was: "At least *peninsulares* remain in the village and try to be involved with our problems, because local teachers commute every day when they finish school."

11. In the last general elections, June 1993, left-wing and right-wing parties made a coalition together under the umbrella of nationalism, and against the two major state parties, the Socialist and the People's party. They took four seats.

12. The last example of this dispute took place when the authorities and the population from Gran Canaria organized a big demonstration supporting the petition for a new university in their island. The reaction from the inhabitants, politicians, and academics from Tenerife, the island where the university is established, was very angry. During these days, I was lecturing to teachers in a workshop in Gran Canaria, and when I fin-

ished I moved to Tenerife for a Conference in Art Education. Some friends, of whom I had the opinion they had a reasonable sense of judgment, asked me why, if I was born in Tenerife, I had been teaching in the "other" island. I asked about the social and economic demands of the Canaries in relation to university planning, . . . and nobody could offer me any answer. The reaction, basically, was emotional, because feelings, especially nationalist and racial, are easily manipulated.

13. Although when these last events happened I had already left the Islands, I took this information from newspapers and magazines, my visits to the Canaries, and exchanges with friends and colleagues.

14. This expression had a double meaning. On the one hand it referred to the proper use of the Catalan language, without Spanish language influences, and. on the other hand, it made the use of the Catalan language a norm and current rule for all the people living in Catalonia.

15. An interesting task for sociologists would be to write the recent history through the slogans originated in "La Generalitat," which on some occasions were in dialectical confrontation with those slogans coming from Barcelona's town hall, which has always been under the rule of the Socialist Catalan Party.

16. This narrow view of cultural identity Is reflected in two examples coming from the director of the office in charge of Catalanizing children in schools. In the earlier 1980s, a colleague was talking with him about the experiences of multiculturalism in Great Britain, particularly about school activities where knowledge of each child's culture was part of the curriculum. His reaction was clearly conclusive: "*Això may passará a Catalunya*" ("It will never happen in Catalonia"). This public figure is also well known for his definition of the mother tongue: "*És la llengua vehicular del territori*" ("Catalan is the working language of this country").

17. In the early 1980s more than 2000 people, most of them teachers running from school level to university, signed a manifesto demanding recognition of the right of free expression for the Spanish-speaking people living in Catatonia. The manifesto was interpreted as an attack on Catalan identity; one of the relevant promoters of the manifesto was shot in the leg by a Catalan radical militant, and in these negative circumstances some of the signatories decided to leave Catalonia. Similar phenomena happened when it became compulsory to teach only in Catalan in primary school. Some teachers decided to return to their family lands in other parts of Spain.

18. There are many illustrations of this superiority belief. One teacher in the Catalan Department at one secondary school said to a student, the daughter of immigrants who was intending to speak in Catalan, but who on this occasion had initiated the conversation in Spanish: "If you speak to me in Castilian. I will place you on the same level as my cleaning lady."

19. It is commonplace in sociolinguistic studies (see Basil Bernstein (1971) as an example) that the person who controls the use of the language has control of the symbolic meanings behind it. Consequently, those who have less skills or those who use other cultural codes are not less intelligent, but they have no similar possibilities in the face of the dominant linguistic code and cultural values.

20. It would be interesting to research the social distribution and presence of non-Catalan people in political and cultural institutions, and also how these people feel about their representation in the Catalan Parliament.

21. These ideas are more developed in regard to gender differences than about cultural idiosyncracies. Under the present Catalanization, it is hard to start a public debate, for example, on the rights of the children from Andalusian families (this is the cultural

heritage of the majority of immigrants living in Catalonia) to study and express their cultural values.

22. These populations are basically working in farms under general conditions of economic exploitation.

23. I maintain this position after the recent Conference in Vienna, where the representatives of some countries attacked the idea of common human rights, using multicultural arguments that these come from a Western perspective and do not take into consideration that, especially in some Arabic and Asian countries, the notion of human rights has different meanings. Starting from the recognition of the hypocritical positions on human rights defended through recent world history by the Western countries, we could arrive, using this relativistic argument, at a defense of the Holocaust, colonialism, genocides, and forms of oppression as idiosyncratic and cultural forms of expression.

24. My personal experience in Barcelona, as I noted above, has been fundamental to my identity and social commitment. From the beginning, my attitude was receptive to the use of the language (Catalan is my main form of communication, especially at the university and in my work with teachers) and with other cultural expressions of the country. However, this position has no special merit, because I would do the same in any country where I live, because this is the only way of being culturally flexible and building independent and critical thought.

25. These are norms and rules that many of the elite's members do not practice. When the test of the Catalan language became compulsory in the exam prior to university admission, the students from some elite schools, like the German School, were allowed directly by the President of the Catalan Government not to take the exam.

References

Banks, J. A. (1993a). Multicultural education: Historical development, dimensions, and practice. *Review of Research in Education, 19*, 3–49.

Banks, J. A. (1993b). The canon debate, knowledge, construction, and multicultural education. *Educational Researcher, 22*(5), 4–14.

Bernstein, B. (1971). On the classification and framing of educational knowledge. M. Young (Ed.), *Knowledge and control: New directions for sociology of education*. London: Collier-Macmillan.

Bernstein, B. (1973). Education cannot compensate for society. J. Raynor & J. Harden (Eds.), *Equality and city schools*. London: Routledge.

Condominas, G. (1991). *Lo exótico es cotidiano*. Gijón: Cátedra.

Chanda, J. (1992). Multicultural education and the visual arts. *Arts Education Policy Review, 94*(1), 12–16.

Chicago Cultural Studies Group (1992). Critical multiculturalism. *Critical Inquiry, 18*, 530–555.

Estrada, K., & McLaren, P. (1993). A dialogue on multiculturalism and democratic culture. *Educational Researcher, 22*(3), 27–33.

Geyer, M. (1993). Multiculturalism and the politics of general education. *Critical Inquiry, 19*, 499–533.

Goldner, L. (1993). Eurocentrism and its mirror images: Postmodern versus world history. *Against the Current*, July/August, 26–35.

Gray, J. (1993). Can we agree to disagree? *The New York Times Book Review*, June 16, 35.

Greene, M. (1993). The passions of pluralism: Multiculturalism and the expanding community. *Educational Researcher, 22*(1), 13- 18.

Haro Teglen, E. (1993). Imperatives, *El País*, July 3, 54.

Hernandez, F., & Ventura, M. (1992). *La organización del curriculum por proyectos de trabajo.* Barcelona: Graó.

Ogbu, J. U. (1992). Understanding cultural diversity and learning. *Educational Researcher, 21*(8), 5–14.

Paglia, C. (1992). *Sex, art, and American culture.* New York: Vintage Books.

Schelesinger, A. M. (1992). *The disuniting of America: Reflections on a multicultural society.* New York: W. W. Norton.

Sleeter, Ch. E., & Grant, C. A. (1987). An analysis of multicultural education in the United States. *Harvard Educational Review, 57*(4), 421–444.

Smith, R. (1993). The question of multiculturalism. *Arts Education Policy Review, 94*(4), 2–18.

Tomhave, R. D. (1992). Values bases of multicultural art education. *Studies in Art Education, 34*(1), 48–60.

Please Stand By for an Important Message: Television in Art Education

Kerry Freedman and Karen Schuler
Northern Illinois University

The paper begins with a survey of research on television reception, arguing that television blurs the boundaries between information and entertainment to such an extent that students need an education in television. It examines television viewing as a developmental process and the extent to which students understand the authorship of television programs. In particular, the paper discusses the role television plays in inculcating a consumer culture, offers material from which students construct identities, and presents images of violence, stereotypes, and sex. Finally, it offers a series of recommendations and activities to help teachers take television studies into the art room as part of a curriculum in visual culture.

Increasingly, researchers and theorists have argued for a visual-culture model of art education, recommending serious consideration of popular visual arts forms in teaching and research (e.g., Blandy and Congdon, 1990; Duncum, 1997; Freedman, 1994, 2000; Freedman and Wood, 1999; Hamblen, 1990; Stuhr, 1994). Students are now understood as having a range of visual arts experiences in their daily lives to which art classroom experience should consciously connect. If our goal is to enrich students' understanding of the visual arts, art education should inform them about the range of visual culture as it deepens knowledge about particular art forms. As art educators move toward teaching visual culture, questions remain about the most appropriate ways to infuse content about popular visual arts, such as television programs and commercials, in art curricula.

Although television is probably the visual art form with which most students have the most experience, surprisingly little attention has been given to it in art

From *Visual Arts Research*, Vol. 29, No. 57 (2003), pp. 163–172

education literature. Viewed as part of visual culture and art curricula, television is a highly complex visual art form. Several issues, particularly those concerned with curriculum content and children's development, need to be addressed concerning appropriate theoretical foundations and practices of teaching television in art classrooms.

Television functions on several different levels of influence and representation. Television programming and commercials are delivered into people's homes, where the machine is turned on an average of seven hours a day. People have more televisions and video recorders, and more is spent on television advertising, in the United States than in any other nation. TV has a capacity to simultaneously present illusion as reality, represent various visual arts forms, and exist as a visual art form. Television is a form of art education: people learn about and through the visual arts when they watch it (Freedman, in press).

More than any other technology, television illustrates the critical connections among advertising, entertainment, broadcasting, journalism, sports, and now satellite and web technologies. On television, students see imagery from a variety of cultures, from fine art, films, and other forms of visual culture. Soon, the television/web connection will be common in households, and television channels and programs already have web sites with additional information related to a show containing links to other sites.

Visual art forms such as films, web sites, and television programs are in several ways similar to fine art and therefore can be analyzed using similar methods. However, these popular time-based arts are different from fine art, too, and require consideration in relation to the best ways in which they can be taught in art classrooms.

In this article, we will first survey literature about television and television audiences that relate to the ways in which television is now breaking down conceptual borders between entertainment and education. We will consider television's "edutainment" qualities and conditions. Second, we will discuss research concerning children and adolescent viewing of television and relationships between television and other visual culture forms. In this section, we will focus on two issues: a) the importance of fantasy and narrative in children's visual development, and b) the functions and processes of creative transformations in, for example, role-play. Third, we will present recommendations for teaching television as visual culture.

TV Edu-tainment: The Viewing Experience

In the United States, TV functions as a national curriculum: More students watch the same nationally broadcast television program than are taught based on a single school curriculum (Freedman, in press). Television is the visual arts form with which most students have the most experience, and it is the foundation of most of their

information about visual culture forms. Attention to television begins in infancy, and by the age of 75 a typical individual will have spent about nine years in front of the television (Kubey and Csikszentmihalyi, 2002).

In some ways, television is similar to other visual art forms. However, it is also different in many ways. Television is not just a series of texts; it has visual form. As a result, it has a power that written texts do not. It attracts attention and is processed with an immediacy not associated with reading texts. People often remember images more easily and with greater fluidity than texts. As a result of our perceptual systems, images are inherently didactic in their capacity to teach people how to interpret them (at some level), whereas texts require a special facility with language (Ewen, 1988).

Research has also suggested that television may cause people to behave in a manner similar to that of a physical addiction (Kubey and Csikszentmihalyi, 2002; Mcllwraith, 1998). Much of the data on which this conclusion is based comes from self-reporting.

In Gallup polls in 1992 and 1999, 2 out of 5 adult respondents and 7 out of 10 teenagers said that they spent too much time watching TV. Other surveys have consistently shown that roughly 10% of adults call themselves TV addicts (Kubey and Csikszentmihalyi, 2002, p. 76).

People report that they cannot concentrate as well after watching television. They report that, after turning the set off, their moods are the same or worse than before watching (which is contrast to mood improvement after taking part in hobbies or playing sports), and that they feel lethargic.

The physical evidence is also suggestive. Our heart rate decreases for a few seconds as a result of mental arousal after a stimulus is encountered that requires us to orient ourselves, such as a sudden movement. Formal features change about once per second in ads, action sequences, and music videos, continually reactivating the orienting response (Fox, 1996). Even children's television includes the use of attention-getting formal features to promote learning. But we have a saturation point. Too many editing cuts or bright, flashing colors can repel and even make people feel physically ill.

Even if watching television is not actually addictive, the results of such research raise important questions. For example, how is watching television different from other types of visual experience? EEG results indicate that less brain activity is apparent when people watch TV than during reading (Kubey and Csikszentmihalyi, 2002). This result makes sense when considered with the fact that during reading we must construct our own images, and television provides images for us. However, it does not mean that little brain functioning is necessary while watching TV. The social conditions of viewing are vital to the way in which visual messages are received and understood (Morley, 1992). Many people do not watch TV with a critical eye, but those who do can make choices about the ways in which they interact with programs and commercials.

The viewing process is a highly interactive relationship between imagery and audience in which cultural and personal meanings are created (Morley, 1992). These meanings are created as a result of social knowledge, including, for example, gendered associations, formal and informal education, and socioeconomic level. Therefore, focusing attention only on the technical aspects of visual arts in education, such as manipulating computer software or animating film, results in missing vital aspects of imagery. The type and level of interaction with all screen viewing, for example television and computer games, is important, and the physical interaction now available when using computers will soon be a common part of the television experience. Empirical research suggests that, "as with video games, the ability of web sites to hold the user's attention seems to depend less on formal features than on "interactivity" (Kubey and Csikszentmihalyi, 2002, p. 80).

The formal qualities of television are, in part, what keeps our attention. Television first brought into our homes the quick cuts, fast movements, and brightly lit colors that fasten our natural attention to a novel or sudden stimulus. It makes us want to look. But even if the quick intercutting of unrelated imagery plays an important role in just maintaining our attention, it also suggests meaning. For example, advertisers base their work on the assumption that we will remember name brands simply because they have been attached to something else memorable or attention getting.

A major part of the television-watching experience is exposure to commercials. An average adult is exposed to approximately 32,000 commercials a year (Consedine and Haley, 1992). News programs are now full of advertisements, not only in advertising spots but also during programming through, for example, the inclusion of information about upcoming events.

The Power of TV Imagery

How and What Do Kids Learn from Watching?

The effects of television are still a question for research. However, as discussed above, research has demonstrated that people do not simply and uniformly absorb television messages. The context of viewing, including the age of the viewer, is an important issue when considering the influence of television and ways to teach about and through it. The overwhelming evidence indicates that television does influence students' views of reality (e.g. Greenfield, 1984; Fox, 1996).

Several statistics about TV viewing conditions can help provide a context for analysis. At 6 months, an infant's gaze at the television is sporadic. Reaching 1 year, the child begins to watch the shapes presented, yet is only able to watch consistently 12% of the time that the television is on. By age 2–3, viewing capacity reaches 25%–45% of the time. At age 4, 55% becomes the norm for most children's viewing, even when

distractions such as toys and games are present (National Institute of Mental Health, 1982). By the teenage years, television consumption averages 22 hours per week, and the average adult American watches approximately 4 hours a day (La Ferle, Li and Edwards, 2001).

Studies have found that children's comprehension of programs depends on three factors: age, general experience, and knowledge of the television medium (National Institute of Mental Health, 1982).

Eight-year-olds have been found to recall about 65% of the content viewed. However, by 8th grade, retention and understanding soars to 90% or more. The reason for this increased awareness has been attributed to programming content, which promotes a personal relationship to the viewing child. "By 9 years old, children decode television programmes with essentially the same 'grammar' as adults do" (Tulloch, 2000, p. 129).

Like adults, adolescents use media for a variety of reasons, from entertainment to self-identification to escape. However, adolescents are at a time in their lives when they are developing their identities. When viewing television, they are able to explore the construction of identity through a variety of roles and life possibilities presented on the screen. Adolescents also do this with written texts, but television presents these life and identity possibilities more vividly and concretely than written texts.

Children seek out information that will aid in their development into adulthood (Chapin, 2000; Arnett, 1995; Fine, Mortimer, and Roberts, 1990). They want to know what is real, what is right and wrong, what is important, and how people relate to one another (Austin, 2001, p. 378). Television today requires a mature audience that is capable of asserting selective attention to information provided implicitly as well as explicitly, that is able to understand a variety of perspectives both in front of and behind the camera, and that is able to comprehend the meaning of graphic elements and techniques applied to the medium (Dorr, 1980).

While critical skills are learned over time, children tend to emulate material that is relevant, useful, realistic, normative, desirable, and rewarding (Reeves, 1978; Hawkins and Pingree, 1982; Austin and Meili, 1994). However, as the research discussed in the following sections illustrates, few televised offerings can claim those good qualities, and students are becoming part of consumer culture and constructing their individual identities with little critical reflection.

Buying Commercials: TV and Kids' Part in Consumer Culture

Commercials on television have a huge impact on children and adolescents. The makers of commercials develop and check their creations using scientific methods to guarantee their potency, with, for example, computerized equipment that tracks eye movements and responses (Consedine and Haley, 1992).

Approximately 31 million teenagers in the U.S., each with an average weekly expendable income of $75, are targeted with television advertising (Mediascope, 1999; Omelia, 1998). In 1998 alone, teens spent $141 billion of their own earned money (Mediascope, 1999). So it is no surprise that advertisers focus their efforts on teens and their pocketbooks. Students who watch a lot of TV tend to be more materialistic than those who watch little (Greenfield, 1984), and 70% of teens believe that brand names are important (Fox, 1996). Branding has been found to produce a sense of identity for teens in the process of creating their sense of self (La Ferle, Li, and Edwards, 2001). As a result, advertisers realize that establishing brand loyalty at an early age will help ensure lifelong users.

Advertising has begun to invade nontraditional venues such as music videos, television series, and daily news programs. For example, the TV show *Friends* paired up with Pottery Barn through the incorporation of their furnishings into sets. The agreement ensured that 22 airtime minutes per show are spent where the cast discusses or is around Pottery Barn products (La Ferle, Li, and. Edwards, 2001). TV shows specifically directed at adolescents, such as *Felicity,* incorporate selling techniques throughout the series. *Sex and the City, 90210,* and other series have started fashion trends and many shows, including films shown on television, now deliberately incorporate shots of billboards and other signs and objects with brand names prominently displayed.

Not only do students watch a large number of commercials outside of school, they are watching them inside of school without learning critical response methods. Channel One is a commercial television venture begun by Christopher Whittle, a media mogul who gained wealth by designing advertisements for captive audiences, such as patients in doctor's offices. Schools get Channel One on the condition that certain rules are followed. In exchange for approximately $50,000 of electronic equipment (which must be returned if the school stops requiring students to watch Channel One), programs including 8 minutes of what is presented as news and 2 minutes of commercials must be watched in their entirety (Fox, 1996). Some of the schools also have vending machines containing the products that are advertised, such as Pepsi, Kit Kat, and other food items.

Channel One was sold to schools under the guise of promoting "cultural literacy," which was the result of the "get back-to-basics" movement during the political conservatism of the late 1980s. This movement was reflected in *A Nation at Risk,* E. D. Hirsch's *Cultural Literacy* (1987), Harold Bloom's *The Closing of the American Mind* (1987), and William Bennett's *What Works: Research about Teaching and Learning* (1986). By 1993, Channel One had spread to more than 12,000 schools in 48 states (Solomon, 1993).

Commercials on Channel One have been created in ways that fool students into believing they are not commercials, just as news programs work in ways that

trick adults into believing that "what's going on" spots are not advertisements. For example, in a study he did on student responses to Channel One commercials, Fox (1996) reported that out of 150 students only 5 understood that Pepsi had produced a commercial for the purpose of selling their product. The commercial focused on adolescents that the students thought were "just like them" in the process of a discussion of teen issues. Pepsi cans were shown throughout the commercial and the name and logo were included, but because the amount of time spent on images of the adolescents talking was relatively greater, the students did not understand that they were seeing a Pepsi commercial. They thought that the statements by the teen actors, which were portrayed as "videotaped confessions," were truthful, rather than being those of the producer and writers hired by the company to sell the product. Students who watch Channel One tend to learn the message of commercials while not learning a substantial amount from the "news" programs (Knupfer and Hayes, 1994; Tiene, 1994).

The importance of visual imagery is illustrated by the influence of the length of time spent showing a product on whether students understand what they are seeing. The image is of critical importance in its ability to lull students into a false belief that their purchases are not being shaped by the companies that sell the products. Some of the adolescents in Fox's study even believed that sports people pay to be in commercials so that they can be seen in order to improve their careers or boost their egos through an association with the product (rather than the other way around). The huge salaries actually paid by the product companies to sports celebrities confirm the success of the strategy for selling products to adolescents.

Students psychologically replay commercials in various ways, acting them out, singing jingles, and recycling images in their artwork. The commercials become part of their way of thinking and communicating; they are a common bond between peers (in part because the commercials they attend to are not the same commercials given attention by their parents). And, although students often deny that they pay any attention to advertising or that it has any influence on them, they can often recount commercials and advertisements in great detail.

Constructing Identity: Creating the Self through TV Role Models

Much of the research on children and television has focused on issues of student identity, such as responses to violence and sexual content, body image, and stereotyping. In a survey of over 1,200 students, 40% indicated that they learned "a lot" from TV; 25% said that "television shows what life is really like" and that "people on television are like real life" (Lichter and Lichter, 1988). This occurs in other visual forms as well, such as magazine advertisements (Beach and Freedman, 1992). The visual impact of photographic imagery may have a great deal to do with the belief that television is like real life. Students may understand fictional qualities of television when it is presented

visually as fiction (as in science fiction), but they think of television as a window to the world when it comes to issues of identity and their own social life. Even adults have difficulty distinguishing visual fact from fiction because photographic imagery is still generally thought to be believable (Freedman, in press). It is logical to assume that children and adolescents who believe that television represents real life, and who see actors portraying scenes similar to situations they encounter, will think that similar outcomes will occur. They use television role models to define their identity, particularly as they separate themselves from their parents.

Violence on television. Many studies have connected violence on television to violent behavior in children and adolescents. However, the connection is complex. The National Television Violence Study (NTVS) was a summary of the results of research on violence and television (Wilson et al., 1997). The NTVS indicated that acts of justified violence increases violent tendencies among viewers while unjustified violence may decrease aggression in viewers (e.g. Berkowitz and Powers, 1979; Geen and Stonner, 1973). However, as a study by Kremar and Cooke (2001) point out, viewer determinations of whether violence is justified is open to interpretation, which changes as children get older. So it is the "reading" or interpretation of violent imagery that is most important. The NTVS report concludes:

> Television, with its abundance of violent depictions, offers child viewers many opportunities to employ skills of moral reasoning. When children are presented with a violent act, they must decide if the act is justified or appropriate, and as suggested earlier, acts that the viewer perceives as justified are more likely to increase aggression in the viewer. Therefore, it is important to know how the child draws such conclusions. Particularly in the case of young children, an ample understanding of their interpretations of television images would take us far in dealing with media violence for young children. (Wilson et al., p. 303)

Body image and stereotyping. In Western culture, moral character is believed to be symbolized by the conditions of the physical body (Foucault, 1978). In advertising, messages of attractiveness are present in at least 1 out of every 3.8 commercials (Martin, Gentry, and Hill, 1999).

The influence of body image portrayed on television is a major concern to researchers. Children consider physical appearance more important as a result of television than they did in the past (Greenfield, 1984). Female adolescents are particularly vulnerable to influences of body image during identity formation and sexual development. Differences in girls' body image also exist based on ethnicity: Black and white girls

> . . . were equally likely to compare themselves and their friends to television images, and the more all of the adolescents make those comparisons, the more they engage

in eating-disordered behaviors, the stronger their drive to be thin, and the more dis-satisfied they are with their bodies. The only difference comparisons made between the white and black girls was that making more comparisons is related to white girls choosing a thinner figure size than black girls. (Boffa, 2000, p. 154)

Although things have changed to a small extent in the area of stereotyping, gender and racial stereotypes are still prevalent. Independent working women are still rarely seen on TV, and even when we are told that female characters have jobs they are still usually seen in home environments doing traditional homemaker activities.

Sexual content. In many schools, art teachers are not allowed to show historical nude masterpieces in class, yet kids see nudity and explicit sexuality in soap operas, drama series, and Victoria's Secret commercials. Adolescents now develop sexually years earlier than in generations of the past. For example, girls generally begin menstrua-tion at about 12 or 13 now, while 150 years ago it began at about age 16 (Hamburg, 1992). While adolescents' bodies are maturing and their psychology is changing, their emotional maturity is not yet matching their overall developmental stage.

As children develop, and increasingly seek information, especially about devel-opmental issues such as sex, they focus on socialization and self-representation, which often have sexual connections. Approximately one-third of the content in primetime shows popular with adolescents is sexual (Ward, 1995). Sexually oriented television programs focus on three common themes: sexual and/or romantic rela-tionships as competitions, men choosing and valuing women as a result of physical appearance, and sex as the defining act of masculinity (Chapin, 2000). Kids see sexual scripting behavior (such as premarital and extramarital sex) on TV that they do not see in other places (Gagnon and Simon, 1987). Action adventure series, par-ticularly favored by males, incorporate frequent encounters with both prostitution and premarital sex.

While the average teenage viewer absorbs thousands of sexual innuendoes, there is little portrayal of preventative efforts against pregnancy or sexually transmitted diseases. And yet in one study, nearly 50% of the teenagers surveyed acquired informa-tion about birth control through the media (Strasburger, 1995). Furthermore, studies have concluded that teenagers think of unprotected sex as spontaneous, pleasurable, natural, and private, whereas protected sex is viewed as artificial, work, cautious, and planned.

Recommendations for Research and Teacher Practice

As discussed above, it is not the amount of time by itself that is a predictor of the influence of television on students, but the relationship students have with what they are watching. This means that neither the impact nor what is learned from television

is beyond our influence as art teachers. Student experience with and through television involves learning, and we can help students to view critically so that they can make choices about which influences they are willing to accept.

Defining what constitutes a critical approach to viewing television is a challenge and one that is in debate even in the field of media studies. Often in the past, television was considered mainly as a form of text, as media studies was included as part of social studies or English education. However, we believe that art educators may be most appropriately placed to meet this challenge because we can address the complex interactions of the various forms of the visual arts and the impact these interactions have on students. Art educators can give particular attention to the visual characteristics that make these visual culture forms most powerful. As discussed above, it is the increasing sophistication of imagery that has taken such popular art forms out of the realm of text and transformed them into a pervasive and mind-shaping visual culture.

Recommended Outcomes

As a result, we recommend working toward the following responses from students:

1. Viewing television with an appreciation of its multiple, complex levels, rather than denying its influence or making dichotomous judgments about it.
2. Identifying the general and overarching tone of television programs or commercials and supporting that identification with evidence.
3. Speculating on or uncovering possible interests of television producers, directors, and other artists and their reasons for making creative choices.
4. Making connections between television and other forms of visual culture and general culture.
5. Comparing and contrasting aspects (conceptual, stylistic, formal, technical, etc.) of programming and commercials.
6. Analyzing the virtual environment of television, its fictional qualities, and the ways in which that environment is supported or contradicted by audio and written texts.
7. Considering the viewing purposes, contexts, and responses of various audiences.

An important part of art education is expression, and students begin to define themselves through their artwork as well as through the images they choose to look at. The creation of their own imagery can be a powerful process in identity formation when teachers have the courage to let students explore what it means to imagine (within institutional boundaries). The making of art has long been valued as a physical manifestation of an artist's social, cultural, and individual identity because it reflects, critiques, and supports the exploration of what it means to be human for

viewers. Unfortunately, some of the emphasis on these issues has lost currency in art education in recent years.

Research on students' interactions with popular visual art forms is needed in the area of art education. As referenced in this article, much research has been done on children's and adolescents' responses to television. However, a major portion of this research has been done by advertisers, who are interested in controlling consumers, and their research questions reflect that interest. Relatively little research has been done in relation to student learning per se and virtually none with regard to issues in art education.

A variety of instructional methods exist that can lead to appropriate learning about television as a visual culture form. The following teaching strategies, listed for each of the above outcomes, are intended as starting points for the exploration of television in art classrooms:

1. Help the students view and interpret television in terms of multiple layers. Students can be encouraged to write, make art, and talk about their perceptions of information presentation, formal qualities, character development, and so on. Ask students to keep records of their viewing habits and record behaviors, such as consumer spending, related to TV. Their perceptions can be used to center group discussion and analysis in the classroom.

2. Analyze and identify the overall tone of commercials and programs by studying the purposes of production and the use of formal qualities (e.g., camera angles, lighting, editing, costume, and set design) to fulfill those purposes. Use brainstorming activities for broad interpretations and "close readings" to focus on details for a deeper analysis. To get at the general emotional states conveyed or initiated by particular television programming, ask students to reflect on their responses while viewing and compare, for example, commercials for different products or different commercials for the same product.

3. Uncover creative decisions made by television producers, directors, actors, and designers. Students can be encouraged to take field trips, do internships, or interview members of production teams to inquire into social, political, and economic aspects of formal, technical, and narrative decisions. Role-playing is an effective method of investigating the roles that people play in television production. Students can use, for example, video equipment and computer technology to make television-like programs and commercials. Some high schools have television broadcasting equipment and access that can be gained by art teachers.

4. Promote an understanding of the conceptual connections that exist between television, other forms of visual culture, and general culture. Games that encourage thinking about visual culture interrelationships, references to television in student art, the development of a television program about art, and analyses of television to find cross-program/commercial references are all effective methods of revealing connections.

5. Compare and contrast television programs in terms of their genres. Directed analysis of television examples in class can help students understand the differences and similarities in the purposes and forms of newscasts, game shows, soap operas, popular teen sitcoms, and so on. Discuss television production and screening procedures and techniques.

6. Analyze the televised environment by asking students to create similar environments. Help them to understand the fictional quality of these environments and the power of images presented in conjunction with texts and sounds in making these environments seem real. Having the students develop, act out, and tape their own televisionlike scenarios will help them understand the ways in which such fictions are created.

7. In considering the viewing purposes, contexts, and responses of audiences, students can participate in simulation activities, visit a local television set, and do audience research by observing and interviewing accessible audiences, such as friends and family members. Invite guest speakers, such as audience researchers, into the classroom.

Conclusion

Television involves sophisticated visual aesthetics to suggest subtle as well as obvious meanings and influence viewers' perceptions of reality. It targets particular audiences through shocking, beautiful, dramatic, action-packed, and seductive forms. It conveys messages, suggests personal and cultural meanings, and elicits emotions. In other words, it is not far different from other forms of visual arts. Therefore, students should come to understand television as part of an art education intended to aid in their overall growth and development in the visual arts. In this, art educators should play a prominent role.

Programming directed toward adolescents typically contains material that is sexual in nature or contains varying degrees of violence. During an average viewing experience, teenagers will view thousands of often negative ideas about how they should look, act, think, and feel. Interpreting and responding to media should include processes of uncovering subtle meanings and discovering cognitive connections between television and other forms of visual culture. The capabilities of computer technology should be highlighted to challenge the way viewers interpret what they see as "real" on television, in film, and on the web. By teaching students to analyze production processes and motives, they will be able to judge the portrayals and messages they are presented on TV.

Television is part of the visual culture of contemporary childhood and adolescence. Many of the issues discussed here concerning TV also relate to other forms of visual culture, such as magazines, billboards, and computer games. In order to provide an art education that is relevant to students today, art educators must address

issues related to the visual arts students regularly encounter as well as teaching them about the visual arts they rarely see.

References

Arnett, J. (1995). Adolescents' uses of media for self-socialization. *Journal of Youth and Adolescence, 24(5)*, 519–533.

Austin, E. (2001). Effects of family communication on children's interpretation of television. In J. Bryant and J.A. Bryant (Eds.), *Television and the American family* (pp. 377–395). Mahwah, NJ: Lawrence Erlbaum.

Austin E., and Meili, H. (1994). Effects of interpretations of televised alcohol portrayals on children's alcohol beliefs. *Journal of Broadcasting and Electronic Media*, (38), 417–435.

Beach, R., and Freedman, K. (1992). Responding as a cultural act: Adolescents' responses to magazine ads and short stories. In J. and C. Cox (Eds.), *Reader stance and literary understanding*. Norwood, NJ: Ablex Press.

Berkowitz, L., and Powers, P. C. (1979). Effects of timing and justification of witnessed aggression on the observers' punitiveness. *Journal of Research in Personality, 30*, 71–70.

Blandy, D., and Congdon, K. G. (1990). Pornography in the classroom: Another challenge for the art educator. *Studies in Art Education, 32(1)*, 6–16.

Botta, R. (2000). The mirror of television: A comparison of black and white adolescents' body image. *Journal of Communication, 51X3)*, 144–159.

Chapin, J. (2000). Adolescent sex and mass media: A developmental approach. *Adolescence, 35*(140), 799–811.

Consedine, D. M., and Haley, G. E. (1992). *Visual messages: Integrating imagery into in struction*. Eaglewood, CO: Teacher Ideas Press.

Dorr, A. (1980). When I was a child, I thought as a child. In S. Withey and R. Abeles (Eds.), *Television and social behavior: Beyond violence and children* (pp. 191–230). Hillsdale, NJ: Lawrence Eribaum.

Duncum, P. (1997). Art education for new times. *Studies in Art Education, 38*(2), 69–79.

Ewen, S. (1988). *All consuming images: The politics of style in contemporary culture*. New York: Basic Books.

Fine, G., Mortimer, J., and Roberts, D. (1990). Leisure, work, and the mass media. In S. Feldman and G. Elliot (Eds.), *At the threshold: The developing adolescent* (pp. 225–252). Cambridge, MA: Harvard University Press.

Foucault, M. (1978). *The history of sexuality: An introduction*, Vol. 1. New York: Vintage.

Fox, R. F. (1996). *Harvesting minds: How TV commercials control kids*. Westport, CT: Praeger.

Freedman, K. (1994). Interpreting gender and visual culture in art classrooms. *Studies in Art Education, 35*(3), 157–170.

Freedman, K., and Wood, J. (1999). Reconsidering critical response: Student judgments of purpose, interpretations, and relationships in visual culture. *Studies in Art Education, 40*(2), 128–142.

Freedman, K. (2000). Social perspectives on art education in the U.S.: Teaching visual culture in a democracy. *Studies in Art Education, 41*(4), 314–329.

Freedman, K. (in press). *Teaching visual culture*. New York: Teachers College Press.

Gagnon, J., and Simon, W. (1987). The sexual scripting of oral-genital contacts. *Archives of Sexual Behavior, 16,* 1–25.

Geen, R. G., and Stenner, D. (1973). Context effects in observed violence. *Journal of Personality and Social Psychology, 25,* 145–150.

Greenfield, P. M. (1984). *Mind and media: The effects of television, video games, and computers.* Cambridge, MA: Harvard University Press.

Hamblen, K. (1990). Local knowledge of art as a school art alternative. *Australian Art Education, 14(3),* 22–28.

Hamburg, D. (1992). *Today's children: Creating a future for a generation in crisis.* New York: Times Books.

Hawkins, R., and Pingree, S. (1982). Television's influence on social reality. In D. Pearl, L. Bouthilet, and J. Lazar (Eds.), *Television and behavior: Ten years of scientific progress and implications for the eighties,* Technical Reviews (pp. 224–247). Rockville, MD: National Institute of Mental Health.

Knupfer, N., and Hayes, P. (1994). The effects of the Channel One broadcast on students' knowledge of current events. In A. DeVaney, (Ed.), *Watching Channel One: The convergence of students, technology, and private business* (pp. 42–61). Albany, NY: State University Press.

Kremar, M., and Cooke, M. (2001). Children's moral reasoning and their perceptions of television violence. *Journal of Communication, 51*(2), 300–316.

Kubey, R., and Csikszentmihalyi, C. (2002, February). Television addiction is no mere metaphor. *Scientific American,* 74–80.

La Ferle, C., Li, H., and Edwards, S. (2001). An overview of teenagers and television advertising in the United States. *Gazette, 63*(1), 7–24.

Lichter, S. R., and Lichter, L. (1988, Spring). Does television shape ethnic images? *Media Values,* (43), 5–8.

McIlwraith, R. D. (1998). "I'm addicted to television": The personality, imagination, and TV watching patterns of self-identified TV addicts. *Journal of Broadcasting and Electronic Media, 42(3),* 371–386.

Martin, M., Gentry, J., and Hill, R., (1999). The beauty myth and the persuasiveness of advertising: A look at adolescent girls and boys. In M. Macklin and L. Carlson (Eds.), *Advertising to children: Concepts and controversies* (pp. 165–187). Thousand Oaks, CA: Sage Publications.

Mediascope (1999). Popular culture and the American child. URL http://www.mediascope.org.

Morley, D. (1992). *Television, audiences, and cultural studies.* London: Routledge.

National Institute of Mental Health (1982). *Television and behavior: Ten years of scientific progress and implications for the eighties,* Vol. 1. Washington D.C.: U.S. Government Printing Office.

Omelia, J. (1998). Understanding Generation Y: A look at the next wave of U.S. consumers. *Drug and Cosmetic Industry, 163*(6), 90.

Reeves, B. (1978). Perceived reality as a predictor of children's social behavior. *Journalism Quarterly,* (55), 682–689, 695.

Solomon, J. (1993, August 16). Mr. Vision, meet Mr. Reality. *Newsweek,* 62–64.

Strasburger, V. (1995). *Adolescents and the media: Medical and psychological impact.* Thousand Oaks, CA: Sage Publications.

Stuhr, P. (1994). Multicultural art education and social reconstruction. *Studies in Art Education, 35*(3), 171–178.

Tulloch, J. (2000). *Watching television audiences: Cultural theories and methods.* London: Arnold.

Ward, L. M. (1995). Talking about sex: Common themes about sexuality in the prime-time television programs children and adolescents view most. *Journal of Youth and Adolescence, 24*(5), 595–616.

Wilson, B. J., Kunkel, D., Linz, D., Potter, J., Donnerstein, E., Smith, S., et al. (1997). Television violence and its context. In Mediascope (Ed.), *National Television Violence Study* (Vol. 1, pp. 7–10). Newbury Park, CA: Sage.

Including Lesbians and Gays in Art Curricula: The Art of Jeanne Mammen

Laurel Lampela
University of New Mexico

Teachers can focus on art instruction that recognizes lesbian and gay relationships. The work of Jeanne Mammen provides art teachers with suitable imagery that sensitively depicts candid relationships between two women. Providing our students with an inclusive and balanced curriculum will ensure that all students see something of themselves in the art lessons and may help them to understand the meaning of living in a democracy.

Many of today's news headlines focus on lesbian and gay issues. It seems one cannot open a newspaper or turn on the television without hearing something about the movie *Brokeback Mountain*, same-sex marriages in Massachusetts and Canada, or the President Bush's push for a constitutional amendment banning same-sex marriage. As Lipkin notes (1999), homosexuality has gone public and teachers can no longer silence the discussion. We owe it to our students to address lesbian and gay issues in school in professional and educated ways thereby providing them with a complete education.

For the past 10 years several art educators (Check, 2004; Cosier & Sanders, 2004; Lampela, 1996; Smith-Shank, 2004) have been calling for such discussions in the schools. Check (2004) insists that the National Art Education Association (NAEA) take a pro-queer stance and implores readers not to choose between color wheels and social issues. Cosier and Sanders (2004) in the *NAEA News*, a publication that all members of the NAEA receive, call for further discussions about what art educators can do to teach about lesbian and gay issues in the schools. Two art

54

From *Visual Arts Research*, Vol. 33, No. 1 (2007), pp. 34–43

educators (Check & Lampela, 1999) provided NAEA members with resources to address lesbian and gay issues in the classroom and another art educator encouraged art teachers to include the study of lesbian and gay artists as part of an inclusive curriculum (Lampela, 1996).

Some art teachers, who are members of the NAEA, have indicated they want more information about the lives and work of lesbian and gay artists and are willing to address issues of sexual identity in the classroom (Check & Lampela, 1999; Lampela, 2001; Pierce, 2001). In this article I provide to interested teachers who want to learn more about lesbian and gay art with information about the life and work of Jeanne Mammen, a 20th century German artist who created striking and sympathetic images of lesbians. I present lesbian art as an example of the ongoing process of curricular revision, and as one of seven objectives of the Lesbian, Gay, Bisexual and Transgendered Issues Caucus (LGBTIC), an affiliate of the NAEA.

Lipkin (1999) provides a sound argument for an inclusive curriculum that addresses the lives and accomplishments of lesbians and gays. He notes that to prepare students for democracy they must learn about lesbians and gays as part of the American patchwork, and further contends that educators are obligated to impart accurate and complete information in their classes (Lipkin, 1999). In the art room, accomplishments of all groups of artists including lesbian and gay artists should be addressed.

For 30 years art educators have advocated for teaching art from a multicultural perspective. Beginning in the late 1970s attention was drawn to creating art curricula that were sensitive to the various ways people were identified or self-identified. These identifiers included race, gender, religion, age, ethnicity, and physical/mental abilities. McFee and Degge (1977) promoted the understanding of cultural diversity and how culture and art are related. Collins and Sandell (1984) encouraged art educators to embrace an art curriculum that included the accomplishments of women artists. Blandy and Congdon (1987) focused on cultural pluralism and the need for a diversity of art forms. Wasson, Stuhr, and Petrovich-Mwaniki (1990) advocated for art curricula that recognized and respected the sociocultural diversity of every student in the classroom. Yet it wasn't until Cahan and Kocur (1996) published *Contemporary art and multicultural education*, that attention was given to including sexual identities in discussions of a culturally inclusive curriculum.

It is understandable, then, that in the new millennium the translation from theory to practice has included little or no mention of sexual identities as part of culturally competent art curricula, as evidenced in articles written by practicing art teachers and devoted to diversity and tolerance. Beginning in 2000, *School Arts* began to include articles that focused on diversity or tolerance, but no article mentioned sexual orientation as a cultural identifier.

Why Include Lesbians and Gays in the Art Curriculum?

There are other reasons for advocating teaching about lesbian and gay artists in the art classroom. To exclude study of lesbians and gays is to knowingly provide an incomplete, inaccurate, and unbalanced curriculum. Students are well aware of lesbian and gay characters on network and cable television shows, in movies, in books, and in newspaper articles. Just by turning on the television, students can find gay or lesbian characters on *Will and Grace*, *The Ellen Show*, *Buffy the Vampire Slayer*, *Queer Eye for the Straight Guy*, *The L Word*, and *Queer as Folk*. Wyatt (2001) compiled a list of both network and cable television programs in the United States, Canada, the United Kingdom, and Australia since 1961 that have included lesbian, gay, and bisexual characters as a part of the regular or semi regular casts. Of those, at least 65 were run on U.S. television stations, including such contemporary shows as *Big Brother*, *Boston Public*, *Friends*, *My So-Called Life*, *The Real World*, *Seinfeld*, and *Xena: Warrior Princess*.

Lipkin (1999) states that young people are turned off by a curriculum that does not reflect the real world. Students want opportunities to think critically about their own experiences and those around them. By providing students with information and lessons that address the work and lives of lesbian and gay artists, teachers can impart accurate and complete knowledge in their classes, provide a more balanced curriculum, and reflect the real world in their teaching.

Knowing about lesbian and gay artists and art is also very important for lesbian and gay adolescents, as well as for others. These adolescents need role models. Lesbian and gay adolescents need to know that there were/are others like them who were/are lesbian or gay and artists and had/have great success. An LGBT-informed curriculum is about uncovering the past and about learning that there have been some artists who lived openly, as who they were. If lesbian and gay adolescents receive information about other accepted and productive lesbian and gay artists who could serve as positive role models, they may feel relieved they are not alone and can accept who they are. Learning about historical lesbian and gay artists in the classroom also can help students recognize that same-sex love has existed for centuries.

Depictions of Couples in Art

In a school environment, students can see depictions of heterosexual identity scattered throughout the curriculum and at extracurricular events. Students may read *Romeo and Juliet*, *The Great Gatsby*, or *The Scarlet Letter* in English class (Applebee, 1990) and learn about heterosexual relationships. During the rituals of homecoming and prom, male kings and female queens are crowned and primarily heterosexual couples attend the dances associated with these rituals. Schooling is set up with a

heteronormative bias, but there is a need for a balanced curriculum that depicts more than the heteronormative examples.

For lesbian and gay students who are also beginning to develop their sexual identities, the process of identity formation is a struggle because they generally do not see obvious examples of their own identities. In order for lesbian and gay students to develop a positive sense of self in relationship to their sexual identities, they too need to see expressions of others like themselves in social situations. By including such examples of life experiences, every student will see and hopefully learn that all people have strong emotions and complex relationships. The school curriculum and more specifically the art curriculum can provide a more balanced and complete picture of the kinds of connections a variety of people have with each other.

Art often shows depictions of human relationships. Depictions of couples in paintings or sculpture have been avenues for adolescents to see such expressions of others in social situations, albeit most often with a heteronormative bias. Many art teachers are familiar with portraits of heterosexual couples in art including Picasso's *La Vie*, Grant Wood's *American Gothic*, and Rodin's *The Kiss* and may use these portraits in their classroom instruction. But teachers may not be as familiar with portraits of lesbian and gay couples understandably so. This is because most mainstream art history texts do not include such portraits or provide information about them as portraits of couples. Teachers can obtain information about portraits of lesbian and gay couples by such artists as Gluck, David Hockney, Paul Cadmus, and Jeanne Mammen if they are willing to search for them in books that specifically address art by lesbians and gay men. Many teachers may not have the time to do such research which is why the LGBTIC has as one of its goals the promotion of quality instruction relating to the understanding of lesbian and gay content in artists' works (LGBTIC, 2003). Producing such resources that would be available to teachers for use in their classroom instruction will take time since many mainstream publishers of art education materials are not amenable to such ideas.[1] Yet, if students are shown only portraits of heterosexual couples they may begin to assume that there are no portraits of lesbian and gay couples. This would comprise an incomplete and inaccurate education in art.

In an LGBT-balanced curriculum, students would be introduced to positive portrayals of lesbians and gays to counteract biased curricula and to combat many negative and homophobic comments that students hear throughout the school day. Sadly, this is generally not the case. Often schools promote only a heterosexist curriculum, one that "confers privilege and dominance on heterosexuals and those who match society's expectations with regard to gender" (GLSEN, 2002). Providing students with positive information about lesbians and gays is not only necessary but also crucial. The Gay, Lesbian, Straight Educators Network (GLSEN, 2002) notes:

> For LGBT youth—many of whom lack support systems at home, in their
> places of worship, and in the community at large—school may be the only

hope for a safe haven. When that refuge is marred by prejudicial practice, our educational system cannot fulfill its promise of protection . . . (para. 12)

This is exactly the reason why schools should face the issue of heterosexism head on and level the imbalance; first by naming it and then offering alternatives (GLSEN, 2002).

How can schools, and more specifically art programs in schools, dismantle institutionalized heterosexism? One way is to focus not only on the art that honors heterosexual relationships (Picasso, Wood, and Rodin) but one that also focuses on art instruction that recognizes lesbian and gay relationships. The work of Jeanne Mammen provides art teachers with suitable imagery that sensitively depicts candid relationships between two women.

Recognizing Lesbian Relationships in Art Instruction: The Art of Jeanne Mammen

It has been noted (Förderverein der Jeanne-Mammen-Stiftung e.V., 2003) that Mammen is one of the most versatile and unusual artists of her time. She often is mentioned in connection with Käthe Kollwitz and Hannah Höch whose most successful years also date to the Weimar era (1919–1933). Mammen is also compared to two other German artists of the same period, George Grosz and Otto Dix, but in a different light. Mammen's works are not marked by denouncement or pity of those she depicted, as Grosz and Dix were inclined to do (Lütgens, 1994; Tripier, 1998). Rather, Mammen conveyed sympathy for the women she portrayed (Tripier, 1998). I will argue here that she went as far as empathizing with the lesbians she depicted in her *Songs of Bilitis* series of lithographs.

Mammen's watercolors and drawings from 1927 to 1933 focus on gender roles and on the theme of lesbian love. Mammen unabashedly depicted lesbians of her time in intimate relationships and "disrupted conventional readings of women . . . by including images of lesbians . . . different from the norm" (Tripier, 1998, p. 41). Yet, Mammen's work has been virtually ignored or possibly censored in books that address women artists.[2] Mammen is mentioned in Emmanuel Cooper's (1994/1986) *The sexual perspective.*[3]

Mammen portrayed loving relationships quite boldly in her painting of portraits of lesbian couples. Many, if not all of Mammen's works could be used in a secondary classroom since she created portraits of lesbians together that can be suitable for use at the high school level. I say "suitable" since her work differs greatly from the work of Della Grace and Nicole Eisenman, who have created artworks that could be considered too provocative for adolescents. Both Grace and Eisenman depict blatant sexual imagery of lesbians that would not be appropriate for art instruction at the high school level. Similarly, some of the work of artists such as Jeff Koons and Eric

Fischl, who depict blatant sexual imagery of heterosexuals, would not be proper for this level, as well.[4]

An Overview of Mammen's Life and Work

Jeanne Mammen was born Gertrud Johanna Mammen on November 21, 1890, in Berlin to a well-to-do family, who moved to a suburb of Paris when she was 5 years old. At an early age, Mammen started to draw and paint people and scenes. She later attended art schools in Paris, Brussels, and Rome. In the 1920s, Mammen was well known as an artist in Germany. She received commissions from fashion magazines, a German movie company, and journals. She compassionately portrayed her female subjects as involved in intense relationships with other women and who also chose to live without men (Sykora, 1989).

Mammen created several portraits of lesbian couples, but her portrayals vary in approach. For example, some couples are less obvious and more covert than others. In two of Mammen's paintings we see restrained and possibly coded portraits of lesbian couples. In *Zeebrugge* two women lean together against a seaside railing; one appears more masculine and somewhat forceful with short hair, wearing pants and a turtleneck sweater. The other appears more feminine with shoulder-length hair wearing a skirt under her coat. In *She Represents*, or as some refer to it, *Masked Ball*, we

Figure 1. *She Represents* (a.k.a. *Masked Ball*), (ca. 1928), watercolor & pencil, 42 × 30.4 cm. Courtesy of Förderverein der Jeanne-Mammen-Stiftung e.V., © 2018 Artists Rights Society (ARS), New York/ VG Bild-Kunst, Bonn.

first are confronted with what appears to be a heterosexual couple, but soon realize both figures are female. Mammen depicts one figure as more masculine, dressed in pants with a white vest and shirt cuffs, top hat, and scarf in a strong macho stance (Sykora, 1989), with an "air of defiance underlined by her posture" (Tripier, 1998, p. 31). Behind her stands a female figure in a dress who kicks up her legs with her hand on the other's shoulder. Is one figure in disguise or are both in drag in each work?

In *Love Affairs*, Mammen departs from the butch/femme portrayal of two women and depicts two very similar women in a touching situation. Both are seated closely together as one woman tilts her head toward the other who sits with her legs crossed. They are dressed rather conservatively in tailored skirts or dresses. One woman sits with her arms crossed and the other bites on the stem of a flower in a contemplative pose. The title would lead one to assume that the two are romantically involved.

In 1920s Berlin, contemporary women sometimes found refuge in their girlfriends. This came about for two main reasons. Many German women were left alone without the companionship of their husbands or boyfriends since millions of men were called to serve in the German military during World War I (Biackbourn, 1998). This loss left huge gaps in the labor force and women were allowed into the workplace in record numbers. Widdig (2001) notes that by 1917 over 700,000 women worked in the engineering, steel, chemical, and mining industries. Women were able to leave home, support themselves, and make new friendships. They found the freedom to visit bars, nightclubs, and cafes. The need for love, tenderness, and understanding were no longer provided only by men, but from the support of a girlfriend.

More overt portraits of lesbian couples can be seen in several watercolor paintings by Mammen. *Café Nollendorf* depicts an interior of one of the women's clubs popular in 1920s Berlin. In the foreground, there are three women without any visible connection to each other. Two appear to be servers and the third sits alone at a table. But our eye moves to the two women in the back who are embraced in a dance and we witness their intimate relationship. One woman rests her hand on the other's shoulder who in turn rests her hand on the woman's hip.

A similar intimate relationship can be seen in another of Mammen's watercolors. In *Two Women Dancing* the women, both with short haircuts, are entwined in a dance. One woman has placed her hand on the shoulder of the other who places her hand around the other's waist. They clasp their hands together and dance with each other in what appears to be a mixed bar. In the background one can see a man dancing with a woman.

Mammen's depictions of lesbian couples are most aptly and overtly documented in a series of lithographs that beautifully portray homage to the many lesbians with whom she obviously interacted. I would go so far as to say that these images make a strong case for Mammen's lesbianism. Unfortunately nothing is known about her own sexual identity. She never married and there is no information about intimate

Figure 2. *Two Women Dancing* (ca. 1928), watercolor & pencil, 48 x 36 cm. Courtesy of Förderverein der Jeanne-Mammen-Stiftung e.V., © 2018 Artists Rights Society (ARS), New York/ VG Bild-Kunst, Bonn.

relationships other than with the artist Hans Uhlmann, whom she had met in the late 1920s. Yet, by their very nature, these intimate portraits of lesbian couples seem to clearly delineate Mammen as a sexual being and a lesbian. Although some may disagree that Mammen was a lesbian, she clearly was empathetic towards the lesbians of her time.

In The Morning is a color lithograph that depicts the intimacy of two women sitting together on the edge of a bed. One woman with long hair and dressed only in a light negligee top puts her arm around her partner's shoulder. Mammen depicts a softness and warmth emanating from the two figures, which exemplifies her skill as a drafter. She shows more than support in this work and expresses identity with the subjects. This identification with her subjects that moves beyond sympathy strongly identifies Mammen as empathetic towards lesbians.

In 1930 Mammen was commissioned to create two-tone lithographs which were to be published in a German edition of *The Songs of Bilitis* by Pierre Louys (Lütgens, 1994). When the Nazis seized power, however, publication of the book was impossible. Of the eight lithographs that were destroyed by damage from bombs seven proofs survived. *The Songs of Bilitis* is considered a classic of erotic literature. It was originally published in Paris in 1894 by Pierre Louys, and in 1926 an illustrated English edition was published in New York.

Figure 3. *In the Morning* (ca. 1930–1932), lithograph, 45 × 33.5 cm. Courtesy of Förderverein der Jeanne-Mammen-Stiftung e.V., © 2018 Artists Rights Society (ARS), New York/VG Bild-Kunst, Bonn.

Another two-tone lithograph in the Bilitis series is Jealousy, in which Mammen clearly shows the intense emotion coming from the woman who kneels behind another woman standing at her dressing table. The kneeling woman grasps the other around her waist and looks pleadingly up at her while the other woman looks off in the distance seemingly unaffected by the woman's insistence. Nearly everyone, female/male, lesbian/gay/straight, adolescent/adult, can identify with the intense emotion in this work. What more appropriate work of art to use when discussing emotion with students and how best to depict that through art than Mammen's *Jealousy*?

In another color lithograph from the *Bilitis* series, Mammen again depicts with skill and empathy the intense bond between two women. In *Siesta* we see two women, sitting together in an embrace. They are clearly a couple as one cradles the other in her arm. The closeness and intimacy between the women is evident. Sykora (1989) observed that both wear delicate undergarments, which she believes heightens the attractiveness of the two. Both are content as they sit together.

Mammen continued to make art after the Nazis came into power in 1933 Germany, and since she pursued her art work in the seclusion of her apartment studio she was not harassed by the Nazis. She survived the war by becoming an itinerant bookseller, selling old books from a cart that she wheeled around Berlin, and doing all sorts of odd jobs. Her art work went through dramatic changes. She experimented with Cubism and later turned to creating oil paintings consisting of layers of color

Figure 4. *Jealousy* (ca. 1930–1932), lithograph, 45 × 36 cm. Courtesy of Förderverein der Jeanne-Mammen-Stiftung e.V., © 2018 Artists Rights Society (ARS), New York/ VG Bild-Kunst, Bonn.

with surface marks. Mammen died in 1976 at the age of 85. The apartment studio in which she lived for 57 years remains today almost the way she left it and is now operated by the Förderverein der Jeanne-Mammen-Stiftung e.V.

Mammen was able to empathize with the women and lesbians because she too was a woman and a woman-identified woman,[5] which gave her an advantage over male artists of her time in her ability to represent her own gender. She portrayed women in a gentle and understanding way. Lutgens (1994) notes that the 1920s were the happiest times in Mammen's life, possibly due to the fact that the art and culture of the time were infused with dreams about a new world in which German women could freely move about town and earn a living to support themselves.

Classroom Applications

Art teachers choosing to use the work of Mammen in their curricula could have students compare and contrast the many portraits of heterosexual couples that are readily accessible with some of the portraits of lesbians by Mammen. Students could begin by observing Picasso's *La Vie*, Rodin's *The Kiss*, and Gustav Klimt's *The Kiss*. The teacher could ask students to describe what they see and what emotions are being depicted. Students could then be shown some of Mammen's works including *In The Morning*, *Two Women Dancing*, and *She Represents* and asked similar questions.

Figure 5. *Siesta* (ca. 1930–1932), lithograph, 50 x 39 cm. Courtesy of Förderverein der Jeanne-Mammen-Stiftung e.V., © 2018 Artists Rights Society (ARS), New York/ VG Bild-Kunst, Bonn.

Students could be asked to discuss similarities and differences among works by Mammen and other artists. Ensuing discussions could involve commonalities that all people share in relationship to love and intimacy and how artists portray such qualities in their work. Students could begin to see that all people share the need for love and intimacy. Students could then be given an opportunity to create works that speak about their relationships and how they might portray intimacy.

Accessing works by Mammen can prove challenging to art teachers. There are at least 15 images by Mammen that can be accessed on the Internet through the Förderverein der Jeanne-MammenStiftung e.V. (Foundation of the Friends of Jeanne Mammen, Inc.). Several books that focus on the work of Mammen including *Freundinnen* with five of the images from the *Songs of Bilitis* can be purchased directly from the Förderverein.

Engaging Students in Controversial Content in the Classroom

However willing teachers may be to discuss the work of Jeanne Mammen and other lesbian or gay artists, they may encounter obstacles. Opposition to any discussion of lesbians and gays in schools is widespread throughout the United States. One of the main obstacles can be the administrators at the school who may object to discussions

surrounding sexual identity. Similar objections may come from the school board, parents, and the community. As one art teacher noted, "Teaching about homosexuality as it pertains to the arts is prohibited" (Strickland, 2003, p. 95). Teachers who want to include the lives and works of lesbian and gay artists as part of a culturally competent curriculum are well advised to first check with the administration. If the administration is supportive, they will back the art teacher should the parents or community object. Should the administration prohibit any references to lesbian and gay artists, teachers must weigh keeping their jobs with standing by their principles. Teachers can choose to defend their position on scholarly and pedagogical grounds and face possible dismissal or abide by the demands of the administration and instead work outside of the classroom to enlighten administrators and elect a more progressive school board.

Conclusion

Providing our students with an inclusive and balanced curriculum will ensure that all students see something of themselves in the art lessons. Art teachers can provide students with an inclusive curriculum that not only addresses the lives and accomplishments of heterosexuals, but also addresses the lives and accomplishments of lesbians and gays. This will ensure that our students understand that lesbians and gays are part of the American array and will help them to understand the meaning of living in a democracy.

By including the work of Mammen and other artists who address lesbian and gay issues, along with the work of artists who address heterosexual themes, teachers can provide high school students with an art curriculum that is relevant to their lives and provide them with art images that depict a range of human relationships. Mammen did not have a hard edge of cynicism. Instead, she conveyed a sense of understanding and connection and portrayed women as individuals. Rather than depicting lesbians as strange, separate beings she helped the public see that lesbians could be loving, compassionate people and socially acceptable. Her work not only can enhance an art curriculum, but also can provide students with a balanced, inclusive, and accurate art education. Her work can and should be included and discussed as part of an art curriculum that strives for such balance.

Endnotes

1. At an NAEA conference I attended in 2001 I approached one of the more well-known publishers of art education materials about the possibility of producing visual images of works by lesbian and gay artists for use in the art classroom. My idea was not only quickly dismissed but I was laughed at. In 2006 I approached the same publisher of art education resources at the NAEA conference and was again dismissed. I was told there was no market for LGB resources.

2. At least two of the major texts that address art by women from the Renaissance through the late 20th century exclude mention of Mammen; these are *Women artists: 1590–1980* (Heller, 1987) and *Making their mark: Women artists move into the mainstream* (Rosen & Brawer, 1989).

3. This is where I first learned of Mammen. I was later to discover other writings and a website devoted to Mammen at http://www.jeanne-mammen.de/ html/english/overview.html. I realized that Mammen was still living while I was in high school during the late 1960s and undergraduate school during the early 1970s. I was never given information about her and her work in art classes and this realization became a source of frustration. High school and, for some, undergraduate school, are times when adolescents begin to recognize their sexual identities. Had an art teacher or art professor provided information about Mammen and the fact that she so empathetically depicted the loving relationships of lesbians, I, and possibly other lesbians who were undoubtedly in similar art classes, would have had an easier time accepting our sexual identities.

4. Works that address blatant sexual imagery of heterosexuals, including *Wolfman* by Jeff Koons and *Bad Boy* by Eric Fischl, could be considered to be too controversial for adolescents.

5. I use the 20th-century term *woman-identified woman* to describe Mammen since she seemed to defy traditional definitions of a woman's identity in relationship to men. In the 1970s I and some other radical feminists used the term as a code to define who we were without coming out as lesbians.

References

Applebee, A. N. (1990). *Book-length works taught in high school English courses*. Bloomington, IN: ERIC Clearinghouse on Reading and Communication Skills. (ERIC Document Reproduction Service No. ED318035).

Blackbourn, D. (1998). *The long nineteenth century: A history of Germany, 1780–1918*. New York: Oxford University Press.

Blandy, D., & Congdon, K. G. (Eds.). (1987). *Art in a democracy*. New York: Teachers College Press.

Cahan, S., & Kocur, Z. (1996). *Contemporary art and multicultural education*. New York: Routledge.

Check, E. (2004). Queers and art education in the war zone. *Studies in Art Education, 45*(2), 178–182.

Check, E., & Lampela, L. (1999). Teaching more of the story: Sexual and cultural diversity in art and the classroom. *NAEA Advisory* (Summer). Reston, VA: National Art Education Association.

Collins, G., & Sandell, R. (1984). *Women, art, and education*. Reston, VA: National Art Education Association.

Cooper, E. (1994). *The sexual perspective: Homosexuality and art in the last 100 years in the west* (2nd ed.). New York: Routledge. (Original work published 1986)

Cosier, K., & Sanders, J. (2004). Lesbian, gay, bisexual issues caucus (LGBTIC) column. *NAEA News, 46*(4), 17.

Förderverein der Jeanne-Mammen-Stiftung e.V. (2003). Jeanne Mammen's different style periods: "Metropolis Berlin," Watercolours, ca. 1924–1934. Retrieved May 15, 2003, from http://www.jeanne-mammen.de/english/ contents_style_periods.html.

GLSEN [Gay, Lesbian, Straight Educators Network] (2002). From denial to denigration: Understanding institutionalized heterosexism in our schools, Apr. 30. Retrieved August 16, 2004, from http://glsen.org/cgibin/ iowa/educator/library/record/1101.html.

Heller, N. G. (1987). *Women artists: An illustrated history.* New York: Abbeville.

Lampela, L. (1996). Gay and lesbian artists: Toward curricular inclusiveness. *Taboo: A Journal of Culture and Education,* Fall, 2(2).

Lampela, L. (2001). Lesbian and gay artists in the curriculum: A survey of art teachers' knowledge and attitudes, *Studies in Art Education, 42*(2), 146–160.

LGBTIC [Lesbian, Gay, Bisexual Issues Caucus] (2003). *Amended and restated bylaws of the Lesbian, Gay. Bisexual, Transgendered Issues Caucus (LGBTIC), National Art Education Association.* (Available from Dr. James Sanders, III, The Ohio State University, Department of Art Education, 340 Hopkins Hall, Columbus, OH, 43210.)

Lipkin, A. (1999). *Understanding homosexuality. changing schools: A text for teachers, counselors, and administrators.* Boulder, CO: Westview.

Lütgens, A. (1994). Jeanne Mammen. In L. R. Noun (Ed.), *Three Berlin artists of the Weimar era: Hannah Hoch, Kathe Kollwitz, Jeanne Mammen.* Des Moines, IA: Des Moines Art Center.

McFee, J. K., & Degge, R. M. (1977). *Art, culture, and environment: A catalyst for teaching.* Dubuque, IA: Kendall/Hunt.

Pierce, J. R. (2001). Letter to the editor. *Art Education, 54*(5), 5.

Rosen, R., & Brawer, C. C. (1989). *Making their mark: Women artists move into the mainstream.* New York: Abbeville.

Smith-Shank, D. (2004). Lesbian, gay, bisexual, transgendered issues (LGBTIC) column. *NAEA News, 46*(3), 14.

Strickland, C. (2003). In a perfect world. In L. Lampela & E. Check (Eds.), From our voices: *Art educators and artists speak out about lesbian, gay. bisexual, and transgendered issues.* Dubuque, IA: Kendall/Hunt.

Sykora, K. (1989). Jeanne Mammen. *Woman's Art Journal, 9*(2), 28–31.

Tripier, S. K. (1998). *Jeanne Mammen: 1920s Watercolor and Pencil Drawings.* Unpublished master's thesis, San Francisco State University, California.

Wasson, R. F., Stuhr, P. L., & Petrovich-Mwaniki, L. (1990). Teaching art in the multicultural classroom: Six position statements. *Studies in Art Education, 31*(4), 234–246.

Widdig, B. (2001). *Culture and inflation in Weimar Germany.* Berkeley: University of California Press.

Wyatt, D. A. (2001). Gay/lesbian/bisexual television characters. Retrieved July 19, 2005, from http:1/home/cc/umanitoba.ca/o/o7Ewyattl tv-characters.html.

Interrogating Girl Power: Girlhood, Popular Media, and Postfeminism

Michelle S. Bae-Dimitriadis
SUNY–Buffalo State College

This article investigates the discourse around a postfeminist investment of girl power, which earlier feminists have scrutinized and criticized for its seemingly celebratory attitudes toward patriarchal norms, including the uncritical pursuit of feminine beauty and commercially produced representations of sexuality and power. Using these criticisms as points of reference, this article offers a rationale for reinterpreting girl power, one in which the alternative forms and meanings of subversion to patriarchal norms are marked by contradiction. This approach underscores that the dominant discourse on girl power is still located in an essentialist frame of Western White hegemony. Instead, placed against a postfeminist theoretical landscape, a Korean immigrant girl's written and visual narrative becomes both a manifesto of and an intervention in postfeminist girl power by appropriation, reinterpretation, and revision.

Since the 1990s, the discourse on girl power, a popular media initiative of new femininity, has been shaking the conventional ground of feminist thinking and proclaiming a new mode of girlhood. Launched by the popular British punk group Spice Girls, the popular cultural version of girl power has redirected the representation of girlhood from a strong, proactive, smart heroine to a worshiper of feminine beauty and heterosexuality. Revising earlier feminists' overtly politicized approaches to patriarchy, the girl power located in postfeminism[1] has sought out the relevance for contemporary young women. Not surprisingly, this sexualized, individualistic, external beauty-oriented consumerist attitude has provoked an outcry from earlier feminists for having an uncritical stance that seemingly celebrates patriarchal norms (McRobbie, 2007; Taft, 2004).

68

From *Visual Arts Research*, Vol. 37, No. 2 (Winter 2011), pp. 28–40.

To examine this contention, this article first explores the critical issues surrounding the discourse on postfeminist girl power, beginning with a sketch of the major disagreements between young feminists and the earlier generation of feminists, which stem from their different theoretical assumptions and agendas. Rejecting an essentialist framework, which produces a dominant construction of girlhood as a hegemonic tool within feminism, I first locate one immigrant Korean girl's media and texts in postfeminist girl power discourse as a disruption of the essentialist understanding of postfeminist girl power. Then, to illustrate a contemporary representation of girlhood marked by contradiction—one that reflects girl power, yet renders many other possibilities for "being a girl"—I examine the girl's visual narratives as interventions in the girl power discourse that portray her simultaneous negotiation with and challenge to this discourse.

Demystifying Girl Power: Is It Aesthetic or Political?

One much scrutinized issue of the postfeminist conceptualization of girl power is the aesthetically oriented consumerism that structures it, a consumerism created through mainstream commodification for economic purposes. For example, Godfrey (1993) insisted that girl power's antifeminist message draws young women's attention to fashion and appearance, an emphasis on style and aesthetics that then becomes a marketing strategy for the culture industry, which uses media to disseminate girl power to every aspect of the cultural arena. Some scholars have therefore questioned the authenticity of such mass-produced, merchandized girl power (Douglas, 1994; Taft, 2004).

This postfeminist view of girl power centered on style is seemingly shared by commodity feminism, which redefines feminism as "a style—a semiotic abstraction—a set of visual sign values that say who you are" (Goldman, Heath, & Smith, 1991, p. 337). More specifically, postfeminism aligned with commodity feminism is seen as a weakening of conventional feminist social goals through an aesthetic depoliticization that, by focusing on individual style, fetishizes feminism. Additionally, despite postfeminism's noncontradictory unification of feminism and femininity, postfeminism is thought to inherently involve an ideological contradiction: Women use autonomous control over their bodies and appearance to build a construct that will eventually be objectified by the male gaze. Thus, according to Goldman et al. (1991), this feminist search for value and the meaning of women's emancipation through sexuality and bodily appearance constitutes pseudoliberation.

In spite of such concerns, the postfeminist interpretation of girl power has given a new meaning to external beauty and sexual attractiveness that conveys "an oppressive imperative of patriarchy" and, contradictorily, "a source of power over it" (Roberts, 2007, p. 237). Hence, girls' empowerment through external beauty has

played havoc with the conventional power hierarchy between male and female, in whose long tradition girls have been taught the importance of external appearance in the pursuit of beauty as the essence of femininity. That is, beautifying oneself has been predominantly based on patriarchal standards, and demands have been made that the female body be decorated for the pleasure of the male gaze. This description positions the female body as an object of the male gaze. The objectifying gaze thus disempowers the female in a binary relationship in which the female is a powerless, passive object and the male, an empowering subject.

As reproduced in girl power, however, this dynamic has a liberating aspect. That is, in girl power, a well-groomed, sexual, feminine body is a site of liberation by which girls attract boys' attention but use their freedom to choose what they desire. This view of feminine practice as liberation is marked by girls' self-centered attitudes and use of autonomous decision making about the female body and sexuality for the sake of their own pleasure. Hence, girl power sends the message that the paramount importance of sexualized appearance and style in girl power is to encourage contemporary girls to take care of the self as a major part of self-improvement. Such self-improvement is believed to provide girls with the power that comes from achieving social distinction and attracting male attention. Thus, the male's objectification of the female body is no longer related to the female's powerless, subordinated position; rather, the objectified-girl-as-empowering-subject rhetoric shatters the earlier hierarchical binary construction of gender. As a result, the ideal for the postfeminist body is a construction of gender that is liberated through beautifying practices.

On the trajectory of this new gender identity focused on beauty and style, Roberts (2007), in a study on refurbishing the postfeminist body through the TV show *What Not to Wear* (2009–), highlighted girls' beautifying practice as an embodiment of the imagined self that provides a sense of empowerment. Specifically, he observed that a young woman's body can be transformed into "a new self" being beautified through consumption by "chucking out ill-suited clothes" (p. 236) and replacing them with new ones. Such a "self-renewal" project reinforces discovery and embodies "a more authentic 'true self'" (p. 237) that is consumer oriented. Based on this observation, he proposed that postfeminism

> articulates a model of feminine identity unthinkable outside consumption and [constructs] a logic in which "empowerment"—perhaps the central tenet of postfeminist ideology—is shown as dependent on self-confidence and sexual attractiveness, which in turn depend on the services of the fashion and beauty industries—all of which, needless to say, must be purchased. (p. 229)

Such a circuitous system of postfeminist ideologies suggests a close tie among individual power, feminine identity, consumption, and girls' self-monitoring practices in

a neoliberal capitalist regime. Thus, empowerment through a beautifying project in postfeminist girl power presupposes an understanding that female empowerment is possible in negotiation with the dominant social/cultural field (Butler, 1990).

Within this framework, certain theoretical underpinnings of the polemic statement that girl power is nonpolitical yet aesthetically oriented consumption locate resistance, a quality of agency, in aesthetic and critical judgment. Indeed, William (1977) proposed that aesthetics, political and social power, and ideology converge in contemporary popular culture, so resistance cannot be separated from aesthetic experiences. This converged form of resistance also takes into account the idea of liberation; for example, the type of pleasurable resistance (*jouissance*) proposed by Barthes (1990) is expressed through bodily pleasure but functions to release subjects from social discipline and desire. Applying this viewpoint to female resistance, the female struggle to be liberated from the forces of patriarchal social disciplines occurs through the female's evasive bodily pleasure.

In a patriarchal system, however, female bodily pleasure is a social taboo, while male bodily pleasure is publicly sanctioned. Moreover, although earlier feminists fought against such an unequal binary gender system, they failed to resolve the debate in the area of female physicality and sexuality. That is, while working hard to recover female social positions and gender equality, they failed to deal with the female body and its sexuality and accepted the long-held view of female sexuality as an oppressive site of masculine power. Instead, their solution for overcoming this representation of the female body and sexuality as an object of the male power gaze was to transcend the boundaries of masculine norms by being or acting more like a man and disregarding female sexuality. This perspective is perpetuated by a hierarchical positioning of female sexuality as inherently suppressed and problematic.

Young feminists, in contrast, see the possibility in postfeminist girl power, one that, to a great extent, may be able to solve the aforementioned conflicts by bringing the suppressed female body and sexuality to the fore. More specifically, reemphasizing overtly normalized female sexuality may productively respond to subversion of the female body by dominant masculine norms. As a feminist quality, such an approach is reminiscent of Butler's (1990) theorization of a "culturally intelligible" agency based on the belief that female agency is constructed *through* rather than *against* culture (p. 23). Such a view conveys the effectiveness of female agency by encouraging girls and women to cross boundaries of patriarchal norms even while bound to and within heterosexual male social anticipation. In this way, the culturally negotiated approach of postfeminist girl power can dilute the inherent hierarchical gender positioning between male and female. Such a culturally discerning construction of girl agency, however, relies on the understanding that aesthetics and agency are nonoppositional, nor are they separate entities.

Challenging (Questioning) Girl Power: Missing Girls from Other Contexts

Whereas the postfeminist investment of girl power in the media has focused predominantly on issues pertinent to patriarchal hegemony, the issues of race and class have been relatively underrepresented, although a few feminist scholars have critically observed that the postfeminist girlhood popularized by girl power perpetuates a racial and class hierarchy (Chesney-Lind & Irwin, 2004; Griffin, 2004; Ono, 2000; Projansky & Vande Berg, 2000; Springer, 2007). Griffin (2004) argued critically that the discourse of girl power and its representation of modern girlhood have been associated exclusively with Western White girls, conveying the strong message that "sassiness," sexual empowerment, individuality, and a consumerist attitude belongs to them and them alone. As a result, girl power remains mired in the hegemonic discourse of "sisterhood" supported by earlier feminists, which homogenizes all other races, ethnicities, classes, or nations within the one feminist agenda against patriarchy. Such ideas about girl power perpetuate the hierarchical dominance of Western White girlhood norms over those of other marginalized girls and suggests that girl power's celebration of individuality does not recognize the cultural and racial differences in girls' actions and girlhood.

Aligned with Griffin, Ono (2000) pointed to the danger of the popular media's defining girl power as White because it marginalizes girls of other races by weakening or demonizing images of and ideas about them. He further argued that popular media construct the White heroine through villainous association with girls of other races. Thus, the girl power discourse tends to valorize White girls' socially accepted aggressiveness and link it to the rhetoric of liberation and empowerment through "heroification." In contrast, girls of other races—portrayed as insignificant characters that eventually disappear—are characterized by their inability to self-empower.

Chesney-Lind and Irwin (2004) argued that because the bad-girl image has severe consequences for lower class girls of color, girl violence in the media also sends racist messages. In contrast, the behavior of bad White girls, known as "[W] hite queen bees," is regarded as less serious or in less need of discipline. Such stereotypically false images of girls of other races create a racial hierarchy in girl power rendered by their exclusion. In the same vein, Projansky and Vande Berg's (2000) critique of *Sabrina*—a representation of girl power in a TV show for teenagers—draws attention to the centrality of whiteness in girl power. Specifically, these authors observed that, by bringing in various cultures, the show superficially appears to cross national and racial boundaries into multiculturalism but is actually devoid of deep cultural meanings and does nothing more than create stereotypical images of particular cultures for Sabrina's own pleasure and class privilege (p. 33).

They therefore criticized this "ersatz" multiculturalism as a means of centralizing whiteness and the middle class.

Such invisible, underrepresented, or twisted images of girls from other races and classes in the girl power discourse have recently been reexamined and reinterpreted by Banet-Weiser (2007), who, in a striking argument based on the current proliferation of racial ambivalence in girl power, proposed that this new girl power trend is an "ironic configuration of power" framed by postracial culture in alignment with postfeminism (p. 210). Most particularly, in her examination of *flava*, a new icon of racially hybrid girl power found in a new line of dolls by Mattel, she claimed that postracial/postfeminist media have created girl power with racially ambiguous yet gender-specific images.

This new form of girl power, which popular media uses as a marketing strategy, is attached to a cultural meaning of "cool, authentic, and urban" (Banet-Weiser, 2007, p. 204) and therefore sends a message that race is no longer salient. Such racial ambivalence in the representational landscape is believed to provide audiences various ways of culturally defining diversity devoid of any hint of segregation, a practice that consolidates an urbanism that is market oriented. Such repackaged race in girl power, ambiguous and diverse, can be viewed as a subversive act against traditional ideological frameworks that "makes disenfranchisement antiquated" (p. 215). In the framework of diversity and multiculturalism, racial ambivalence has taken precedence over the previous media strategy of racial specificity.

Accordingly, in any exploration of what it means to be a girl and a young feminist, the intervention of this ironic production of girl power in a racialized and gender-specific culture calls for reconsideration of girl power as a style, an aesthetic, a hip way of being that presents an alternative means of cultural expression, and a pedagogical site for and of girls' coming of age. Overall, the understanding of girl power in postfeminist (postracial) media culture reemphasizes that consumption and female identity are inseparable and that identity categories have become cultural capital framed within a neoliberal capitalist social system.

It is against this landscape of media discourse on postfeminist girl power that I next present a case study of one Korean immigrant teenage girl's visual media creation on her webpage and accompanying dialogue, which clearly portray her struggle to appropriate, respond to, and negotiate with the messages of the postfeminist girl power culture. My observations present a clear challenge to the media's essentialist construction of girlhood, which too often portrays girls as passive victims of media power. Such a monodirectional power mechanism obscures the dynamic and multifaceted forms of girlhood derived from a dialogic array of power relationship between girls and the media. My analysis therefore extends this dynamic beyond such monodirectionality toward a multifaceted postfeminist girl power.

A Korean Immigrant Teenage Girl's Manifesto:
A Response to Postfeminist Girl Power

Jooyoung (pseudonym), a Korean immigrant teenage girl, moved to the United States during her preteens in pursuit of a prestigious education, one that would ensure career success and a financially secure, high-quality metropolitan lifestyle. Her immigration was thus a case of the educational exodus[2] that has characterized South Korea's movement toward globalization since the late 1990s. In this context, young women's achievement of higher education in the West and subsequent career success has been socially idealized as the epitome of a cool modern South Korean girl. Nevertheless, this notion of the "girl par excellence" still retains the implicit assumption of eventual participation in a successful heterosexual relationship. Such an ideal for the modern girl requires individualization, independence, cultural knowledge, and aesthetic sophistication as a consumer. As Jooyoung discovered, however, becoming this modern girl also involves the reality of being categorized as an Asian girl in the United States. Hence, although the South Korean social climate brought her to the United States, her dreams of becoming a South Korean girl par excellence have departed.

Like many girls of her generation, popular culture is an arena in which her daily lived experiences take place. Having grown up with the girl power movement, she not surprisingly favors the messages of girls that have individuality and style-oriented consumption and are in charge of their own heterosexual relationships. Simultaneously, however, she is also aware of the disconnectedness and lack of fit of such messages with herself and her own experiences. Therefore, when Devon Aoki, an Asian American supermodel, arrived on the American scene, Jooyoung immediately became a fan, an admiration she explains as follows:

> White girls occupy the fashion world. When you see New York and Paris fashion shows, the majority of models are White Western girls, with similar facial and body structures. I am a little tired of that. They are like White dolls. However, when I saw Devon, her look captured me. First, she looked half Asian because she is half and half. So her face is not the same as the typical super model. She has a round, wide face, and her eyes, nose, and lips are tiny, not those of a typical western super model. Not that her looks are beautiful by Asian standards; if you saw her on the street, you would just pass by without noticing her. She has a plain look. However, I found her very enigmatic mixture of Asianness and whiteness among all the White models very attractive and captivating. Her mixed ethnicity makes me feel closer to her. (personal correspondence)

As this excerpt reveals, Jooyoung's admiration for Devon derives primarily from the fact that the supermodel's appearance breaks free of normalized Western

standards of ideal beauty. That is, Devon's hybridity captivated Jooyoung by its very racial ambivalence, which, as Banet-Weiser (2007) explained, opens access to "increasingly diverse and segmented audiences without alienating specific groups" (p. 214). Another reason for her admiration is Devon's independent attitude toward career success: although from a wealthy family, she succeeded at an early age without family support, which impressed and motivated Jooyoung to pursue her own career success more aggressively.

As frequently happens in fan culture, Jooyoung's interest in Devon led to digital image making (Figure 1), which despite Devon's not fitting the supermodel status quo, accentuates Devon's sensual feminine body and heightens U.S. standards of Western beauty to create a phantasm. This standardized image occupies a large part of the screen, while Devon's outlandish Asian girl face appears in a small square box topped by a dialogue box containing the word "beauty." These images, however, are accompanied by an equivocal visual statement that questions the social construction of the beauty ideal: "But the question is: What is beauty anyway? My outer self or inner self?" As Jooyoung commented to me later, "An Asian girl's look never falls into the category of the Western beauty standard. It is perceived merely as cute, never

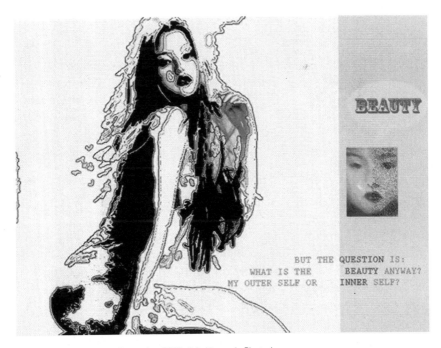

Figure 1. Jooyoung, *Beauty*, December 2007, digital image in Photoshop.

sexy. The U.S. ideal demands a sexy look. So I sometimes wonder if appearance is really that important."

Jooyoung's imagery and comments convey a multilayered message. On the one hand, they suggest a desire to look beautiful and sensual, as if submitting to the requirement of satisfying male desire. On the other hand, although the larger image may to some extent reflect her hidden desire for an external beauty that meets U.S. ideals, her conscious quest for race and ethnicity within White dominant culture is expressed as a critical form of inquiry. The fact that this critical question remains unanswered leaves it open to reflection and interpretation in her search for her ethnically gendered self. Such inquiry thus implies a struggle to shake the hierarchical binary assumption that associates the dominant social/cultural demands of external physicality with Western ideals of beauty. Yet at the same time, it also suggests that Asianness is a suppressed domain that in the U.S. context conveys a less desirable appearance and identity while still being expected to relate to inner attributes like hyperfemininity. This convoluted message reflects a search for a negotiational intersection between Jooyoung's ethnically/racially gendered self and the pursuit of consumerist Western-based aesthetics and feminine beauty.

Interpreted in this way, Jooyoung's visual response to Devon shatters earlier feminists' concerns about the aesthetically oriented consumerist nature of postfeminist girls' coming of age. Rather, it demonstrates not only that girls' aesthetic- and beauty-oriented consumption is closely tied to power struggles and racial ideologies, but also that the cohesive, yet complex, nature of this political/aesthetic mechanism waters down the polemic distinction between aesthetics and politics. It thus provides a pedagogical possibility for Jooyoung to explore, challenge, accommodate, and negotiate the messages of a postfeminist culture of girl power while retaining awareness of her bicultural upbringing and seeking an alternative standard not merely as a girl, but as a Korean American girl.

A Girl's Voice: Critically Consuming Self

In like manner, Jooyoung's beautifying practice in a self-improvement project on her website (Figure 2), rather than reflecting the uncritical consumption that so disappointed earlier feminists, illustrates a critical if self-centered consumption. Admittedly, her ever-expanding image collection and fashion collages of products from high-end designers could be interpreted merely as an obsessive consumerist desire to purchase such products in the pursuit of beauty. However, while aesthetically enjoying the products, on her webpage she criticizes them by ridiculing their prices and comparing them with similar but far less expensive items put out by other companies. Specifically, she asserts that it is unnecessary to purchase the expensive designer brands and emphasizes the enormous fees amassed in the merchandising process, including

Figure 2. Jooyoung, *Fashion*, January 2008, digital image on her webpage.

advertising. Hence, the high-end products posted on her home page, although they provide a source of updated fashion trends for potential self-improvement, function primarily for her visual pleasure. Such critical consumerist practice suggests that the view of girls' consumption as uncritical needs amendment.

This alternative interpretation of postfeminist girl power is also implied in Jooyoung's commentary on her home page about her decision making during self-beautification:

> A girl must take care of herself. Her beauty is her responsibility. It is eventually for her satisfaction. I do not wear or put makeup on for a boyfriend, but rather for myself.

Although such beautifying is by no means a new practice for girls, Jooyoung's comment implies a more narcissistic approach than ever before, one that obscures whether such practice is a feminist quality or mere femininity. On the one hand, such a self-centered attitude can be seen as a product of neoliberal capitalists' reinforcement of individualism; on the other, it can be read as a feminist quality, a female expression of beauty for her own pleasure not the male's. In addition to this ambivalence in her narcissistic beautifying practice, another confident comment by Jooyoung hints at an alternative way of decision making that places her in charge of the beautification project:

> I also would not want [a boy] to choose certain types of clothing for me to wear. I would want to choose for myself. Even if there were an occasion when

he might choose a style for me, I would not let him do whatever he wanted. Rather, I would give him two clothing options and have him choose one.

The idea of such choice making—of a boy making a choice that is essentially a girl's prerogative—introduces a redirection and reinterpretation of the female control in decision making that is considered a core quality of autonomous feminist agency. Unlike female decision making that transcends male power, a reaction by earlier feminists to the belief that decision making belonged to the male, this move signifies an ambivalent way in which a female can both cross and control male power. Jooyoung's comment also indicates that her choice making in beautification is not done solely for a boy's gaze, but is ultimately for her own pleasure. This remarkable shift suggests a need to rethink postfeminist girl power's contribution to feminism; that is, rather than being ambivalent, it is marked by a contradictory blend of self-centered attitudes reinforced by neoliberal capitalism and perpetuated in beautifying practices enacted not for male viewing pleasure but rather as a potential feminist investment. Hence, although such ambivalent forms and methods may superficially appear to undervalue feminism, they eventually help demarcate the line between feminism and femininity, thereby producing a new, meaningful, hybrid form of feminism for coming of age.

Conclusion

This case study of a U.S. minority girl's image making suggests a reinterpretation and disruption of the postfeminist girl power discourse. This discourse focuses on a complex array of desires, practices, and values, including, most importantly, a valorization of educational and economic success and a hyperaestheticized consumerism that highlights female individuality and freedom of choice; I have found all these qualities in the image-making practice I have studied here. From this study, I pose postfeminist girl power discourse not simply as antithetical to feminism, but as an alternative form of resistance to power and identity politics revolving around consumer-led capitalism. This discourse's complex assemblage of politics, aesthetics, and representation allows for possibilities of feminist critique, yet in a nonaggressive manner. The going-back-to-patriarch politics shatters the previous generational feminist appraisal of girl power's investment in media as one simply marked by an apolitical attitude, style-centered consumption, and adoration of heterosexual relationships because that appraisal was based on an essentialization of media power as a force directly shaping girls as obedient, docile recipients. This view underestimates girls' capabilities of critical thinking and agency, which can be presented in a negotiated manner. Further, by critiquing the focus on White, middle-class girls in postfeminist girl power discourse, I redirect and reshape the notion of feminism

and femininity through a contextual awareness of race, ethnicity, and class. This questioning of the cultural dissonance within the "we" postulated by dominant U.S. girl power discourse opens an opportunity to make visible the cultural heterogeneity of particularized girls. This study lends itself to demystification of what postfeminist girl power displays in terms of girlhood and girls' agency, contributing to a realistic representation of girlhood.

Notes

1. The term *postfeminism* was widely disseminated in popular media forms and texts during the 1980s and was widely accepted as a backlash to second-wave feminism. Because *post* refers to after, beyond, and past; postfeminism, having to do with the pastness of feminism, means a revolt against feminism. In reality, it is a set of values embracing both antifeminist and feminist values.

2. As used here, the term *educational exodus* refers to a particular type of dispersion of middle-class South Korean youths to the United States and other English-speaking nations at remarkable rates since the 1990s to seek a prestigious education that provides English proficiency. One prominent demographic feature of this phenomenon is that many Korean youths come alone and others come with only one parent (most often the mother).

References

Banet-Weiser, S. (2007). What's your flava? Race and postfeminist in media culture. In Y. Tasker & D. Negra (Eds.), *Interrogating postfeminism: Gender and the politics of popular culture* (pp. 201–226). Durham, NC: Duke University Press.

Barthes, R. (1975). *The pleasure of the text.* New York: Hill & Wang.

Butler, J. (1990). *Gender trouble: Feminism and the subversion of identity.* New York: Routledge.

Chesney-Lind, M., & Irwin, K. (2004). From badness to meanness: Popular construction of contemporary girlhood. In A. Harris (Ed.), *All about the girls: Culture, power, and identity* (pp. 45–58). New York: Routledge.

Douglas, S. J. (1994). *Where the girls are: Growing up female with the mass media.* New York: Times Books.

Godfrey, R. (1993). Riot girls in the alternative nation. *Alphabet City,* vol. 3.

Goldman, R., Heath, D., & Smith, S. (1991). Commodity feminism. *Critical Studies in Communication, 8*(3), 333–351.

Griffin, C. (2004). Good girls, bad girls: Anglocentrism and diversity in the constitution of contemporary girlhood. In A. Harris (Ed.), *All about the girl: Culture, power, and identity* (pp. 29–44). New York: Routledge.

McRobbie, A. (2007). Postfeminism and popular culture: Bridget Jones and the new gender regime. In Y. Tasker & D. Negra (Eds.), *Interrogating postfeminism: Gender and the politics of popular culture* (pp. 27–39). Durham, NC: Duke University Press.

Ono, K. (2000). To be vampire on *Buffy the Vampire Slayer*: Race and ("other") socially marginalizing positions on horror TV. In E. R. Helford (Ed.), *Fantasy girls: Gender in the new universe of science fiction and fantasy television* (pp. 163–186). New York: Rowman & Littlefield.

Projansky, S., & Vande Berg, L. R. (2000). Sabrina, the teenage . . . ? Girls, witches, mortals, and the limitations of prime-time feminism. In E. R. Helford (Ed.), *Fantasy girls: Gender in the new universe of science fiction and fantasy television* (pp. 13–40). New York: Rowman & Littlefield.

Roberts, M. (2007). The fashion police: Governing the self in *What not to wear.* In Y. Tasker & D. Negra (Eds.), *Interrogating postfeminism: Gender and the politics of popular culture* (pp. 227–248). Durham, NC: Duke University Press.

Springer, K. (2007). Divas, evil black bitches, and bitter black women: African American women in postfeminist and post–civil-rights popular culture. In Y. Tasker & D. Negra (Eds.), *Interrogating postfeminism: Gender and the politics of popular culture* (pp. 249–276). Durham, NC: Duke University Press.

Taft, J. (2004). Girl Power politics: Pop-culture barriers and organizational resistance. In A. Harris (Ed.), *All about the girls: Culture, power, and identity* (pp. 69–78). New York: Routledge.

William, R. (1977). *Marxism and literature.* Oxford: Oxford University Press.

Girl Stories: On Narrative Constructions of Identity

Kimberly Cosier
University of Wisconsin–Milwaukee

Helping students understand the complexities of identity is a fundamental component of our teacher education program. Gender, race, class, sexuality, and other markers of identity are inextricably linked, yet students often come to us unaware of the social construction of identity. We have found that stories are compelling tools that can give students access to such understanding. In this article, I examine various approaches to narrative inquiry and inquiry into narratives that have proved to be fruitful. Focusing on relationships between power and position—in their own stories and stories of others—gives students entry points to understand the complex nature of identity. In a society founded on Puritanism and slavery, it is imperative that we find ways within teacher education to address such issues if we are to work toward justice.

The unexamined life is not worth living. — Socrates (quoted in Plato, 1996)

Sure you can do anything when you are talking or writing, it's not like living when you can only do what you are doing. — Precious Jones, the protagonist in Push: a Novel *by Sapphire (1996, p. 3)*

Growing up girl has had very little impact on my students' lives—at least that is what they would have me (and themselves) believe at the beginning of our work together in the teacher education program at the University of Wisconsin-Milwaukee. Like the majority of teacher education programs, our student body is made up of mostly women.[1] Because of this lopsided female population, I am regularly puzzled by students seeming to feel that gender has no influence on, or only slightly impacts, their

From *Visual Arts Research*, Vol. 37, No. 2 (Winter 2011), pp. 41–54

identities. I expect young women to be more conscious of gender than they appear to be, if only from past experiences in school.

Research shows that girls have made academic gains since Title IX was enacted[2] (Corbett, Hill, & St. Rose, 2008) but also continues to demonstrate that sexual harassment in schools has strong negative effects on girls (Gruber & Fineran, 2008). Yet my students, most of whom came of age in the post–Buffy the Vampire Slayer era, seem to take girl power and other aspects of being girl (both positive and negative) for granted. We have found that turning to Buffy, and other narrative representations of girls in our culture, is an excellent way to engage students in an analysis of the social construction of identity.

Narrative Inquiry and Inquiry Into Narrative

We are always on the lookout for curricular routes our students can take to examine the influences that have shaped their identities and that will influence the way they think of themselves as teachers. We want them to be conscious of the many factors that impinge upon identity as they form the expectations they will hold for their students. Because our program has an urban focus, we feel it is vital that students understand the legacy of the twin perversions of Puritanism and Slavery, upon which America was founded. Hester Prynne and Sally Hemings join hands with Buffy in the construction of American identity.

For many, engaging in inquiry about identity is a new and challenging process. Our students are predominantly White, from working-class and middle-class families. They have thought little about how their own identities have been formed or how they have come to perceive gender, race, class, sexuality, and other markers of identity in others. They take for granted that their life experiences are "normal" and, most often, do not recognize that their worldviews has been shaped by stories passed down from family and community members and through media and popular culture.

It takes sustained work on their parts to see that the stories they have been told all their lives are limited by forces that seek to maintain power (Weis & Fine, 2000). Through a steady barrage of limited story lines, mainstream narratives have become so naturalized that people most often don't even notice them (Butler, 2004; Driscoll, 2002). Lessons about what are acceptable and desirable beliefs and behaviors are taught through narratives that conceal socially binding rules. We aren't meant to notice, for these narratives are the support structure for institutionalized racism, classism, sexism, and homophobia, the legacies of Puritanism and Slavery.

When our students come to us, many think that their identities are already solidly formed. We believe it is important to plumb the depths of this starting-point identity in order to move on to a more mindful, critical, and empathetic teacher

identity. In order to understand others, we must first work to understand ourselves, taking into account the powerful political, cultural, and social forces that have shaped us—often without our knowing it!

To help students understand the complexities of identity, an understanding we believe to be fundamental to critical pedagogy, my teaching partner, Laura Trafi-Prats, and I have engaged students in focused explorations of the social construction of identity (Congdon, Stewart, & White, 2002). Because we teach from a queer, critical, feminist pedagogical stance (Cosier & Sanders, 2007; Desai, 2003; Garber, 2003) with a focus on urban education (Weis & Fine, 2000), we feel that the ability to self-reflect on the socially constructed, contextual nature of identity—including understanding self in relation to others—is vitally important to teachers' development (Neito, 2010). To facilitate such development, we use an array of curricular approaches, including employment of visual journals throughout the program, in which students respond, in writing and through imagery, to various identity-related readings (Allison, 2009; Briggs, 2007; Clark, 2002; Congdon et al., 2002; Nieto, 2010), contemporary artwork, media artifacts, and other prompts. We focus on narrative inquiry into the construction of identity—and inquiry into narratives about identity—because experience is shaped by social and cultural forces and is understood through stories that unfold through time in shared environments (Connelly & Clandinin, 2000).

Narrative Inquiry: Constructing and Deconstructing Identity Through the Power of Story

To pursue narrative inquiry into the construction of identity, we have had students create teacher puppets and portraits followed by storytelling and discussions about the ways identity markers like gender, race, ability, age, and sexuality are encoded in their ideas of what and who teachers are. We've developed alter-ego comics and other graphic narratives to explore students' ideas about themselves in relation to their burgeoning teacher identities and to better understand the conflicts that arise as they try to reconcile their conceptions of self to socially constructed notions about teachers and teaching, especially in urban schools.

Through artistic production and engagement with the visual journals, we have also done various forms of memory work (O'Reilly-Scanlon & Dwyer, 2006/2009) and visual narrative investigations of cultural signifiers with our students. We have used visual memory prompts such as toys, food, clothing, advertisements, movies, and television shows to get students to look closely at the social and cultural influences that have shaped them, often without their knowing it. Throughout this work, narrative inquiry remains an important tool. To one class, I read the story "Undoing the Dress" (Cosier, 2006), in which I tell the tale of my entry into a new school culture

in the seventh grade. In this story, a dress my mother forced me to wear on the first day of school is a gendered/feminine cultural signifier that stands in strong opposition to my emerging youthful butch identity.

After hearing my story, students developed stories of their own in which an object or thing stood for a conflict over identity in their past. One student, who is of Hmong descent, wrote a beautiful story that centered on the tug-of-war she had with her refugee parents, who were horrified when she wanted to get her hair cut short in middle school. She had argued that a short haircut was merely a matter of expressing her own fashion and style, but for her parents, such an act meant she was turning her back on her Hmong heritage while also, perhaps, stepping away from traditional heterosexual norms. In this story, the girl's hair stands in for a variety of identity markers, including age/generation, gender, ethnic traditions/culture, and sexuality.

Another student also chose to tell her story by using hair as a cultural signifier. In her case, hair care became symbolic of social class and gendered identity. Her story told of a young girl washing her long blonde hair in freezing buckets of water because her family, lacking funds to pay the gas bill, did not have hot water for bathing. This story reveals how clean, long hair was emblematic of middle-class respectability and idealized femininity in a young girl's mind and the lengths to which she was willing to go to maintain that representation of identity. What she did not recognize until we discussed the story in class, however, is that long, straight, blonde hair also signifies racial identity. The invisibility of this aspect of hair as a cultural signifier highlights how whiteness is narratively constructed as the norm. If the story had been about straightening kinky hair, for example, it would have automatically been understood to be about racial identity. In this way, our students learned that cultural signifiers hold powerful meanings and can be read differently by readers with backgrounds that differ from ours. In all of these curricular encounters with story, we worked with our students to understand that identity is a narrative process, which can be learned through stories that we tell. Of equal importance to the construction of identity is an ability to deconstruct the stories that are told to us.

Inquiry Into Narrative: Retelling Stories Familiar and Strange

Stories define us and help us to become. We know ourselves, and others, through a patchwork of biography, memoir, myth, parable, and prophesy. Of course, there are some facts we draw from, dates of birth and death, graduation, and marriage, but these usually tell us very little about the lives of people who have shaped us. On my birth certificate, for example, I am told that my father's occupation was porcelain dipper, which hints at my working-class roots but tells little of my childhood or the man who raised me. Had I not been raised while listening to him tell stories about

his wild adventures with the Chittenden boys, I may not have been compelled to live my life as a girl with reckless abandon. No doubt, I would have been a pint-sized butch no matter who my dad was, but the kind of person I was then, and am now, is at least partially due to my dad's stories.

His were not the only stories to influence me, however. Popular media representations of gendered, raced, and sexualized identity also impacted my childhood narrative. Because of my penchant for adventure, as a young child my favorite television show was *Honey West*, which was a short-lived series (1965–1966) about a female private detective who ran around with a pet ocelot named Bruce. When I look back at that show now, it seems heartbreakingly misogynistic, but when I was four I thought Honey West ruled the world.

Another profound early influence was *Roots* (1977, dir. Marvin J. Chomsky), a miniseries based on Alex Haley's (1996) book of the same name, which told a semifictionalized story about Haley's family from the capture of his ancestor, Kunta Kinte, in Africa through the end of slavery. *Roots* aired while I was a freshman in high school, and it seemed to be watched by everyone in America. Like many White people who were protected from the truth about slavery and our country's origins through sanitized and depersonalized accounts of history, *Roots* opened my eyes. I realized that I had a lot to learn about race and American identity—as it turns out, everything I have learned so far has taught me that unlearning racism, the legacy of slavery, will be ongoing throughout my lifetime.

Looking back on stories that shaped us can be an important tool of self-discovery. So, too, can be looking at the stories of the present. Critically engaging with stories of the familiar and unfamiliar can teach powerful lessons on the construction of identity. In 2009, two movies emerged as cultural touchstones, *Precious*[3] (dir. Lee Daniels) and *The Princess and the Frog* (dir. Ron Clements and John Musker) Precious and the Princess join hands with Hester Prynne and Sally Hemings to teach us about growing up girl in a society mired in the legacy of Puritanism and Slavery. Both of these movies, when closely read, are complex commentaries on the contested terrain at the intersection of gender, race, class, and sexuality in American society (White, 2009a, 2009b).

On Encountering Two Stories About Black Girls

Our day began with a class discussion of Paul Duncum's (2010) article "Seven Principles for Visual Culture Education," in which the principles of power, ideology, representation, seduction, gaze, intertextuality, and multimodality are proposed as "sources from which to create curriculum commensurate with the extent and complexity of today's visually mediated world" (p. 6). To facilitate the discussion, I showed the "Circle of Life" clip from Disney's *The Lion King* (Allers & Minkoff,

1994). In this scene, the light-furred, male lion cub, Simba, is presented by a colorful, primate shaman to an adoring throng of all the less regal animals of Africa, who bow down before him as their natural king while an orchestrated tune tells us what we are witnessing is perfectly fitting and natural.

Within a beloved film from their youth, students were astonished and dismayed to suddenly see hidden messages about gender, race, class, and colonialism when viewed through the new lenses of Duncum's proposed principles. A few argued (predictably) that we were making too much of the symbolism of the film. Because I try to remain faithful to the tenets of feminist pedagogy (Garber, 2003, Smith-Shank, 2000), I resisted an urge to steer the discussion. Thankfully, a classmate challenged the incredulous ones by saying, "But, if they made it obvious, it wouldn't work, now would it?!" Wrapping up the discussion, I asked them to make entries in their visual journals about what they had taken away from this experience. We ended the morning session by talking about two new films that would be interesting to watch with the lens of the new principles: *Precious* and the *Princess and the Frog.*

That day, I had signed up for a digital storytelling workshop, which was held over our lunch break and for the first half hour of the afternoon session of our class. The students were supposed to be working on clay tiles that were going to be permanently installed in a collaborative mural inspired by Howard Zinn's quote: "You can't be neutral on a moving train." When I got back to the classroom after my workshop, however, the students were watching *Precious*, and they had already watched *The Princess and the Frog* over the lunch break. I was mystified not knowing how they had gained access to the movies (once I found out, I was sorry I asked) and flabbergasted that they were watching *Precious* in class while also working on clay tiles. But, since the train had already left the station, I decided to try to make the best of it.

For readers who have not seen one or both of the movies, the following are brief overviews of each. From Lionsgate, distributor of *Precious*:

> Precious Jones, an inner-city high school girl, is illiterate, overweight, and pregnant . . . again. Naïve and abused, Precious responds to a glimmer of hope when a door is opened by an alternative-school teacher. She is faced with the choice to follow opportunity and test her own boundaries. Prepare for shock, revelation and celebration. (http://www.lionsgateshop.com/product.asp?Id=23085& TitleParentId=6482)

As we discovered through prolonged discussion and research about and contemplation of this movie, *Precious* cannot be so neatly summed up. To a lesser degree, this is also true of *The Princess and the Frog*, which is Disney's first attempt at portraying an African American animated heroine. According to Roger Ebert (2009, para. 7),

it is the "first animated feature since 'Song of the South' (1946) to feature African-American characters." Here is the story according to Disney:

> Walt Disney Animation Studios presents the musical *The Princess and the Frog*, an animated comedy set in the great city of New Orleans. From the creators of "The Little Mermaid" and "Aladdin" comes a modern twist on a classic tale, featuring a beautiful girl named Tiana (voiced by Anika Noni Rose), a frog prince who desperately wants to be human again, and a fateful kiss that leads them both on a hilarious adventure through the mystical bayous of Louisiana. (http://disney.go.com/disneypictures/princessandthefrog/index_full.html)

Digging Deeply Into Narrative Constructions of Identity

After the movie ended, we had a discussion that raised numerous troubling aspects of *Precious*. One student noted with irritation that all of the helpful characters in the movie were light-skinned. Pointing out that this could reinforce stereotypes that are detrimental to African Americans, she asked in exasperation, "Why would a Black director do such a thing?" Many echoed this student's response, and we decided that this was a good question to pursue through research. I asked them also to consider the context of the story—Harlem circa 1987—urging them to think about ways context impacted the meanings we could make out of *Precious*. At the end of class, I asked students to do some research over the weekend and to write responses in their journals to one or both of the movies in relation to the Duncum's (2010) seven principles in order to be prepared to engage in a deeper discussion when we came back to class the following week.

When we returned to class, students complained that the seven principles were too numerous and overlapping to be very useful. We agreed that Duncum intended, like Olivia Gude (2004), who first proposed new principles, to move away from the formalist/modernist principles of the past and toward a useful framework for uncovering meaning in art and visual culture. We decided not to try to address each of the seven principles but rather work with the spirit of new principles to discuss the films.

Student responses were predominantly focused on *Precious*, but a few reflected also on the *Princess and the Frog*. For those students, the most striking thing about the latter film was the irony that Disney's first African American animated heroine spends most of her time in the story as a "reptile of color." That being said, most students agreed that the movie did not seem to harbor as many negative messages about blackness and gender as had past Disney films. To be honest, I expected to hate the *Princess and the Frog*. I was pleasantly surprised that it managed not to be overly offensive, even giving a nod to institutionalized racism and sexism in a scene in which

two sleazy, White realtor types tell Tiana that they sold her beloved restaurant out from under her to another buyer, saying that it probably was for the best, given her "background." Instead of siding with whiteness and maleness, as with the implied position of the audience of *The Lion King*, in this film we are meant to identify with a young Black woman and to be outraged at the discrimination she faces—a pretty big leap for Disney!

Through research, students found positive commentary from Black film critics. For example, in her review of *Princess and the Frog*, Demetria Lucas (2009) wrote,

> We all know Black folk have a murky history with our stories being told by non-Blacks; too often our culture seems to get lost in translation from one side of DuBois's veil to the other. But not this time. Disney's much-anticipated "The Princess and the Frog" is finally here and our Black Princess doesn't disappoint—in fact, she exceeds expectation. (para. 1)

As we discovered, however, not all critics were so enamored. Film critic Armond White (2009b) saw much to criticize in the movie:

> Hyped as offering the Walt Disney corporation's first African-American animated heroine, *The Princess and the Frog* actually refrains from expanding our social imagination. Based on the venerable *The Frog Prince*, it uses that fairy tale's moral about seeking inner value and personal worth to exploit "post-racial" complaisance. (para. 1)

Students pointed out that White not only slams the film's portrayal of racial identity but also teases out its sins of classism and gender representation. For example, White argues that Tiana is not allowed into Disney's canon of heroines, saying that by turning her into a frog for 80% of the movie, Disney "does not confer a modicum of idealized beauty or grace on a black girl's countenance" (para. 4; and quoted in a student visual journal).

Through our discussion of White's analysis, students also came to recognize an implied reinforcement of the notion that class and race are naturally linked within the bootstrap narrative of hard work lifting the poor Black girl into a better life, which is revealingly contrasted with Lottie, Tiana's rich, White friend, who could expect to have her every whim granted by virtue of her birth into wealth and whiteness. Finally, a gay male student pointed out that both girls in *The Princess and the Frog* are indoctrinated into heteronormative, race-specific, gender and sex roles in the movie, as well. Overall, students felt that Disney did a better job than they expected, but still had a long way to go if it truly wanted to tell a story about Black girlhood that does not reinforce stereotypes and limit little girls' imaginations about the possibilities of identity.

Regarding *Precious*, several interesting problems arose. First, as mentioned, was the question of why a Black director would make a movie in which all the helpful characters are light-skinned while all the troublemakers are dark, a fact one student said he would not have recognized if we hadn't engaged in the close reading of *The Lion King*. Some online digging revealed that Lee Daniels, the director of the film, admitted to being prejudiced against people with dark skin. A student quoted Lynn Hirschberg (2009) quoting Daniels:

> "Precious" is so not P.C. What I learned from doing the film is that even though I am black, I'm prejudiced. I'm prejudiced against people who are darker than me. When I was young, I went to a church where the lighter-skinned you were, the closer you sat to the altar. (p. 1, para. 5)

We discussed this quote in relation to the film, which was widely touted as transcending race. My students were dismayed that Daniels claimed to have learned that he is prejudiced, yet that knowledge seemed to have no bearing on his analysis of the final product or on casting folks in a way that could be seen as reinforcing stereotypes that are detrimental to all of us. The topic of skin color briefly circled back on *The Princess and the Frog* when one student noted that everyone in that movie was the same exact shade of brown.

On the subject of bias, the foregoing quote was followed by another statement by Daniels:

> Anybody that's heavy like Precious—I thought they were dirty and not very smart. Making this movie changed my heart. I'll never look at a fat girl walking down the street the same way again. (quoted in Hirschberg, 2009, p. 1, para. 5)

When my student read that quote, I was astounded! For those were the same words that I had heard from numerous wealthy, White people who had seen the film and been swept away by their first experience of identifying with a poor Black girl. These superficially empathetic statements belie new stereotypes that every overweight Black girl in America is now going to have to carry with her: They are now patronizingly assumed to have the capacity to overcome being poor, illiterate, abused in every way imaginable, and HIV positive, given the care of the right, nearly White teacher.

Out of our investigations emerged a problematic narrative of universality, which was apparent when Daniels was asked in another interview if his identification with the story "meant that he was 'Precious,' too?" (Dudek, 2009):

> He said yes. "And so are you," he added. "That's what I learned. I didn't know it would affect people the way it has. I thought maybe my family, neighbors and people I went to school with" would relate to the film. "I didn't know it would have a universal appeal." (p. 1, para. 11)

Viewers and critics alike were rapturous about the film. Like Daniels, they suddenly felt compassion for a person with whom they thought they had nothing in common, an overweight Black girl who, apparently, they would have either ignored or looked down upon in the past. This is the phenomenon we found to be the strangest surrounding the film: privileged, White viewers, who were given sanitized access to the exotic other through the movie, seemed to exempt themselves from being implicated in the circumstances surrounding the girl's oppression by virtue of identifying with the character Precious.

Problems associated with the supposed universality of *Precious* are connected to how context mattered in the film but was made invisible.[4] We noted that the date of the story was featured only briefly in text at the beginning of the movie, with little else about the film indicating the historical period. The students agreed with one another that the date and its significance could easily be overlooked by viewers who would unwittingly place the narrative in a contemporary framework and that doing so has political and social implications. For example, one student remarked on the way the notoriously hopeful ending of the film glossed over the fact that in 1987 being diagnosed with HIV would have probably been a death sentence for Precious because our government had turned its back on the AIDS epidemic.

The welfare narrative provides another example of how understanding the context of *Precious* matters. Welfare emerges as an evil presence in the film, as welfare is set against the foil of the American Dream/bootstrap narrative. About this, one student wrote in her journal, "Coming from a very Republican family I always heard about the welfare leeches that are 'too lazy' to find a job. The film reinforced this opinion." Yet, in Wisconsin, where my students will most likely be teaching, welfare disappeared when they were small children. According to the Wisconsin Historical Society (n.d.), "On April 25, 1996, Governor Tommy Thompson signed Wisconsin Works into law. The new law ended the Aid to Families with Dependent Children program and replaced it with a program *based on work* known as W-2" (para. 1, my emphasis). The vast majority of my students were unaware of this fact before we engaged in this investigation. The narrative of the Welfare Queen persists even though welfare is a thing of the past in this state. Putting this ideology in relation to the bootstrap narrative, we came to understand that when White viewers identified with Precious they were really identifying with her ability to break free from her pack, to not be what Black girls are assumed to be.

The notion of universal appeal—that "We are All Precious"—was marketed by not only Daniels and Lionsgate, but by nearly every movie critic we uncovered in our research. A notable exception was, once again, Armond White (2009a), who criticized this film as a "con job" and charged,

> The hype for Precious indicates a culture-wide willingness to accept particular ethnic stereotypes as a way of maintaining status quo film values.

> Excellent recent films with black themes . . . have been ignored by the mainstream media and serious film culture while this carnival of black degradation gets celebrated. It's a strange combination of liberal guilt and condescension. (para. 9)

Our investigation into the film and its social/cultural implications led my students and me to agree with Mr. White.

With protracted focus on both movies, but especially on *Precious*, we deepened our understandings of stories that make us who we are and stories that we make of the lives of others. Exploring issues of gender, race, class, and sexuality in two mainstream representations of Black girls' identity gave us much to learn from. As a result of our sustained engagement with these stories, students shared in discussion and in their journals that they now had a much more complex and complicated view of race, gender, identity, and power; a view that will make them much stronger teachers.

Discussion of Narrative Inquiry and Inquiry Into Narratives

Having had some time to reflect on these experiences, I feel strongly that constructing and deconstructing stories is a powerful pedagogical tool that can help students understand the complex nature of identity without hitting them over the head with our dogma. It turned out in this case that the seven categories proposed by Duncum (2010)—power, ideology, representation, seduction, gaze, intertextuality, and multi-modality—were too overlapping and numerous to be very helpful to the discussion. However, my students and I found a close examination of power to be enormously important, particularly as we looked at each player's relationship to it. Elizabeth Garber (2003) calls this relationship "positionality" (p. 59). She suggests using the notion of positionality to unpack identity:

> Positionality derives from relating mastery, authority, and voice to the position of the speaker. Gender, race, class, sexuality, nationality, ability, age, and a host of other descriptors can come into play in understanding this relationship, as well as prior knowledge, education, experiences, and emotions. (p. 59)

Citing Frances Maher and Mary Kay Thompson Tetreault, Garber (2003) argues that "position, perhaps more than any other single factor, influenced the construction of knowledge, and that positional factors reflect relationships of power" (p. 59). We have found that by focusing on the interplay between *power* and *position*, students can tease out the ways gender, race, class, and other factors influence the construction of knowledge and identity.

Because of the intersectionality of identity, the girl can never be completely unbound from other markers of identity, as Mary Celeste Kearney (2009) affirms:

> There are many ways to be a girl, and these forms depend on not only the material bodies performing girlhood, but also the specific social and historical contexts in which those bodies are located. (p. 24)

Gender, race, class, sexuality, and other markers of identity are inextricably linked, yet students often come to us unaware of the social construction of identity. In a society founded on Puritanism and Slavery, it is imperative that we find ways within teacher education to address such issues if we are to work toward justice. Narrative inquiry and inquiry into narratives have proved to be very fruitful in our classroom experiences. Focusing on relationships between Power and Position, their own stories and stories of others become entry points for students to understand the complex nature of identity. If Socrates and Precious are right, this is what makes life worth living.

Notes

1. Presently, around 70% of the public school workforce is female (National Education Association, 2010 p. 111). That number is roughly parallel to the number of women in our art teacher education program.

2. Title IX states, "No person in the United States shall, on the basis of sex, be excluded from participation in, be denied the benefits of, or be subjected to discrimination under any education program or activity receiving Federal financial assistance" (U.S. Department of Labor, http://www.dol.gov/oasam/regs/statutes/titleix.htm).

3. The official title is *Precious: Based on the Novel "Push" by Sapphire*. Although I want to honor Sapphire and admired her book, the title is too cumbersome to work into a discussion, so I will refer to the movie more simply as *Precious*.

4. There are plenty more aspects of the film one could discuss in relation to identity and teaching, such as the anti–public school/pro–alternative school narrative, the Hollywood teacher as Savior trope, and the treatment of queer identities/presentations (in both films), but, for the special topic of this journal and the limits of space, I had to narrow my focus.

References

Allers, R., & Minkoff, R. (Directors). (1994). *The lion king* [Motion picture]. Burbank, CA: Disney.

Allison, A. (2009). Identity in flux: Exploring the work of Nikki S. Lee. *Art Education, 62*(1), 25–30.

Briggs, J. (2007). Celebrity, illusion, and middle school culture. *Art Education, 60*(3), 39–44.

Butler, J. (2004). *Undoing gender*. New York: Routledge.

Chomsky, M. J. (Director). (1977, January 23–30). *Roots* [Television miniseries]. Burbank CA: American Broadcasting Corporation.Clark, V. (2002). The power of suggestion . . . The suggestion of power. In V. Clark (Ed.), *Comic release: Negotiating identity for a new generation* (pp. 26–42). New York: Distributed Arts Publishers (DAP).

Clements, R., & Musker, J. (Directors). (2009). *The princess and the frog* [Motion picture]. Burbank, CA: Disney.

Congdon, K., Stewart, M., & White, J. H. (2002). Mapping identity for curriculum work. In Y. Gaudelius & P. Speirs (Eds.), *Contemporary issues in art education* (pp. 108–118). Upper Saddle River, NJ: Prentice Hall.

Connelly, F. M., & Clandinin, D. J. (2000). *Narrative inquiry: Experience and story in qualitative research.* San Francisco: Jossey-Bass.

Corbett, C., Hill, C., & St. Rose, A. (2008). *Where the girls are: The facts about gender equity in education.* Washington, DC: American Association of University Women (AAUW).

Cosier, K. (2006). Undoing the Dress. In M. Sewell (Ed.), *Growing up girl: An anthology of voices from marginalized spaces* (pp. 131–135). Hyattsville, MD: GirlChild Press.

Cosier, K., & Sanders, J. H. (2007). Queering art teacher education. *International Journal of Art and Design, 26*(1), 21–30.

Daniels, L. (Director/Producer). (2009). *Precious: Based on the novel "Push" by Sapphire* [Motion picture]. Santa Monica, CA: Lionsgate.

Desai, D. (2003). Multicultural education and the heterosexual imagination: A question of culture. *Studies in Art Education, 44*(2), 147–161.

Driscoll, C. (2002). *Girls: Feminine adolescence in popular culture and cultural theory.* New York: Columbia University Press.

Dudek, D. (2009, October 1). "Precious" in many ways. *Milwaukee Journal Sentinel.* Retrieved from http://www.jsonline.com/entertainment/movies/63128877.html.

Duncum, P. (2010). Seven principles for visual culture education. *Art Education, 63*(1), 6–10.

Ebert, R. (2009, December 9). *The princess and the frog. Chicago Sun Times.* Retrieved from http://rogerebert.suntimes.com/apps/pbcs.dll/article?AID=/20091209/REVIEWS/912099996.

Garber, E. (2003). Teaching about gender issues in the art education classroom: Myra Sadker Day. *Studies in Art Education, 45*(1), 56–72.

Gruber J. E., & Fineran, S. (2008). Comparing the impact of bullying and sexual harassment victimization on the mental and physical health of adolescents. *Sex Roles, 59*(1–2), 1–13.

Gude, O. (2004). Postmodern principles: In search of a 21st century art education. *Art Education, 57*(1), p. 6–14.

Haley, A. (1976). *Roots.* Garden City, NY: Doubleday.

Hirschberg, L. (2009, October 21). The audacity of "Precious." *New York Times.* Retrieved from http://www.nytimes.com/2009/10/25/magazine/25precious-t.html.

Kearney, M. C. (2009). Coalescing: The development of girls' studies. *Feminist Formations* (formerly *NWSA Journal*), *21*(1), 1–28.

Lucas, D. (2009, November 25). It ain't easy being green: "Princess and the Frog." *Essence .com.* Retrieved from http://www.essence.com/2009/11/25/it-aint-easy-being-green-princess-and-th/.

National Education Association (NEA). (2010). *Status of the American public school teacher 2005–2006.* Washington, DC: NEA Research.

Nieto, S. (2010). Beyond categories: The complex identities of adolescents. In S. Nieto (Ed.), *Language, culture and teaching: Critical perspectives* (2nd ed., pp. 199–214). New York: Routledge.

O'Reilly-Scanlon, K., & Corbin Dwyer, S. C. (2009). Memory-work as a (be)tween research method: The beauty, the splendor, the wonder of my hair. In C. Mitchell & J. Read-Walsh (Eds.), *Seven going on seventeen: Tween studies in the culture of girlhood* (pp. 79–94). New York: Peter Lang. (Original work published 2005.)

Plato. (1996). Plato in twelve volumes (Vol. 1, H. N. Fowler, Trans.). Cambridge, MA: Harvard University Press.

Smith-Shank, D. L. (2000). Teaching and learning in ART 580: Women artists and feminist art criticism. *Journal of Gender Issues in Art and Education, 1*, 81–94.

Weis, L., & Fine, M. (2000). Disappearing acts: A feminist dystopia for the 20th century. *Signs, 25*(4), 1139–1148.

White, A. (2009a, November 4). Pride & Precious. *New York Press.* Retrieved from http://www.nypress.com/article-20554-pride-precious.html.

White, A. (2009b, November 27). Bait and switch. *New York Press.* Retrieved from http://www.nypress.com/article-20657-bait-and-switch.html.

Wisconsin Historical Society. (n.d.). Governor Thompson introduces "The end of welfare" in 1996. Retrieved from *Wisconsin Historical Society, Turning Points,* http://www.wisconsinhistory.org/turningpoints/search.asp?id=1516.

Informal Youth Cultural Practices: Blurring the Distinction Between High and Low

Christine Faucher
University of Quebec at Montreal

This article argues that art educators need to focus on informal youth cultural practices in order to develop art projects that are meaningful to young people and relevant to their contemporary social media and postmodern artistic context.

First, this article reports on doctoral research that examines informal youth cultural practices in cyberspace, or those taken up by young people "behind the scenes" of school art education and institutional curricula. Various methodological approaches, including a multiple case study, were used to understand the lesser-known dimensions of teenagers' cultural capital. The results underscore the importance of image-processing software in fostering the teenagers' appropriation skills as well as their technical, artistic, and identity exploration. The results also show that the teenagers' creative processes and visual productions migrated from their art class to digital social networks. Furthermore, the youth participants, whose informal cultural practices drew from different genres (friendship-driven and interest-driven), expressed a vision of cyberculture focused on the blurring of cultural boundaries.

Second, this article examines an art project related to the author's doctoral research. The project mobilized the viral distribution of gossip on a digital social network and addressed informal youth creative practices through the notion of cultural landmarks. Cultural landmarks refer to key pedagogical resources that connect teenagers with their culture in art education. Cultural landmarks emanating from commercial culture and young people's informal ways of expressing their inventiveness in digital and analog spaces generated art products and practices that blurred distinctions between high and low culture. Such blurring also happens in the broader context of contemporary art, justifying the need for art educators to consider informal youth cultural practices in their classrooms.

95

From *Visual Arts Research*, Vol. 42, No. 1 (Summer 2016), pp. 56–70

KEYWORDS: Informal cultural practice, art education, youth, high and low culture

The cultural universe of youth has been transformed through new media and greater connectivity (Fize, 2009; Richard, 2012; Rushkoff, 1999) and, according to Fize (2009), young people have been at the core of this digital revolution. Despite this transformation, the field of art education has changed little in response (Gude, 2013; Unrath & Mudd, 2011), and thus modernist representations still predominate in teaching practices (Richard, 2005).

Representations based on a modernist view of art (Greenberg, 1961) frame high and low culture hierarchically, with high culture being positioned as the dominant and more valuable of the two. Noted French sociologist Pierre Bourdieu (1979) referred to the high and low culture relationship as one of legitimacy and illegitimacy. As a high cultural phenomenon, modernism holds that creative expression can remain uncontaminated by "impoverished" popular imagery (Richard, 2005). This modernist tenet persists in contemporary art education and continues to limit its teaching practices (Richard, 2005).

In the contemporary school context, values associated with youth culture and the popular imagery it borrows from extensively contribute to framing youth culture as low culture. The transgressive pleasure related to dimensions of young people's culture, such as the playful and the exploratory, conflicts with the modernist discourse of rationality on which the institution of school was founded (Duncum, 2009). Some teachers position themselves as rivals of youth culture because they feel their art classes seem dull compared to the dazzling arsenal of images deployed by commercialized media culture (Faucher, 2013). In this context, youth culture is perceived as a problem and even a threat.

Even though modernism persists in school art education (Richard, 2005), distinctions between high and low culture have been blurring in the art world since the late 19th and early 20th centuries, particularly with the inclusion of popular culture. This blurring may have reached an apogee with Pop Art in the sixties (Varnedoe & Gopnik, 1990); however, the expansion of new media and cyberspace continues to feed the process in myriad ways. The work of many contemporary artists, such as Cindy Sherman, Damien Hirst, Mouna Andraos and Melissa Mongiat, and Jeff Koons, continues to disrupt the high–low distinction by blending art genres, spaces, and processes.

The blending of high and low culture—a core characteristic of postmodernism— also manifests in young people's informal cultural practices. A cultural practice is defined as an assembly of daily actions that are meaningful to an individual and the group of which he or she is a member. Cultural practice is part of symbolic production processes that contribute to the formation and assertion of an individual and collective cultural identity (Garon, 2006). Youth generate analog and digital

products and processes such as blogs, cartoons, and video games to give meaning to their world, identify with a group, and express their voice and inventiveness through media (Richard, 2012).

Cultural practices today are part of a broader contemporary social context characterized by globalization, intensification of migratory flows, and unprecedented participation (Jenkins, Purushotma, Weigel, Clinton, & Robison, 2009), which are amplified by the exponential development of cyberspace and new media. In this social context, individuals are exposed to more diverse experiences (Van Zanten, 2008). Moreover, cultural practices are more dissonant, meaning they draw both from low culture (e.g., entertainment) and high culture (e.g., the fine arts) (Lahire, 2004). Despite this postmodern context, the modernist pedagogical posture found in schools tends to exclude informal youth cultural practices. Therefore, there is a gap between art education and both youth cultural and professional art practices, in which blurring has existed for some time.

To diminish this gap and use youth cultural practices meaningfully in the art class, it is first important to better understand them. For this reason, I conducted doctoral research[1] with 12 teenagers in a high school in Quebec (Faucher, 2013). The findings presented in this paper are based on this doctoral research and show the kind of informal youth cultural practices teenagers engage in generally, how the contemporary social media context manifests in teenagers' everyday lives, and how their cultural practices can be related to their artistic learning at school. These findings provide clues as to how to include youth culture in art education design. An art project mobilizing social networking will also be discussed. Although not formally studied in my dissertation, this project was briefly described in it because some young participants mentioned the project in their interviews. The art project illustrates how to use teenagers' cultural practices as a pivot point in art education.

Research on Teenagers' Informal Cultural Practices in Cyberspace

Referring to youth in France, sociologist Lahire (2004) states that statistical analysis of cultural profiles highlights the strong possibility (83%), among students, of having a dissonant profile (p. 497). In other words, the cultural profiles, or practices, of the majority of French youth draw both from low culture and high culture. Lahire also notes that young people enjoy a form of dispositional plasticity (p. 502). Put differently, they have the leisure time relative to other members of society to make diverse choices and have multiple experiences (Lahire, 2004). Dispositional plasticity changes when young people reach adulthood because their range of social possibilities narrows and their cultural identities stabilize (Lahire, 2004).

My doctoral research addressed informal youth cultural practices in the context of young people having dispositional plasticity. Six female and six male adolescents

aged 14 in a grade 9 art class at a secondary school in Montreal, Canada, participated in my research. I studied these participants collectively using focus groups and multi-case analysis crossing all participants' cultural practices. The research also focused in-depth on the cultural practices of three teenagers through a multiple case study. I used several methods to collect data, especially ones from visual anthropology (Collier & Collier, 1986; Levy, 2006; Pink, 2007). These methods allowed my participants to create a visual inventory of their cyberpractices (i.e., informal cultural practices in cyberspace) and to express their world views. One of these methods was one-on-one interviews in which screen shots were used to elicit the participants' worldviews. The participants discussed their daily lives and cultural practices outside school, and how both related to art. I analyzed the various actions forming the participants' cultural practices using an interpretative framework with concepts drawn from Garon (2006), Ito et al. (2010), and Jenkins et al. (2009).

My analysis revealed that participants engaged with a diversity of activities, including digital photography, illegal downloading of video games, collaborative writing, and the sharing of visual productions on social media. My analysis also showed that participants activated diverse participatory cultural skills (Jenkins et al., 2009), such as play, transmedia navigation, performance, and appropriation. The participants' informal cultural practices drew from different genres (Ito et al., 2010), with some being more friendship-driven (e.g., mobilizing social networks intensively) and others being more interest-driven (e.g., regularly sharing photographs with an online artistic community). In addition, they expressed a vision of cyberculture focused on the blurring of cultural boundaries and the communicative dimensions of their cyberpractices.

Connections Between Participants' Cyberpractices and Their Artistic Learning at School

Five categories emerged in my analysis characterizing connections between the participants' cyberpractices and what they accomplished in their art class: image searches in cyberspace; image editing software; migration of the creative process and visual productions; appreciation of expressive qualities and different artistic styles; and appropriation. The participants who used postmodern representation[2] provided more examples of activities with these connections.

Image Searches in Cyberspace

Searches, mainly on Google, allowed participants to gather images into a montage using image software. Participants mentioned that searches in cyberspace enlarged their visual repertoire to make images by, for example, finding new typefaces, visual effects, and artistic styles.

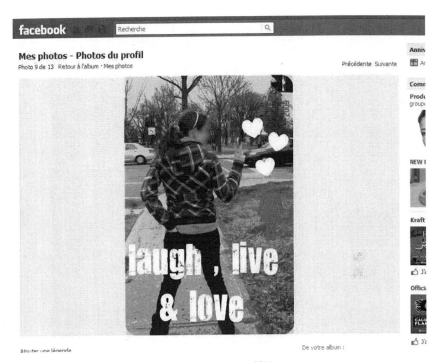

Figure 1. Screenshot taken by one of the research participants, 2011.

Image Editing Software

Image editing software, such as Pixlr and Picnik, fostered technical, artistic, and identity exploration without the consequences associated with the transformation of physical matter. The diverse tools offered by this software nourished inventiveness in the participants' image-making processes and helped them develop visual sensibility and critical judgment. The artifacts and imagery of everyday life—padlocks, jewelry, favorite sports teams, pets, and bands, for example—were sources of inspiration for the participants.

Customized background displays made by some of the female participants demonstrated identity exploration because they created a visual design showing what they liked and identified with the most in relation to their everyday lives, dreams, and interests. Various artistic and technical experimentation allowed these participants to modify images of themselves that they disseminated through social media as public self-representations (see Figure 1).

Migration of the Creative Process and Visual Productions

Certain students identified so strongly with images produced in their art class that they disseminated them through social media. Thus some of the participants' images

Figure 2. Production from the Calacti_CRA art project, 2011.

migrated from the school, a formal learning and creation context, to an informal context. During his elicitation interview, for example, one participant drew attention toward an image he admired on the art class computer's background display. Created by two of his fellow students, the background image was used as his profile picture on Facebook (see Figure 2). One teenage participant said she and her friend used Facebook to share ideas about art projects initiated in school outside class hours. Motivated by the pleasure of self-expression or socialization, then, certain aspects of these young people's cyberpractices merged with their creative process in school.

Appreciation of Expressive Qualities and Different Artistic Styles

Some participants underscored that they were touched by and attracted to expressive qualities in the online videos they watched. One participant mentioned how visual productions shown to the class by his art teacher, as well as his own image searches, allowed him to appreciate expressive qualities in various kinds of images, including works of art. This participant talked about the different artistic styles he could distinguish amongst the multiple images that were shown in the art class or that he encountered in cyberspace.

Appropriation

Teenagers' cultural practices associated with appropriation (Jenkins et al., 2009, p. xiv) involve sampling and remixing media content in a significant and meaningful way within their symbolic universes. Some participants talked about multimedia practices in order to identify relations between their cyberpractice and their artistic practice in school.

The cultural universe of one participant born in Romania revolved around image editing, student journalism, fantasy literature, and collaborative writing with childhood friends still living in her home country. Most of her activities took place in cyberspace, but she also had a sketchbook borrowing certain elements from the imagery of novels she read.

In the context of an ongoing research project,[3] I recently interviewed this teenager again. The follow-up interview with her was done after my doctoral research and focused on multimodality in youth creative practices. The way in which youth combine different modes (written, visual, sound, or gestural) shows how they ignore disciplinary boundaries in their cyberpratices.

Now 18, this young woman's cultural practice involves appropriation of different categories of culture and is multimodal in many aspects (Albers & Harste, 2007; Richard, 2012). She writes novels and socially engaged essays and reads books belonging to both high and low culture. The visual and written modes interact when she creates a quotation wall inspired by the novels she loves or makes drawings in order to better understand creatures and heraldic designs as well as the spatiality of the territories she invents in her narratives.

In light of our postmodern era, the example above shows not only that the distinctions between high art and low art have blurred, but also that social considerations cannot be ignored by art teachers in the culture of young people. Multimodal youth artwork, such as the socially engaged essays and quotation walls mentioned above, cannot be fully understood through the lens of modernism, in which aesthetic and expressive qualities of child and youth art are emphasized and cultural influences are perceived as undesirable.

Designing Art Education Projects with Informal Youth Cultural Practices

During interviews using screen shots as an elicitation strategy, certain participants referred to artistic projects in their school to talk about connections between their informal creative practices and their artistic learning in class. One project they discussed was *La rumeur* (The Rumor) in which an art teacher used social media. This project took place in the school shortly before I conducted interviews with students and mobilized the viral distribution of gossip on a social network (see Figure 3).

Figure 3. Visual montage of La rumeur art project, 2011.

Raising questions about the fluid dimensions of identity in cyberspace (Congdon & Blandy, 2001), the project activated the five aforementioned connections between participants' cyberpractices and what they created in their art class.

For the project, the class's art teacher, Nathalie Claude, produced and placed a hoax image in the grade 9 home room visited by 450 students daily. This image, accompanied by journalistic text, showed the teacher photoshopped as a star walking on the red carpet at the Cannes Film Festival. In regard to the hoax image, the teenagers had some difficulty deciding between the real and the fake (Congdon & Blandy, 2001), or between fact and fiction. They disseminated the image on Facebook in a spontaneous and viral way. Following the hoax, the students were invited to create collages in their art class. Their collages were inspired by the hoax and by gossip about a pop star currently spreading throughout the media landscape. Throughout the creative process, the students were asked to reflect on the issue of playful identity transformation as well as the importance of developing a critical stance toward information they encountered in digital and physical spaces. When art teachers engage social media and contemporary issues through projects such as La rumeur, they reduce the gap between formal and informal practices, digital and analog spaces, and high and low cultures. It is important to note that La rumeur is rare in art education but not inexistent. Relationships between mobile media,

youth creative practices, and formal and informal learning settings are currently being studied by Lalonde and Castro (2015).

Youth Cultural Landmarks

The art teacher who used La rumeur referred regularly to cultural landmarks in the project's pedagogical process with respect to youth culture *reception* (cultural products proposed to young people by commercialized media) or *creation* (cultural production made by teenagers and young adults themselves). The Ministry of Education in Quebec (MEQ, 2003) states that cultural landmarks are meaningful as learning tools about culture. Using them in the classroom allows students to enrich their relationships with themselves, others, and the world (p. 9). Cultural landmarks are drawn from young people's immediate cultural world and are broadly defined by the MEQ. For example, they can be an event (e.g., a concert), a media product (e.g., a magazine for teenagers), or an object from everyday life (e.g, cell phones; MEQ, 2003).

Among the cultural products shown to young people by mainstream media, it is possible to identify examples of popular and youth culture blending with forms of high culture. Coldplay's album *Viva la Vida* (2008) is one such example. In this pop baroque album cover, high art is mixed with low art. The front cover features an appropriation of Eugene Delacroix's *La Liberté guidant le peuple* (1830). Using a white paintbrush, the expression "Viva La Vida" is drawn across Delacroix's painting.

When exploring the cultural universe of youth, it is important to revisit Jean-Jacques Rousseau's *ruse pédagogique* (Meirieu, 2000), or pedagogical ruse, in order to develop art projects that will be truly meaningful to students. Rousseau was an 18th-century French intellectual and writer. Originating from *Émile*'s lesson of astronomy, the ruse can be understood as the pedagogue's efforts to convince children that what they should want to learn is what the pedagogue considers important (Meirieu, 2000, p. 2). The pedagogue's efforts, then, are a ruse because he or she, rather than the children, has chosen what is important to learn (Meirieu, 2000, p. 2).

Thus the underlying questions arise for contemporary art education in relation to Rousseau's concept: How do we truly give meaning to knowledge? If the objective is to invite students to have a full cognitive, cultural, and aesthetic experience while being presented with Delacroix's painting, for instance, what pedagogical strategy should be privileged? According to Rousseau's *ruse*, Coldplay's cultural product is used in an instrumentalist way. Consequently, art teachers become illusionists promoting what they establish as worth learning (i.e., high culture discourses) using all the "teaching tricks" possible.

On the other hand, when approached for their intrinsic value, youth cultural landmarks can become true catalysts for exploring fundamental philosophical questions. The focus is then put on these cultural reference points as crucial means

through which young people can engage questions such as: Where do I come from? Why can I love and hate my siblings at the same time? Why are adults condemning the video games I love while not being peaceful and mature themselves? According to Meirieu (2000), the school system has abandoned the questions that were traditionally present in mythology, fairy tales, and traditional forms of expression. Today, philosophical questions are posed in the context of the economic market and commercialized culture. For example, Pokemon addresses fundamental questions such as that of rivalry between brothers, a recurrent theme since the biblical story of Cain and Abel (Meirieu, 2000, p. 5).

Youth cultural landmarks can become a rich mixing of different types of culture. From Tim Burton's exhibition at the Museum of Modern Art (2009) to Lady Gaga's collaboration with artist Jeff Koons for her album *Artpop* (2013), cultural reference points associated with youth culture address questions that are fundamental for students' identity and cultural construction. Cultural landmarks also have the potential to truly resonate with students' symbolic cultural production processes. Art educators, then, have many reasons to attend to informal youth cultural practices.

A renewed focus on youth culture in art education with both its reception and creation dimensions can be nourished by examining cultural landmarks generated by young people. Being simultaneously consumers and producers, many youth generate analog and digital content and products such as profiles on social networks, blogs, video games, and satirical posters (Richard, 2012). Some young people have no problem calling the products originating from their informal cultural practice "artistic" (Faucher, 2006), a label that sometimes refers to being partly amateur and partly professional. These types of informal creative practices and artistic products of youth found in the margin of school art can refer to the notion of self-initiated art (Ulbricht, 2005).

Youth cultural practices can serve as models in the art class. A good example of this is found in the work of Nicolas Plamondon, a young Quebec artist (1990–2013). Nicolas's fascinating artistic practice was mostly based on prolific cartoon production. When I first interviewed Nicolas, he was 16, and some of his cartoons had already been published, with the help of his father, who has owned a bookstore in Montreal and encouraged his art (Faucher, 2006).

This young cartoonist was passionate about visual, dark, and gory humor. His art exposes the blurring of distinctions between high and low culture. Embedded in popular culture, his productions refer to high culture through the styles of various artists (Wolf & Perry, 1988) that he admired, such as Picasso, Miro, Bacon, and Modigliani. High culture is also activated through references made in the scenarios he invents. Additionally, Nicolas was inspired by the aesthetic of German Expressionism in cinema and visual art. This aesthetic is present in his comic entitled *Ordisjoncté* (see Figure 4), in which Nicolas addresses the Internet as a subject. Nicolas describes

Figure 4. *Left image*: Nicolas Plamondon, 2006, *Ordisjoncté*. *Right image*: Nicolas Plamondon, 2005, *Self-Portrait*.

his comic in our interview, and he states that this story shows characters of all ages interacting in cyberspace and dealing with issues of isolation, addiction, and pornography (as cited in Faucher, 2006, p. 14). Low culture is also present in his artistic practice through the influences, amongst others, of Marc Ryden, for body shapes, and of Tim Burton, for his collection of illustrated poems and his films. Burton is an example of an artist whose production overlaps several types of cultures, where influences from popular culture and Edgar Allan Poe coexist in a pop surrealist aesthetic. Burton's work, then, is a cultural hybrid.

Nicolas deplored the fact that his art teachers did not present any of these artists—who were from high and low culture—in class. He did not find the works of the Impressionists, principal artistic references shown in his art class, very stimulating. He wanted the school to present more contemporary painters and works of art that could actually engage teenagers. Nicolas also told me how his art lessons in grade 8 were so boring that the only pleasure he got was from shocking others by drawing crucified pregnant women or pieces of excrement as still life. Could Nicolas's work have been understood as transgressive pleasure (Duncum, 2009) if the art teacher had known how to use youth culture as a cultural landmark?

Nicolas also had a blog (Faucher, 2008). He used it as an online portfolio that, for him, represented a window to make his art visible in cyberspace (see Figure 5). His blog enabled him to share ideas about his daily life by posting photographs showing arranged objects that amused him or drawings transformed by image-processing

Figure 5. Screenshot from Nicolas Plamondon's blog, 2008.

software. In this young artist's practice, analog and digital spaces were intertwined. The interactive and networking dimensions of his blog allowed young people from various cultures to comment on his art. In that context, Nicolas's practice borrowed from different genres (Ito et al., 2010) but was mostly interest-driven.

The creative strategies used by Nicolas and the participants in my doctoral research included appropriation, irony, sampling, and style exploration. They mixed formal and informal, global and local, digital and analog, and high and low cultural sources and spaces, as well as many skills (Jenkins et al., 2009).

Conclusion

Whether it is the art of young artists, the landscape of informal youth cultural practices, or the production of contemporary artists, they all alter the relationship between high and low culture. Furthermore, skills such as play, transmedia navigation, and performance can be mobilized in these various cultural sites, showing how rich the connections between these types of practices can be. Thus, valuing and being inclusive of informal youth cultural practices are good ways to bridge the gap between types of culture in art teaching, and to be better attuned to contemporary social, cultural, and artistic practices.

Many cultural landmarks originating from students' immediate culture give clues as to what is deeply meaningful to the students. What is meaningful to them

is answering the fundamental questions they feed on to make sense of their world. While they resonate with their symbolic universe, these cultural reference points should be approached with attention to the importance of developing judgment (Jenkins et al., 2009) and critical literacies (Albers & Harste, 2007).

While avoiding giving an exclusively instrumental value to youth cultural landmarks, it is paramount to revisit common understandings of art and art education. Being attuned to contemporary social, cultural, and artistic practices—those that are hybrid, complex, dissonant, and rapidly changing—presents a challenge sometimes characterized by risk, doubt, and instability. This postmodern posture might be less comfortable than its ordered and hierarchical modernist counterpart. By being open to informal youth cultural practices, however, art teachers can access the dimension of students' lives in which they are most invested. Art teachers can then be more connected to the symbolic production processes that contribute to the formation and assertion of the individual and collective cultural identity of young people.

Taking these practices into account has the potential to increase motivation in the art classroom and to enrich students' relationships with themselves and others, and their connections to knowledge and contemporary social and artistic practices. Youth cultural practices can thus be a powerful lever in art education by serving as inspiration and as models.

Notes

1. These results, which appear here as a summary, have been discussed in more detail in an article published in 2014 (Faucher, 2014).

2. The participants who had a representation of art inclusive of popular and visual cultures (postmodernist) could more easily provide examples of activities making connections. This was less the case for those with a more modernist representation, focusing mainly on high art.

3. This research project began in 2013 and is expected to run until 2016. It is led by Professor Moniques Richard at the Université du Québec à Montréal and funded by Insight Program, Social Sciences and Humanities Research Council, Government of Canada.

References

Albers, P., & Harste, J. C. (2007). The arts, new literacies, and multimodality. *English Education, 40*(1), 6–20.

Bourdieu, P. (1979). *La distinction. Critique sociale du jugement* [Distinction: A social critique of the judgement of taste]. Paris, France: Éditions de Minuit.

Collier, J., & Collier, M. (1986). *Visual anthropology: Photography as a research method*. Albuquerque: University of New Mexico Press.

Congdon, K. G., & Blandy, D. (2001). Approaching the real and the fake: Living life in the fifth world. *Studies in Art Education, 42*(3), 266–278.

Duncum, P. (2009). Popular culture and pleasures of transgression. *Art Education, 50*(3), 232–244.

Faucher, C. (2006). Entrevue avec Nicolas Plamondon [Interview with Nicolas Plamondon]. *Vision: Revue de l'association québécoise des éducatrices et éducateurs spécialisés en arts plastiques, 64*, 10–14.

Faucher, C. (2008). Entrevue avec Nicolas Plamondon [Interview with Nicolas Plamondon]. *Corps + fictions technologiques.* Retrieved from http://www.corps.fiction.uqam.ca/images/culture_jeunes/Entreveu%20NICO%202008_C%2BF_nov08.pdf

Faucher, C. (2013). *Pratiques culturelles d'élèves de la 3e secondaire dans le cyberespace: Jonctions avec la classe d'art* [Cultural practices of grade 9 students in cyberspace: Intersections with the art classroom] (Unpublished doctoral dissertation). Université du Québec à Montréal, Montreal, Canada.

Faucher, C. (2014). The cultural practices of youth in cyberspace alongside art classes: What is the relationship? *Canadian Review of Art Education, 41*(2), 150–168.

Fize, M. (2009). *Antimanuel d'adolescence* [The adolescent anti-handbook]. Montreal, Canada: Les Éditions de l'Homme.

Garon, R. (2006). Note on the definition of cultural practice. Unpublished work.

Greenberg, C. (1961). *Art and culture.* Boston, MA: Beacon Press.

Gude, O. (2013). New school art styles: The project of art education. *Art Education, 66*(1), 6–15.

Ito, M., Baumer, S., Bittanti, M., boyd, D., Cody, R., Herr-Stephenson, B. . . . Tripp, L. (2010). *Hanging out, messing around, and geeking out: Kids living and learning with new media.* Cambridge, MA: The MIT Press.

Jenkins, H., Purushotma, R., Weigel, M., Clinton, K., & Robison, A. J. (2009). *Confronting the challenges of participatory culture: Media education for the 21st century.* Cambridge, MA: The MIT Press.

Lahire, B. (2004). *La culture des individus. Dissonances culturelles et distinction de soi* [The culture of individuals: Cultural dissonances and self-distinction]. Paris, France: Éditions de La Découverte.

Lalonde, M., & Castro, J. C. (2015). Amplifying youth cultural practices by engaging and developing professional identity through social media. In J. Black, J. C. Castro, & C.-L. Lin (Eds.), *Youth practices in digital arts and new media: Learning in formal and informal settings* (pp. 40–62). New York, NY: Palgrave Macmillan.

Levy, L. (2006). *Pink politics: A research project about girls* (Unpublished doctoral dissertation). Concordia University, Montreal, Canada.

Meirieu, P. (2000, October). *L'art dans l'éducation. Poudre aux yeux ou discipline fondamentale?* [Art in education: Dust in the eyes or a fundamental field?]. Paper presented at the meeting of the Association for the Promotion of Visual Arts Education, Geneva, Switzerland.

Ministry of Education. Government of Quebec [MEQ]. (2003). *Intégration de la dimension culturelle à l'école* [The integration of the cultural at school]. Québec, Canada: Bibliothèque nationale du Québec. Retrieved from http://www1.mels.gouv.qc.ca/sections/cultureEducation/medias/99-6487-02.pdf

Pink, S. (2007). *Doing visual ethnography: Images, media and representation in research.* London, England: Sage.

Richard, M. (2005). *Culture populaire et enseignement des arts: Jeux et reflets d'identité* [Popular culture and teaching of the arts: Games and reflections on identity]. Sainte-Foy, Canada: Presses de l'Université du Québec.

Richard, M. (2012). Enseignement des arts et dispositifs multimodaux dans les pratiques culturelles des jeunes [Teaching the arts and multimodal devices in the cultural practices of youth]. In M. Lebrun, N. Lacelle, & J.-F. Boutin (Eds.), *La littératie médiatique multimodale: De nouvelles approches en lecture-écriture à l'école et hors de l'école* [Multimodal media literature: New approaches to reading and writing in and outside of school] (pp. 203–215). Sainte-Foy, Canada: Presses de l'Université du Québec.

Rushkoff, D. (1999). *Playing the future: What we can learn from digital kids.* New York, NY: Riverhead Books.

Ulbricht, J. (2005). J. C. Holz revisited: From modernism to visual culture. *Art Education, 58*(6), 12–17.

Unrath, K. A., & Mudd, M. A. (2011). Signs of change: Art education in the age of the iKid. *Art Education, 64*(4), 6–11.

Van Zanten, A. (2008). *Dictionnaire de l'éducation* [Dictionary of education]. Paris, France: Presses Universitaires de France.

Varnedoe, K., & Gopnik, A. (Eds.). (1990). *Modern art and popular culture: Readings in high and low.* New York, NY: Harry N. Abrams, Museum of Modern Art.

Wolf, D., & Perry, M. D. (1988). From endpoints to repertories: Some new conclusions about drawing development. *Journal of Aesthetic Education, 22*(1), 17–35.

Identity Tableaux: Multimodal Contextual Constructions of Adolescent Identity

Martin Lalonde, Juan Carlos Castro, and David Pariser
Concordia University

Mobile and social media are blurring the social spaces in which teens construct and disseminate representations of identity to their peers. We refer to these representations as identity tableaux. In this paper, we present an unexpected finding from a long-term study investigating the use of mobile media, visual art, and civic engagement to re-connect at-risk youth with their education. Using a framework of hybrid spaces and multimodal media literacies, for our analysis, we looked at the processes adolescents utilize to create and share representations of their identity within the social and intimate spaces that they inhabit. From our analysis of social media posts and interviews, we saw that the participating teens defined their social relationships through representations of affective experiences using context-specific multimodal media literacies. Youth identity formation using mobile and social media is a synergetic relationship between the individual and the collective online.

KEYWORDS: Identity, teenagers, mobile media, hybrid spaces, multimodal media literacies

New experiences of mobility (Pachler, Bachmair, & Cook, 2010) shift space into hybrid forms. Within these new hybrid forms, youth continually create and disseminate multimodal expressions of their identity. In this paper, we ask three questions: How do teens use multimodal media literacies to navigate and engage with their socio-cultural physical and online networks? What impact does this engagement have on an individual's conception, construction, and performance of identity online? How does having to represent oneself, in different contexts and using different media literacies, affect an individual's performance of his or her identity online?

110

We present a selective analysis regarding the construction and performance of identity through mobile apps from a long-term study of using mobile media to engage at-risk youth with their education through the visual arts and civic engagement. From our analysis of the formation of youth identity online, we consider three categories: (1) the contextual multimodality of youth identity construction and performance; (2) identity as reflected in images of intimate space; and (3) multimodal representations of identity and emotion.

Spaces, Places, and Context

In our study, we understand the concept of space, place, and context as a hybridity of space, an idea developed by de Souza e Silva (2006). This author examines the shift of cyberspace, a virtual space that at one time existed only online and was primarily experienced through a desktop computer, to a currently more physical, in-the-world virtual interface made possible by mobile computing devices. She argues that the emergence of mobile devices in the communications practices of youth blurs the distinction between physical and virtual worlds for the user. If this is indeed the case, it is necessary to revise our concepts of virtual space and physical space. De Souza e Silva further argues that the physical and the virtual were never separate for mobile media users, as they are essentially the same, since space is primarily a social construction. De Souza e Silva (2006) states:

> A hybrid space, thus, is a conceptual space created by the merging of borders between physical and digital spaces, because of the use of mobile technologies as social devices. Nevertheless, a hybrid space is not constructed by technology. It is built by the connection of mobility and communication and materialized by social networks developed simultaneously in physical and digital spaces. (p. 266)

Mobile computing devices function as conduit interfaces enabling an experience of social spaces online, while users move through physical offline spaces. The smartphone acts as a node or access point in which individuals experience a form of telepresence, of being elsewhere. De Souza e Silva (2006) used Castells's network theory (1996, 2004), specifically the space of flows concept, to define how places are networks. The concept of place is constituted from an inter-relational process that exists between individuals, technologies, and objects. De Souza e Silva regards "space as a concept produced and embedded by social practices, in which the support infra-structure is composed of a network of mobile technologies" (2006, p. 271).

Lefebvre (1974/2000) states that social relations precede the physical experience among individuals. It is the individual who takes part in a network and transforms the space by creating a context that generates the ability to respond to content. Movement in virtual spaces, as in physical spaces, continually transforms our understanding of

a space. This relationship to space, or how one moves through it, is a function that creates nodes in a network, whether human, technical, or conceptual. Massey (2005) also added the critical component of time to understanding experiences of space and place. Movement is particularly appropriate for understanding space in regard to mobile media. Recalling the work of Bergson (1889/2001) regarding the representation of space and movement, Massey emphasized the importance of temporality on the experience of space.

Returning to de Souza e Silva (2006), even if it is not the technology itself that is creating hybrid spaces, recent mobile technology has shifted the character of the physical and virtual worlds that adolescents experience today. Location-based technologies in social media are some of the key features enabling the blurring of the physical and virtual worlds. Brewer and Dourish (2008) state that this phenomenon brings a transition "from objects to processes, and to the relationship between forms of knowing, ways of being and patterns of acting" (p. 970). They add that it is then "particularly useful to think in terms of the legibility of spaces and actions—how it is that they can be read and understood as conveying particular sorts of messages" (p. 970). Users of such networks determine the legibility of interest as they form their own networks around nodes that allow them to have increased sociability in the hybrid spaces that they navigate.

Teens and Identity Construction through Social Media

Within the hybrid spaces experienced through social and mobile media, teens have taken to the practice of carefully constructing, performing, and disseminating facets of their identity. Mobile media hybridize differing contexts by aggregating them through the mobile computing interface. Users of mobile and social media adapt to the social codes in these environments and perform variants of their identity just as they are also participants in the creation of these contexts (boyd, 2014). Social interactions build the communicative standards of a social media community (boyd, 2014). There is a close relationship between the performance of an identity and the context in which it takes place (Ito et al., 2008; Turkle, 1995). There is a reciprocal relationship between how youth construct and perform their identity and how that performance in conjunction with other participants in an online community is also influenced by the identity performance of other members of the community. What is evident is the youth's desire to be part of a community in which she or he can express her/his individuality. In online social networks, youth practices are primarily acts of identity construction and performance in relation to others (Castro, 2014).

Similar to Rolling (2004), we conceptualize identities as constructs made up of personal experiences shaped by psychological interactions, cultural codes, and fragments of popular culture. More importantly, it is the lived emotional experiences

that transform an individual's conception of him/herself. It is the manner in which the subject undergoes these experiences and internalizes them that permits her/him to construct his/her image of self, and to develop a sense for his/her own life narrative within a certain milieu.

Thus identity is performed. It is performed as an understanding of oneself within a certain social context while keeping in mind the audience for which this performance is intended. This performance is understood as a manifestation of socially expected behavioral norms—all of which have the effect of creating strong bonds between the individual or the sub-group and the larger community (Alexander, 2006). We share Judith Butler's (1990) understanding of performance as a repetition of stylized actions that are socially validated and discursively established. Culture emerges out of the negotiated spaces where social dimensions are enacted by the participants (Conquergood, 1986). Therefore, it is the events, interpretable by nature, that constitute the raw material of the aggregate of the individual and collective identity space (Parsons, 1992).

So identity, individual and collective, comes from human experience. Human experience is an understanding, an interpretation, thus it is language, and language is performed in a contextualized framework of interactions. In the context of our study, language can be understood as the artistic media productions developed through digital and Internet-based technology productions that are prompting new sorts of multimodal literacies. Digital art thus becomes the concrete matter of the lived experience of an individual and the self-understanding of a community. With this process in mind, we can begin to understand how identities are constructed through a multi-voiced exchange of narratives and symbolic images (Massey, 2005; Turkle 1995). Identities emerge where multiple narratives interact and intersect within a given relational context (Slattery, 2001). Like artistic creations, individual and collective identities have, at root, the concept of a shared narrative with an imagined audience that the narrator has in mind (Novitz, 1997). The multimodal, image-based discourse generated using the digital Web-based technology is free to deploy beyond the limits of the conceptual framework of formal spaces such as school. It is permitting connections amongst agents that deploy outside the space and time limitations of such a context (Rolling, 2004). As with most artistic creations, these creative products are the results of negotiated interactions within a given context. Over time, every post and comment made by an individual constructs a pattern of activity that is associated with a specific identity (Fuller & Malina, 2005). Identity construction and performance online are a constantly evolving process of dynamic transformation and adaptation (Slack & Wise, 2005).

The adolescent move to construct and perform conceptions of self online is not new. McRobbie and Garber's (1976) work was used by boyd (2014) regarding the bedroom culture of teens as a precursor to the presentation of identity online.

In adolescents' intimate spaces of their bedrooms, they amalgamate various popular visual culture artifacts in order to personalize their spaces. It is the intimacy of the bedroom that is used by the teenager as an anchor, as a starting point for his or her socialization process. Further, Grauer (2002) argued that the space of the teenager's bedroom brings together pieces, fragments of visual and material culture, to construct a social and cultural identity for her- or himself. The bedroom space of the teenager, like her/his online presence, is constantly made and remade to represent, explore, and try out new understandings of self.

Toward a Multimodal Media Literacy

Multimodal media literacy is critical to understanding the contexts, social spaces, exchanges, and interactions online. The mobile media interface that teenagers use to interact is a semantic tool through which young people interpret and represent their social and cultural realities. The mobile computing device has evolved from a simple voice communication platform to a convergence of multiple means of visual, textual, and auditory production (Jenkins, 2006). Further, the mobile device has become the primary means by which teens connect to the Internet (Lenhart & Pew Research Center, 2015). These devices are multimodal communication devices and portals to varied virtual spaces.

In this context, "multimodal" is defined as exploiting at least two different communication modes simultaneously, which are deployed in the transmission of a message (Jewitt & Kress, 2003). For example, an image attached to a text, or a video of a song, are multimodal means of communication. What is more important than just the combination of media forms is the "new production of meaning" (Jewitt, as cited in Lebrun, Lacelle, & Boutin, 2013, p. 73) that arises from the combination of different socio-semiotic modes (Lebrun et al., 2013). Multimodal media literacy is the language that emerges from the intersection of differing digital media. In our study of the communicative practices of adolescents through mobile and social media, we sought to understand the particular literacies and the meanings that are generated. Buckingham (1993) emphasized that the definition of literacies is primarily a social process. These multimodal media literacies are languages constructed within particular socially constructed contexts (Slater, 1997). These observations are important when considering the educational context because of the context-specific nature of multimodal communication (Lebrun et al., 2013). In other words, there are no hard-and-fast rules for multimodal literacies, as such literacies are made and remade overtime. Even though multimodality cannot be identified with a generalizable set of practices, the significance of visual communication must be considered (Duncum, 2004; Lebrun et al., 2013). Faucher and Richard (2009) argue that, in Quebec, digital arts education promotes a disciplinary approach focused more on technical and

professional skills rather than a critical reflection on the new socio-cultural practices that emerge from digital communities. They propose an approach where new media and visual arts education could act as a bridge between the school context and the multiple cultural worlds inhabited by young people. Art educators are in a unique position to address these dynamics because the development of new literacies in and through mobile and social media involves complex modes of communication often observed in contemporary art practice (Castro, 2012; Lalonde & Castro, 2015).

MonCoin

The examples we present in this essay are drawn from a long-term research study that examines the affordances and constraints of using mobile media, the visual arts, and civic engagement to re-engage at-risk youth with their education. The study, entitled "MonCoin," meaning "My Corner" in English, is inspired by the personal, social, and public spaces of teens. This research project focuses on the challenges of educational engagement by implementing a visual arts curriculum, specifically mobile digital photography, through social media with a group of teens at an educational re-integration center for dropouts. We use the Instagram application, and our meetings take place after school outside the classroom.

Participants for this study were recruited from among 16-to-20-year-old students who were attending a center for adult education. The center was specifically designed to help young dropouts to complete their general high school education. Having been informed that a research project was to be launched at the center, about 20 students expressed interest in joining the research project, which was centered around making photos, and posting them on a social network via a mobile Web-based application. This group met three times a week after classes to exchange ideas and talk about the images and posts that were made and shared through the mobile application. Two phases—each 6 weeks in length—were conducted during the same school year and with two different groups. When asked at the first interview why they had been interested in and had enrolled in the project, the participants offered three distinct reasons: The project gave these students a chance (1) to meet new people, (2) to work on their photographic skills, and (3) to develop and test their understanding of a new social media site based on mobile technologies. We note that, more generally, what attracted these voluntary participants was the chance to be part of a media creation interest group addressing questions and issues about the public space.

The question that guided the civic engagement dimension of the curriculum was: How can I improve my neighborhood? This theme was broken down into missions, a form of prompts that were posed to participants through image and text. The themes were sequenced so as to ask students to start with familiar spaces and places and then gradually move toward the explorations of their civic environment. We can

see in Figure 1 the four different themes that were posted at weekly intervals during the first phase of the research. Participants responded to each mission by posting images, textual commentary, and geographic location through the mobile application. Activity on the mobile application was the topic of after-school discussions. Taking advantage of the multimodal qualities of the mobile app, the curriculum was delivered through the app by means of posts to the participants. The initial objectives of the project were to encourage students to examine their civic environment and to gradually think of ways in which they could participate in its improvement. Our first mission suggestions for the first week's activities were dedicated to explorations of personal space. Later mission suggestions expanded the focus to consider broader social space, and the last mission suggested that participants should come up with ideas for the civic improvement of familiar public spaces.

Figure 1. By Martin Lalonde. The four thematics that were explored through the 6-week period of phase 1 of the research in October and November of 2012. In clockwise order, "Chez nous, c'est où" [Where is home?]; "Un regard vers l'extérieur" [A look outside]; "Mon quartier" [My neighborhood]; "Changer mon quartier" [Change my neigborhood].

In order to protect participants' identities, we asked them to create pseudonyms, and encouraged them never to post recognizable images of themselves or other participants. Many participants said they appreciated this because it allowed them to retain a degree of anonymity while knowing somewhat who was a part of the group. We formed a private group of 20 participants who opened new accounts to ensure that no individual external to the project had access to the interactions that occurred inside the group. Semi-structured interviews were conducted at the introduction and conclusion of the project to cover the before and after phases. All participants' and the instructor's posts (images, text comments, and information such as author, date, and location data) were stored and coded in a database. Data analyzed included field research journals maintained by researchers and research assistants, photographic documentation of field activities, educational materials, transcribed interviews, and the posts of the participants.

Design-Based Research

The ongoing MonCoin project is conducted using a Design-Based Research (DBR) methodology. Design-Based Research seeks to address two concerns in education: the first is the need to develop researched educational interventions in the form of curricula, technological interfaces, and so on. The second concern is to develop contextual theories of learning (Wang & Hannafin, 2005). That is to say, DBR is the naturalistic study of learning in classrooms and educational environments instead of the study of learning in isolated laboratory settings (Brown, 1992). In MonCoin, we sought to develop new curricula and pedagogies for mobile media while simultaneously considering the shifts in teaching and learning required by these new technologies and cultural practices. Wang and Hannafin (2005) attribute the following characteristics to the DBR approach: pragmatic, collaborative, interactive, iterative, and flexible.

We have also deployed Image-Based Research (Prosser & Loxley, 2008; Stanczak, 2007) regarding the analysis of digital content that was generated by the participants. Analysis of participants' posts afforded us important data for understanding the self-representation of youth and their conception of the social spaces in which they live. What we have documented are the socio-cultural attitudes of young people as regards the ongoing process of conceptualization, construction, and the performance of identity online. Further, images and posts were conceived as not only personal, but also as material produced by their social interactions (Stanczak, 2007). We used methods of thematic analysis for each type of data (interview transcripts, notes of observation, diary digital database, etc.) (Miles, Huberman, & Saldaña, 2014). The themes identified in the different types of data were then pooled by a process of triangulation (Bernard, 2010; Paquay, Crahay, De Ketele, & Huberman, 2006; Van Campenhoudt & Quivy, 2011). We linked participants' responses to their visual

production and finally to their observed behavior online. A number of themes from our analysis emerged from the different iterations of the construction, adaptation, and changes of the MonCoin curriculum (Barab & Squire, 2004; Design-Based Research Collective, 2003). The focus of this manuscript is the importance that the participants placed on the evolution and validation of their identities using multimodal approaches online. We call these posts, which consist of images, texts, and references to material culture "identity tableaux."

Identity Tableaux: Multimodal Contextual Constructions of Identity

In interviews with participants, we noted that they were preoccupied with communicating ideas about space and identity. The act of making images with their mobile devices was a process of discovery, definition, and the appropriation of spaces in reference to themselves. By creating multimodal publications that mingled picture, text commentary, geographic location, and temporal and emotional state, participants developed what we called "identity tableaux"; that is, the multimodal construction of self in space through posts that include images, textual commentary, and their actual location. Participants performed their identities in private and public spaces. What is most critical about this activity is the notion that participants created and disseminated their identities for the benefit of a selected audience of their peers. In their interviews, participants emphasized that this would not have been possible outside a group context. They also recognized that they needed a community of peers who were interested in making images. Within this familiar community, our participants were motivated to post images of objects that were of a personal nature. But the impulse to show such images depended on the knowledge that an audience was interested enough to look at and comment on their posts. As participant Tornadodee18 stated:

> If you post things in order for people to see them and there is no one who comments, it is as if it was no use.

Constructing and Sharing Personal Space

As noted earlier, it was the aim of the MonCoin curriculum to gradually walk participants through their personal spaces toward public and civic spaces. We began the project with missions that focused on investigations of personal space. We identified this theme as the one our participants responded to most strongly. When we asked what theme she had preferred, participant Djulye_in_the_sky replied:

> The personal theme. I liked it better because I could show where I feel good. Such as at school, even if I'm at school, I can feel at home because my boyfriend is there and it is in this environment where I feel good. I wanted to

show everyone that this is perhaps not the material possessions we needed but personal relationships with others, it allowed me to express my point of view on this subject.

These are also the posts that were produced in response to this theme that clearly reflected the adolescents' concept of hybrid social spaces. We have observed that the principle of personal or private spaces for youth participants was not necessarily associated with a specific geographic location or particular physical surroundings. When participants explored this theme in their images and exchanges through the mobile app, we observed different conceptual understandings of the intimate, the private, and the personal. It is through multimodal image/text constructions that participants expressed their interpretation of their sense of home. As exemplified above by Djulye_in_the_sky, what we observed was that several participants sought to illustrate the idea of home in terms of a relationship with another person.

In the following, we will refer to specific posts in which we observed this principle of conceptual multidimensionality in the explorations of personal space. These posts function as articulations of the participant's identity. Each of the posts presents a multimodal approach, or different digital media and even languages (French and English) to express ideas about personal space.

Multimodal Representations of Hybrid Spaces of Identity

The first example is a post by participant _mysterygirl, where she made a screenshot showing a text message from a friend that shows her appreciation and thanks for having "done a lot" (Figure 2). She uses the screenshot of the visual text message as intimate and personal space. It is within this space that she experienced an emotionally meaningful exchange. As a result, she cites this exchange with her peers to reveal an aspect of her personality. She is showing her personal qualities through documenting her generosity and willingness to help her friends. This operates as a form of transfer of language by extracting the text message from her own personal space to another area of virtual exchanges: from Short Message Service (SMS) text to Instagram. Such a compound representation appeals to her peers by including a text message that is associated with the intimate space of communication. We observed that the camera and the personal nature of connections mobile media allowed for enabled youth to reference intimate space and to share events that are emotionally significant.

The Emotional Experience as a Construction and Performance of Identity

In the following example, as seen in _mysterygirl's post, communication is intended to evoke the interest of all participants by citing a specific kind of experience. In

Figure 2. By _mysterygirl. The text in the image reads: "Merci beaucoup. Et oui, tu en as beaucoup fait, je le sais et je t'en remercie tellement. C'est fou, tu en as tellement fait pour moi que je ne sais pas comment te remercier. Merci d'être une si bonne fille. Je te jure que je t'adore beaucoup. Merci, et il faut se refaire des soirées comme ça à se parler, merci" [Thanks a lot. Yes, you have done a lot for me and I thank you so much for it . . .]. _mysterygirl writes in the comments box: "Un beau petit message d'une très bonne amiee" [A nice little message from a good friend].

this example (Figure 3), the participant shares her personal experience of listening to a song that is emotionally significant to her. Participant Zelexy attempts to summarize the experience and to show that she is knowledgeable about popular culture (i.e., literate) by combining references to music, quotes from performers, lighting, and composition. She considered this particular type of experience as belonging to the personal sphere. Zelexy constructs an image in this emotional space and thereby constructs her identity among her peers, who will recognize the multimodal conventions to which the post refers. Her post is representative of what participants were doing to distinguish themselves from their peers though the presented assemblage of objects, visual elements, and textual descriptions. Similarly, the following post (Figure 4) illustrates another example of how participants' personal emotional experience functioned as a form of intimate space. Participant Zelexy posted an image that is essentially used as a backdrop and placeholder for an emotional state. She took this image on the way home from school and remembered her recently deceased uncle—personal information that she shares in the accompanying comment. The image, with the geographic location tagged, documents the moment when this strong memory

came to her and the emotions she experienced. All of this was an articulation and dissemination of her identity at a time when most of the participants were using the app. Late afternoon and early evening were the most active times of the day on the app for most participants. Interaction on the app was high, and responses to posts were almost instantaneous. The timing of the post was strategic, as it effectively got the attention of her peers moving from school to work or to home.

While some participants sought to share emotional states, other participants constructed and presented more literal depictions of their personal space. In the following two posts, two male participants communicated their current activities at home. In Figure 5, participant Alaxar666 presents a constructed scene from his home at the end of the day. In the post, he explained that the objects presented: candy, guitar pick, glass of milk, and a laptop about to play a movie symbolized his ideal way to relax. His post was also a prompt to motivate his peers to share their own ways of relaxing at that moment. The post gave proof of his location and activity, and he remained online to converse with his peers in the comments. In Figure 6, participant Sidviscious584 posted an image during a late Friday evening. In so doing, he shared his activity, a party at his home, with his peers. In this post, there is a more ambiguous aesthetic through soft focus and high contrast, but similar to Alaxar666, his goal was to communicate his identity through his activity.

Figure 3. By Zelexy. "Rien de mieux que du bobby vinton pour se sentir chez soi :)" [Nothing better than Bobby Vinton to feel at home :)].

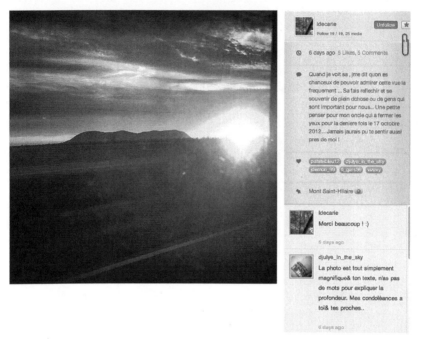

Figure 4. By Zelexy. "Quand je vois ça, je me dis qu'on est chanceux de pouvoir admirer cette vue-là fréquemment. . . . Ça fait réfléchir et se souvenir de plein de chose ou de gens qui sont important pour nous. . . . Une petite pensée pour mon oncle qui a fermé les yeux pour la dernière fois le 17 octobre 2012. . . . Jamais je n'aurais pu te sentir si près de moi!" [When I see this, I tell myself that we are lucky to be able to admire such a view on a regular basis. . . . It makes you think and remember a lot of things and people that are important to us. . . . A little thought for my uncle who closed his eyes for the last time on 17 October 2012. . . . I could have never felt you so close to me!].

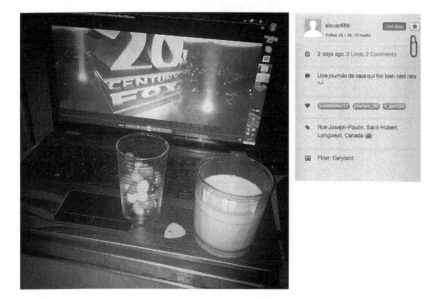

Figure 5. By Alaxar666. "Une journée de caca qui finit bien c'est rare" [A bad day that ends well, it is rare].

In the examples presented, we found that, in each case, social interaction is initiated by the image. The posted image serves as a cornerstone to a complex, multimodal representation of personal and emotional experiences through which participants construct their identity. The message participants sought to communicate was sometimes beyond the observed content of the image. Youth appropriate and deploy the experiences and artifacts that they encounter and represent themselves through them. They also sought to have their posts seen, liked, and commented on, though their primary motivation was to externalize inner states and ideas of who they are. In other words, their main motivation was to construct and present their identity to others. Their relationship to their peers was essential to their process of identity formation, as they sought affirmation for each post communicating ideas of self. Speaking of what she found motivating about the project, participant Tornadodee18 noted:

> What was motivating, I think it was the enthusiasm of others . . . You didn't
> have the impression that nobody was listening and that you were doing
> this for nothing.

The expectation that participants' peers would view and analyze their images also encouraged them to create personal compositions. Seeing their peers develop and disseminate such posts through the mobile application prompted each participant to publish her/his own identity tableaux.

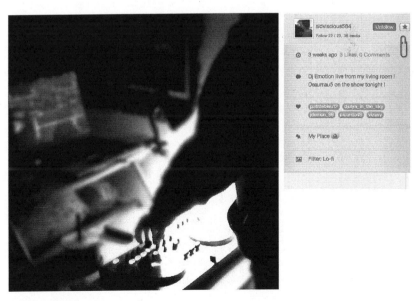

Figure 6. By Sidviscious584.

Conclusion

While we did not intend to study the identity tableaux created and disseminated online by youth, we recognized that this experience is central to the ongoing identity formation and socialization of adolescents who use mobile and social media. Oftentimes, for the participating teens, the image created did not matter as much as the experience to which it referred—as in the case of the Zelexy's post that warmly evoked her recently deceased uncle. Her multimodal representation of lived experience served as an element in Zelexy's ongoing process of identity construction and performance.

Our analysis demonstrated how these young people were able to construct their individual and collective identities through the aesthetization of daily events in their lives. It was through identifying and sharing their everyday experiences that the young people were able to simultaneously develop their own unique online identities and to also develop a sense of common purpose as a group. In general, we know that, among everyday adolescents, acts of multimodal creation and exchanges occur ubiquitously and are embedded in their lives. As we have seen, this sort of multimodal creation leads to reshaping participants' understandings of individual and collective experiences. The postings of identity tableaux on the online network contributed to the development of a particular collective multimodal media literacy.

The group started out as a gathering of unique individuals where each person worked on his own problems concerning his image in front of a select audience of his peers. But there was also a gradual development of collective inquiry. At their exit interviews, the participants stated that they were initially interested in developing technical expertise in image making. However, they also admitted that working in this project had helped them to learn more about themselves and about the ways in which their peers saw and understood a variety of everyday experiences. The participants would come back to the fact that they were learning from being constantly aware of the point of view of others. Their approach to interpreting the visual and multimodal documentation of personal, social and school spaces contributed to the creation of their shared symbolic codes. These codes offered a way for them to explore, experiment, and construct their own identities while, at the same time, identifying themes and motifs that the group as a whole shared. This created solidarity within the group.

Bey's (2014) research showed that popular culture constitutes a powerful vehicle for conveying social values by way of aestheticizing embodied everyday experiences. Our research shows how young people can also deploy their own normative system of values through the ways in which they build and deploy media language codes of their own, arising from the aesthetization of their own identity-formation process. Whereas Bey's work focuses on the performativity of genders as shaped by popular culture, our work examines a related question: What are the ways in which identity

is performed and constructed on the collective and individual level among teenage learners in a formal school context? We have gained some insights into the formation of youthful identities and the sorts of virtual/online learning environments that youth find congenial. From our perspective, we see art education as playing an important role, not only in terms of helping students to respond critically to the implicit codes embedded in popular (consumer) culture, but also as contributing to the development of the youthful learners' sense of their own particular aesthetic. Thus we see a role for art education in moving learners toward the formation of their authentic and fully realized individual and cultural identities.

Acknowledgments

We gratefully acknowledge financial support of this research through a Canadian Social Science and Humanities Council Insight Grant, "MonCoin: Investigating Mobile Learning Networks to Foster Educational Engagement with At-Risk Youth" (Juan Carlos Castro, principal investigator; David Pariser, co-investigator).

References

Alexander, B. K. (2006). *Performing black masculinity: Race, culture, and queer identity*. Lanham, MD: AltaMira Press.

Barab, S., & Squire, K. (2004). Design-based research: Putting a stake in the ground. *Journal of the Learning Sciences, 13*(1), 1–14.

Bergson, H. (2001). *Time and free will: An essay on the immediate data of consciousness*. Mineola, NY: Dover Publications. (Original work published 1889)

Bernard, H. R. (2010). *Analyzing qualitative data: Systematic approaches*. Los Angeles, CA: Sage.

Bey, S. (2014). An autoethnography of bodybuilding, visual culture, aesthetic experience, and performed masculinity. *The Journal of Visual Culture and Gender, 9,* 31–47.

boyd, d. (2014). *It's complicated: The social lives of networked teens*. London, England: Yale University Press.

Brewer, J., & Dourish, P. (2008). Storied spaces: Cultural accounts of mobility, technology, and environmental knowing. *International Journal of Human-Computer Studies, 66*(12), 963–976.

Brown, A. L. (1992). Design experiments: Theoretical and methodological challenges in creating complex interventions in classroom settings. *The Journal of the Learning Sciences, 2*(2), 141–178.

Buckingham, D. (1993). *Children talking television: The making of television literacy*. London, England: The Falmer Press.

Butler, J. (2006). *Gender trouble: Feminism and the subversion of identity*. New York, NY: Routledge.

Castells, M. (1996). *The rise of the network society*. Malden, MA: Blackwell.

Castells, M. (2004). *The network society: A cross-cultural perspective*. Cheltenham, England: Edward Elgar Publishing.

Castro, J. C. (2012). Harrell Fletcher: Shaping a new social. In T. Quinn, J. Ploof, & L. Hochtritt (Eds.), *Art and social justice education: Culture as commons* (pp. 101–103). New York, NY: Routledge.

Castro, J. C. (2014). Constructing, performing, and perceiving identity(ies) in the place of online art education. *Journal of Cultural Research in Art Education, 31*(1), 31–53.

Conquergood, D. (1986). Performing cultures: Ethnography, epistemology, and ethics. In E. Slembeck (Ed.), *Miteinander sprechen und handein: Festschrift für hellmut geissner* (pp. 55–66). Frankfurt, Germany: Scriptor.

The Design-Based Research Collective. (2003). Design-based research: An emerging paradigm for educational inquiry. *Educational Researcher, 32*(1), 5–8.

de Souza e Silva, A. (2006). From cyber to hybrid: Mobile technologies as interfaces of hybrid spaces. *Space and Culture, 9*(3), 261–278.

Duncum, P. (2004). Visual culture isn't just visual: Multiliteracy, multimodality, and meaning. *Studies in Art Education, 45*(3), 252–264.

Faucher, C., & Richard, M. (2009). L'art comme seuil entre les pratiques culturelles des jeunes et les pratiques scolaires: Investir le cyberespace au Québec. In L. Trémel (Ed.), *Les pratiques audiovisuelles: Réflexions sur des questions d'éducation, de culture et de consommation de masse* (pp. 135–163). Dijon, France: Editions d'un autre genre.

Fuller, M., & Malina, R. F. (2005). *Media ecologies: Materialist energies in art and technoculture.* Cambridge, MA: The MIT Press.

Grauer, K. (2002). Teenagers and their bedrooms. *Visual Arts Research, 28*(2), 86–93.

Ito, M., Horst, H., Bittanti, M., boyd, d., Herr-Stephenson, B., Lange, P. G. . . . Robinson, L. (2008). *Living and learning with new media: Summary of findings from the digital youth project.* The John D. and Catherine T. MacArthur Foundation Reports on Digital Media and Learning. Retrieved from http://digitalyouth.ischool.berkeley.edu/files/report/digitalyouth-WhitePaper.pdf

Jenkins, H. (2006). *Convergence culture: Where old and new media collide.* New York, NY: NYU Press.

Jewitt, C., & Kress, G. R. (Eds.). (2003). *Multimodal literacy.* New York, NY: P. Lang.

Lalonde, M., & Castro, J. C. (2015). Amplifying youth cultural practices by engaging and developing professional identity through social media. In J. Black, J. C. Castro, & C. Lin (Eds.), *Youth practices in digital arts and new media* (pp. 40–62). New York, NY: Palgrave Macmillan.

Lebrun, M., Lacelle, N., & Boutin, J.-F. (2013). La littératie médiatique à l'école : Une (r)évolution multimodale. *Globe: Revue internationale d'études québécoises, 16*(1), 71–89.

Lefebvre, H. (2000). *La production de l'espace* (4th ed.). Paris, France: Édition Anthropos. (Original work published 1974)

Lenhart, A., & Pew Research Center. (2015). *Teens, social media and technology overview 2015.* Retrieved from http://www.pewinternet.org/2015/04/09/teens-social-media-technology-2015

Massey, D. B. (2005). *For space.* London, England: Sage.

McRobbie, A., & Garber. J. (1976). Girls and subcultures. In S. Hall & T. Jefferson (Eds.), *Resistance through rituals: Youth subcultures in post-war Britain* (pp. 209–222). New York, NY: Routledge.

Miles, M. B., Huberman, A. M., & Saldaña, J. (2014). *Qualitative data analysis: A methods sourcebook* (3rd ed.). Thousand Oaks, CA: Sage.

Novitz, D. (1997). Art, narrative, and human nature. In L. P. Hinchman & S. K. Hinchman (Eds.), *Memory, identity, community: The idea of narrative in the human sciences* (pp. 143–160). Albany: State University of New York Press.

Pachler, N., Bachmair, B., & Cook, J. (2010). *Mobile learning: Structures, agency, practices.* New York, NY: Springer.

Paquay, L., Crahay, M., De Ketele, J.-M., & Huberman, A. M. (Eds.). (2006). *L'analyse qualitative en éducation des pratiques de recherche aux critères de qualité: hommage à Michael Huberman.* Brussels, Belgium: De Boeck Université.

Parsons, M. J. (1992). Cognition as interpretation in art education. In B. Reimer & R. A. Smith (Eds.), *The arts, education, and aesthetic knowing* (pp. 70–91). Chicago, IL: University of Chicago Press.

Prosser, J., & Loxley, A. (2008). Introducing visual methods. ESRC National Centre for Research Methods Review Papers, 010. Retrieved from http://eprints.ncrm.ac.uk/420/1/MethodsReviewPaperNCRM-010.pdf

Rolling, J. H., Jr. (2004). Text, image, and bodily semiotics: Repositioning African American identity. In D. L. Smith-Shank (Ed.), *Semiotics and visual culture: Sights, signs, and significance* (pp. 72–79). Reston, VA.: National Art Education Association.

Slack, J. D., & Wise, J. M. (2005). *Culture + technology: A primer.* New York, NY: Peter Lang.

Slater, D. (1997). *Consumer culture and modernity.* Cambridge, England: Polity Press, Blackwell.

Slattery, P. (2001). The educational researcher as artist working within. *Qualitative Inquiry, 7*(3), 370–398.

Stanczak, G. C. (2007). *Visual research methods: Image, society, and representation.* London, England: Sage.

Turkle, S. (1995). *Life on the screen: Identity in the age of the Internet.* New York, NY: Simon & Schuster.

Van Campenhoudt, L., & Quivy, R. (2011). *Manuel de recherche en sciences sociales* (4th ed.). Paris, France: Dunod.

Wang, F., & Hannafin, M. J. (2005). Design-based research and technology-enhanced learning environments. *Educational Technology Research and Development, 53*(4), 5–23.

(Re)Born Digital—Trans-Affirming
Research, Curriculum, and Pedagogy:
An Interactive Multimodal Story
Using Twine

Adetty Pérez Miles
The University of North Texas

Kevin Jenkins
The University of North Texas

Supplementary material for this article can be found online at http://www.press .uillinois.edu/journals/var/media/43.1/miles/index.html.

In this essay, the authors discuss Twine, a powerful tool for creating games to introduce students to game design and the creation of interactive stories that are nonlinear and choice-based. The latter term refers to games that allow players to choose one path over another by clicking on hyperlink(s) in order to progress the story. It is further proposed that making games is as much fun as gameplay, and that the technical skills and creative ideas involved in conceptualizing interactive stories enhance people's ability to consider pressing social issues. The objective of the interactive story explored here is to create a platform where players—for example, students and educators—better understand the personal experiences of transgender youth, potentially identify and intervene in classroom practices that are oppressive toward gender-nonconforming students, and create spaces that foster behavior and actions that are respectful and affirmative toward all students.

Introduction

In this visual essay, we introduce Twine, a free and open source tool that can be used to create games that are nonlinear, interactive, networked, and multimodal (see how-to video[1]). We propose that media-rich platforms have the potential to expand how we create, consume, and produce text. The research for this essay is centered on transgender issues and concerns, which we present in the form of a digital and interactive story (see Figure 1). The story is a springboard to promote learning about

128

On the first day of class, Zoe approaches her first period teacher, Ms. Michaels, who is a white cisgender woman, to discuss a basic issue for transgender students, but one that can be very distressing for the student if not addressed.

Figure 1. Adetty Pérez Miles and Kevin Jenkins, 2016, "Introducing Zoe" [Screenshot]. Here, Zoe meets her teacher and makes her initial request. Image courtesy of the authors. http://philome.la/kcjenkins9/introducing-zoe/play.

gender identities, trans etiquette, trans ethics, and creating an environment that promotes self-esteem and student success. Additionally, we discuss how our research efforts that aimed to improve the school climate for LGBQ and transgender students were embraced by the National Art Education Association but were derailed by the very state professional art education association that purports to support diversity and inclusion.

(Re)Born Digital—Trans-Affirming Art Education Curricula and Allyship Through Interactive Multimodal Storytelling

The increased visibility of transgender people in the media has brought trans issues into the home and school environments as never before. Topics such as name and pronoun use, public facilities, and sports competition are met with a broad range of reactions. Although the general level of acceptance in U.S. culture is still evolving, nonconforming gender identities and expressions are less accepted than cis/hetero/normative gender norms. This is not lost upon transgender youth who, according to the National Center for Transgender Equality, report higher levels of discrimination, harassment, and assault than their cisgender peers, resulting in higher rates of suicide attempts and dropping out of school (Grant et al., 2011).

Students may seek out teachers they feel will be accepting of their gender identities (Testa, Coolhart, & Peta, 2015) and, therefore, art educators are in a strong position to offer support to those students and to improve the climate in their schools for trans students by becoming allies. Allyship takes many forms, including simple measures like modeling behaviors of respect in the classroom or introducing inclusive curricula, as well as more direct involvement such as sponsoring a Genders and Sexuality Alliance (GSA) group at school (Brill & Pepper, 2008). Creating equitable school experiences for all students also involves scaffolding LGBTQ-affirming

content throughout the curriculum. Instructional scaffolding is enriched by the use of computer-mediated technologies. In fact, socially interactive technologies (SITs), for example, social media platforms, chat venues, and blogs, serve as places in and through which many LGBTQ individuals feel themselves reborn as these SITs continue to play a significant role in the struggle of LGBTQ communities to learn about themselves, to locate supportive relationships, and to seek opportunities for civic engagement to effectuate positive sociopolitical change.[2] In this research, we offer an example of transing[3] art education scholarship, curriculum, and pedagogy through an interactive story/game that supports an inclusive environment for gender-nonconforming youth.

Whereas the aforementioned teaching and learning strategies are important, and although LGBTQ students often seek the support of their teachers, the fact remains that many educators report feeling unprepared and uncomfortable discussing issues related to LGBTQ content. This content is not only underrepresented in publications but also in teacher education. Graybill and Proctor (2016) surveyed over 4,000 journal articles between the years 2000 and 2014 and found that, overall, only 0.3 to 3% of the publications included LGBTQ-related content. It would be safe to say that LGBTQ-related content is similarly underrepresented in art education publications. Our teaching experience over the last 10 years also supports the argument that LGBTQ-related content is covered minimally in the field of art education and teacher education programs.

The lack of LGBTQ-related publications and minimal preparation in teacher education programs surrounding gender diversity and inclusion are significant reasons for educators' discomfort and unfamiliarity with content related to LGBTQ issues and concerns. Similarly, the void in professional development for educators to gain knowledge and skills to integrate technology into the curriculum often contributes to educators' reluctance to teach with/about technology. Open source authoring and publishing platforms as well as research conference proceedings offer a corrective to the dearth of LGBTQ-related content and publications. Similarly, curriculum development plays a key role in analyzing experiences that expand the intersections of emerging technologies and LGBTQ-content-based knowledge in art and art education.

In the spirit of exploration and intersections, and in order for our undergraduate pre-service art educators to gain a better understanding of gender variance, we created a nonlinear and interactive story that uses narrative, images, and variables that result in multiple outcomes and dialogic questions and forms of inquiry. For some students, "Introducing Zoe" was their first exposure to trans-related issues, including the term "transgender" itself; some chose to research further on transgender issues and expressed a greater sense of empathy for trans people. And through the introduction of Twine as a medium for their own art and education practices, our

preservice students created interactive multimodal stories with Twine, for potential use in K–12 curricula, that addressed issues important to them such as respecting personal boundaries, experiencing social anxiety, or adjusting to school in Texas as an English-language learner and an immigrant student. Accordingly, we propose media-rich platforms and interface structures that encourage nonlinear, interactive, and multimodal outcomes and have the potential to expand how we create, consume, and produce text. Text in this context is considered broadly from poetry to storytelling to fine art to performance art—which brings us to a second story, a personal encounter in this brief conversation.

Talking Back: Are Sessions About Transgender Issues in the Classroom Needed at This Time in Art and Education Conferences?

We recently submitted LGBTQ-related content conference proposals to the national and state professional art education associations. Our goal was to discuss how our research and activism aim to improve the school climate for LGBQ and transgender students. Our research proposal was accepted, considered timely, and praised as significant content for the field of art education by the *National Art Education Association*. However, the same content, with some variations to accommodate different conference goals, was derailed by the very state professional art education association that purports to support diversity and inclusion. The letter we received explained:

> Dear _____,
>
> . . . We regret to inform you that at this time we will not need a workshop along the lines specified in your proposal (Trans-Affirming Research, Curriculum, and Pedagogy). There are many workshop proposals and a limited number of spaces and times allotted.

Unfortunately, this type of rejection is not an anomaly. The state organization under discussion has a long history of validating heteronormative ways of knowing, and invalidating certain types of knowledges, for instance, gender-variant ways of knowing and being. These are beliefs and actions that have not gone unnoticed. In fact, art educators have contested and intervened in homophobic censorship in state art education association annual conferences (Fehr, Check, Akins, & Keifer-Boyd, 2002[4]). Not *needing* research that is grounded on gender-inclusive and affirming studies, curriculum, and pedagogy is akin to erasing an entire group of people. As one of the authors of this text, and as a transgender man and educator who experienced bullying for my gender nonconformity and dropped out of high school, I know firsthand the necessity of improved teacher education, allyship, and curricular development to address the needs of LGBQ and transgender students. From the perspective of allyship and as co-author of this essay, my argument is that a dialogic

or intra- and interpersonal approach to education is not possible without reciprocity (Pérez Miles, 2012[5]). This means taking seriously the disability rights adage, *Nothing about us without us.*[6] This maxim evokes the idea of personal involvement in how one's stories, needs, hopes, and desires are written about, mediated, and circulated—not as research subjects—but as authors of one's own text. Accordingly, to be informed that an educational association deems that a workshop such as we proposed is not needed or desired erases transgender students, faculty, staff, community members, and allies who rely on our educational institutions to help create better-informed and more compassionate citizens dedicated to building an equitable and just society.

The rejection motivated us to create an alternative plan, and the presentation was reborn as a digital intervention. We have found that at many art education conferences, the foci of technology-based workshops are on tutorials and the integration of technology as a tool rather than a medium to enhance students' critical thinking. We resubmitted a proposal that did not engage directly with questions of gender identity but instead offered a presentation on digital storytelling. The proposal was accepted within 24 hours of the submission. Talking back (hooks, 1989) to the rejection letter and its subtext is a feminist trope and action of self-recovery to test one's strength against oppression; thus, the question that informs the architecture of the proposal and future presentation is as follows: *Are sessions about transgender issues in the classroom needed at this time in art and education conferences?* Furthermore, given the rapidity with which technology has changed how and what we teach and learn about art and education, we ask: *How can the current generation of learners use digital competencies to enhance students' critical thinking, viewing, and making skills?*

In "answering" the question, we take the reader through Zoe's journey, a fictional eighth grade girl who is transitioning from male to female (MTF). We introduce variables into the story and highlight the significant role that teachers play in creating anti-bullying and anti-violence curriculum and classroom practices that support positive and safe environments where *all* students can learn (see Figure 2).

Clearly disappointed, Zoe tells her, "But my parents are ok with it and told the office. Mr. Vogel said the school will make accommodations."

Figure 2. Adetty Pérez Miles and Kevin Jenkins, 2016, "Introducing Zoe" [Screenshot]. This image shows the result of an option from the initial meeting with the teacher. Image courtesy of the authors. http://philome.la/kcjenkins9/introducing-zoe/play.

Continue to use the name "Zach" for Zoe until speaking with the principal, Mr. Vogel, to learn what the policy is.

Call Zoe by her new chosen name even though the roster says "Zach" and then speak with Mr. Vogel about the policy.

Final Considerations

In closing, we have proposed that multimodal research is necessary to create rich and complex LGBTQ-related content, curriculum, and pedagogy. Research shows that increasingly, LGBTQ communities use socially interactive technologies, for example, video/photo sharing websites, social media platforms, virtual reality forums, and gaming to build community and a sense of belonging. These forms of self-identification and collective identity are significant to access LGBTQ-specific resources, to exchange information, and to build supportive relationships. It is our hope that schools can be places to practice developing trusting relationships with educators, parents, and peers, and can be sites of critical reflection about systems of power and oppression that result in an ethics of care. Competencies, theories, and actions that promote learning about a wide spectrum of gender identities, trans etiquette, and trans ethics create an environment that promotes self-esteem and student success.

Notes

1. "How to Use Twine," an instructional video created by Kevin Jenkins. https://www .youtube.com/watch?v=kNoL_zajyAo.

2. Although the opportunities afforded by the Internet, media communications, and computer-mediated technologies are many, it is not our intent to gloss over the risks associated with the use of SITs, such as loss of friendships, isolation, and online harassment (trolling and cyberbullying). http://www.pewinternet.org/2014/10/22/ introduction-17/.

3. "Transing" is used here to refer to both the inclusion of transgender issues as content but also to multiple processes of change, including transition, translation, transformation, and transcendence.

4. For an article on disrupting heteronormative conference practices, see Fehr, Check, Akins, and Keifer-Boyd (2002).

5. For an article on reciprocity and dialogic pedagogy, see A. Pérez Miles (2012).

6. We would like to thank Finn Enke for bringing the disability rights adage to our attention.

References

Brill, S., & Pepper, R. (2008). The transgender child: A handbook for families and professionals. San Francisco, CA: Cleis Press.

Fehr, D., Check, E., Akins, F., & Keifer-Boyd, K. (2002). Canceling the queers: Activism in art education conference planning. Journal of Social Theory in Art Education, 22, 124–14.

Grant, J. M., Mottet, L. A., Tanis, J., Harrison, J., Herman, J. L., & Keisling, M. (2011). Injustice at every turn: A report of the national transgender discrimination survey [Executive summary]. National Center for Transgender Equality. Retrieved from http://www.transequality.org/sites/default/files/docs/resources/NTDS_Exec_ Summary.pdf

Graybill, E. C., & Proctor, S. L. (2016). Lesbian, gay, bisexual, and transgender youth: Limited representation in school support personnel journals. *Journal of School Psychology, 54,* 9–16.

hooks, b. (1989) *Talking back: Thinking feminist, thinking Black.* Boston, MA: South End Press.

Pérez Miles, A. (2012). "Silencing" the powerful and "giving" voice to the disempowered: Ethical consideration of a dialogic pedagogy. *The Journal of Social Theory in Art Education, 32,* 112–127.

Testa, R. J., Coolhart, D., & Peta, J. (2015). *The gender quest workbook: A guide for teens & young adults exploring gender identity.* Oakland, CA: New Harbinger Publications.

The University of Illinois Press
is a founding member of the
Association of American University Presses.

University of Illinois Press
1325 South Oak Street
Champaign, IL 61820-6903
www.press.uillinois.edu